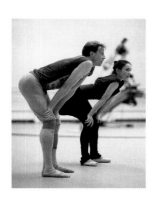

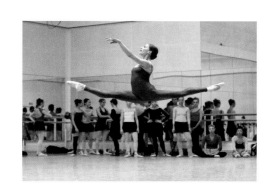

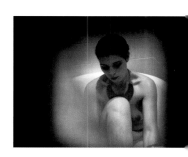

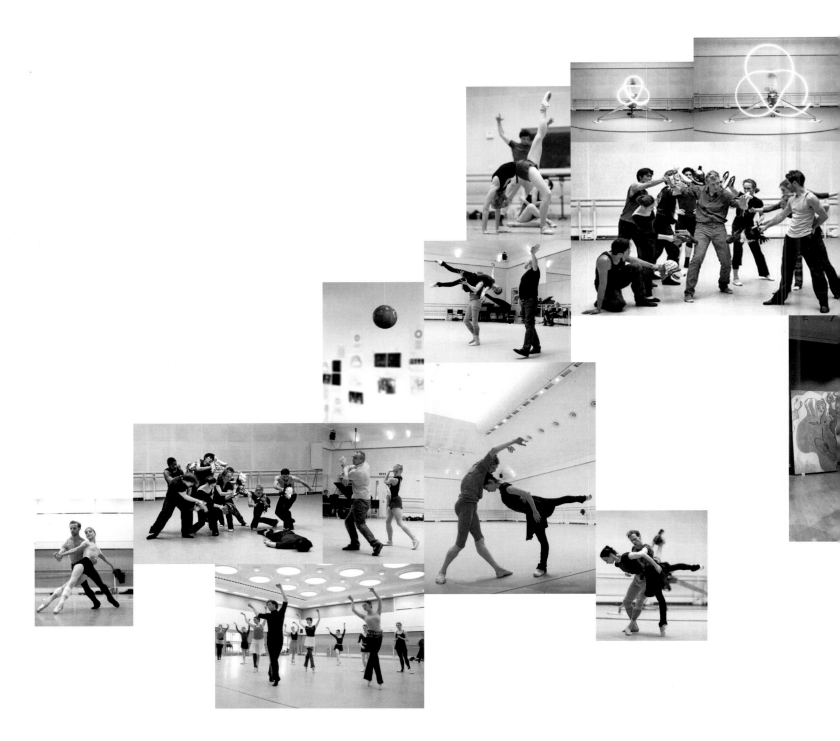

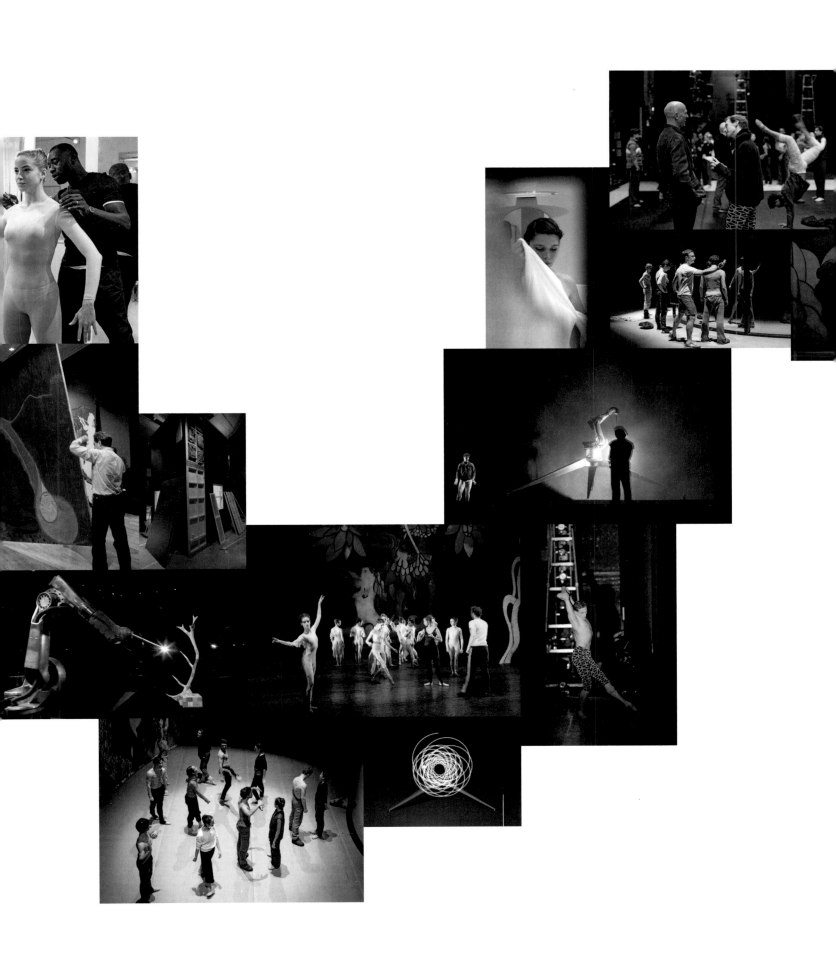

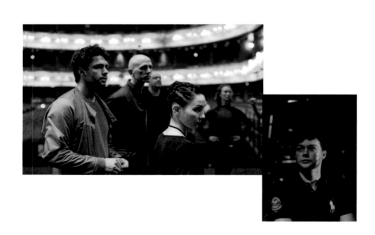
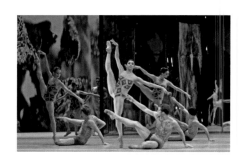

Titian | **METAMORPHOSIS**

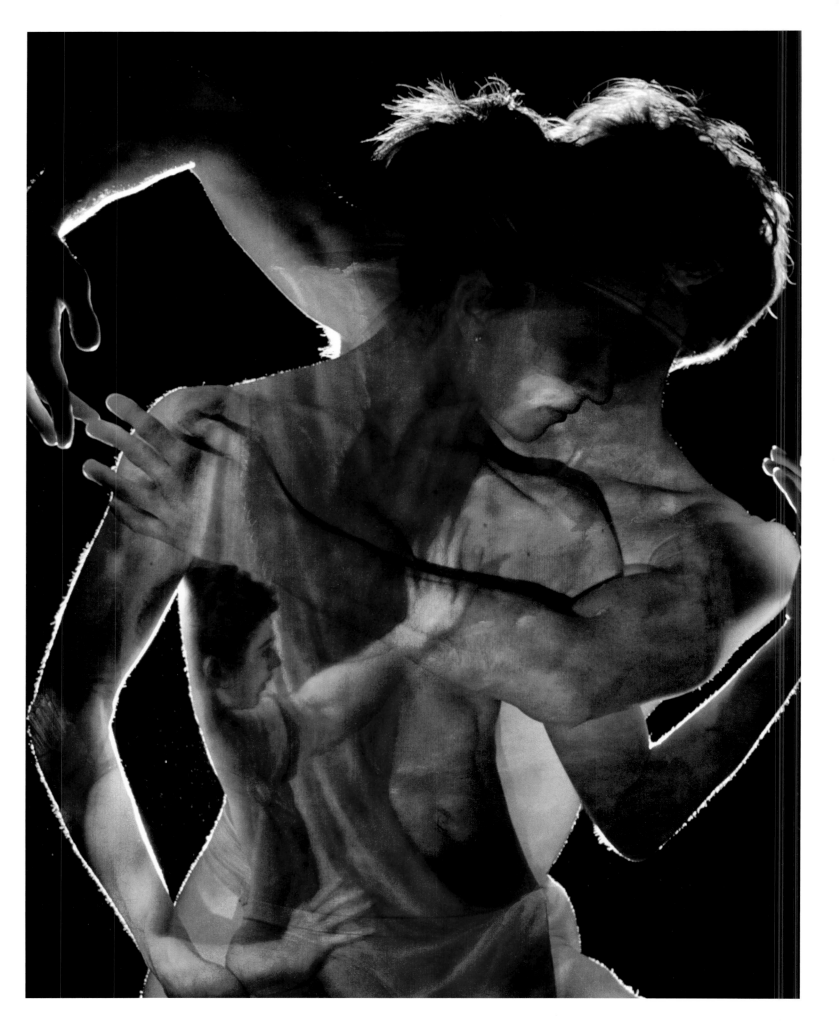

ROYAL
OPERA
HOUSE

Titian | **METAMORPHOSIS**
Art Music Dance

A collaboration between The Royal Ballet and the National Gallery

Edited and introduced by *Minna Moore Ede*
Foreword by *Dame Monica Mason* DBE

With photography by *Gautier Deblonde,*
Johan Persson and *Andrej Uspenski*

ART/BOOKS

Dr Minna Moore Ede is Assistant Curator of Renaissance Paintings at the National Gallery, London, and curator of 'Metamorphosis: Titian 2012'. She completed her doctoral thesis at Keble College, Oxford, in 2002 on 'Religious Art and Catholic Reform in Italy 1527–1546'. She has since written for and worked on a number of exhibitions at the National Gallery, including 'Leonardo da Vinci: Painter at the Court of Milan' (2011), 'Renaissance Faces: Van Eyek to Titian' (2008–9), 'Rubens: A Master in the Making' (2006), 'Raphael: From Urbino to Rome' (2004) and 'Polidoro da Caravaggio: The Way to Calvary' (2003).

First published in the United Kingdom in 2013 by Art Books Publishing Ltd in association with the Royal Opera House, London

Art Books Publishing Ltd
77 Oriel Road
London E9 5SG
Tel: +44 (0)20 8533 5835
info@artbookspublishing.co.uk
www.artbookspublishing.co.uk

British Library Cataloguing-in-Publication Data
A catalogue record for this book is available from the British Library

ISBN 978-1-908970-04-6 trade edition
ISBN 978-1-908970-07-7 limited edition

Design SMITH
Alice Austin
Maria Juelisch
Justine Schuster
Production by fandg.co.uk
Printed and bound in Italy by EBS

Distributed outside North America by
Thames & Hudson
181a High Holborn
London WC1V 7QX
United Kingdom
Tel: +44 (0)20 7845 5000
Fax: +44 (0)20 7845 5055
sales@thameshudson.co.uk

Available in North America through
ARTBOOK | D.A.P.
155 Sixth Avenue, 2nd Floor, New York, N.Y. 10013
www.artbook.com

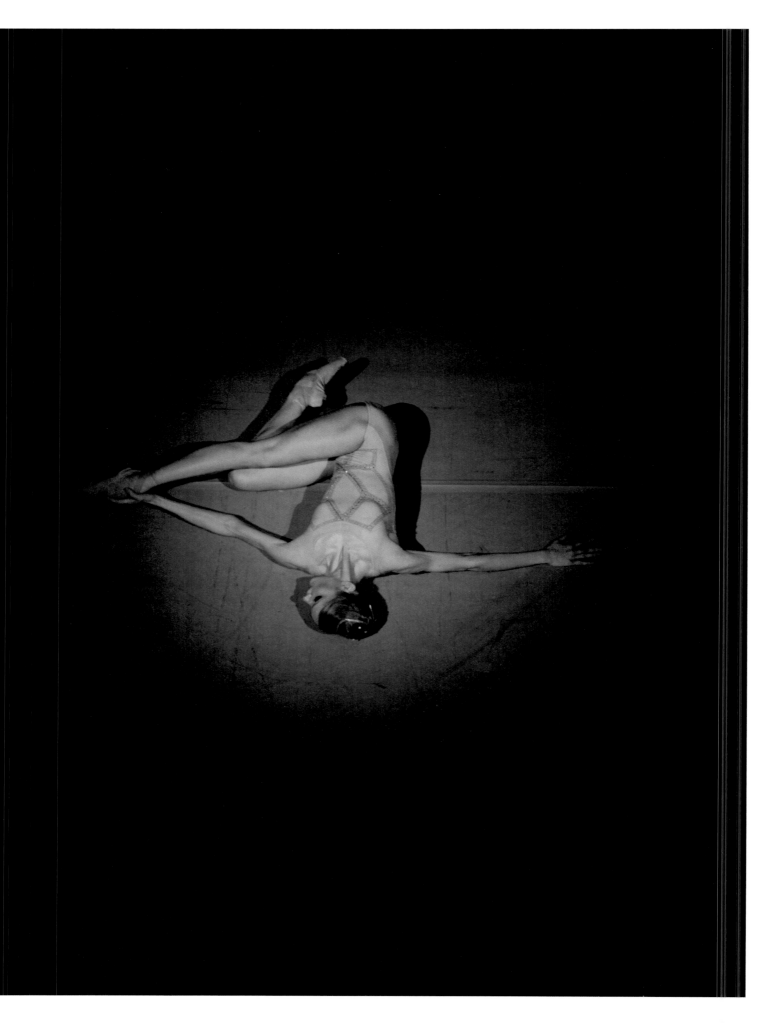

Foreword
Dame Monica Mason DBE

In 2010, the National Gallery's Dr Minna Moore Ede approached me with a request for a piece of choreography that could be performed in the gallery as part of a large project that she was curating. Three great works by the artist Titian – *Diana and Actaeon*, *Diana and Callisto* and *The Death of Actaeon* – were to be exhibited together for the first time since the eighteenth century, and her plan was to commission three contemporary artists to create work inspired by the paintings.

I was immediately intrigued by the project and wanted to explore whether the National Gallery and The Royal Ballet could collaborate further in some way to make what would be the final programme of my directorship. I asked Minna whether she felt that the artists could provide the designs for three new ballets at the Royal Opera House.

She loved the idea, so I set about planning the creative team. I wanted to involve seven choreographers, all of whom I had previously commissioned to make ballets. And together with Wayne McGregor, The Royal Ballet's Resident Choreographer and Artistic Associate, I spoke to the Company's Music Director, Barry Wordsworth, about the viability of commissioning new music as part of this exciting adventure. It was then a question of arranging the artists, choreographers and composers into three separate groups to create three one-act ballets.

The ensuing collaborations were at times challenging, perhaps even a little unnerving, but ultimately brilliantly creative. The culmination was an entire evening of new art, music and dance that more than fulfilled our ambitions. I am absolutely delighted that it has been possible to publish this book as a record of a unique event, which was, without doubt, one of the highlights of my directorship of The Royal Ballet.

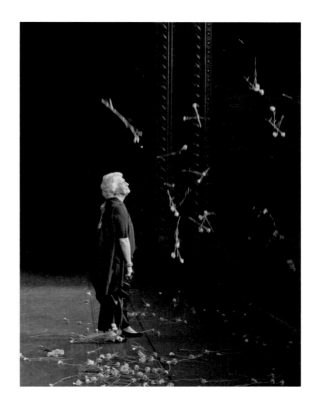

ABOVE Dame Monica Mason takes the curtain call and receives a flower tribute on the last night
OPPOSITE Melissa Hamilton in *Trespass*

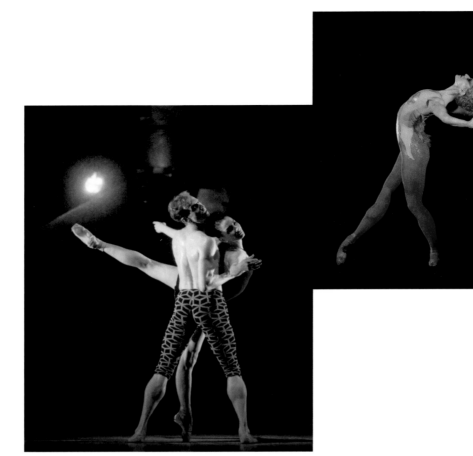

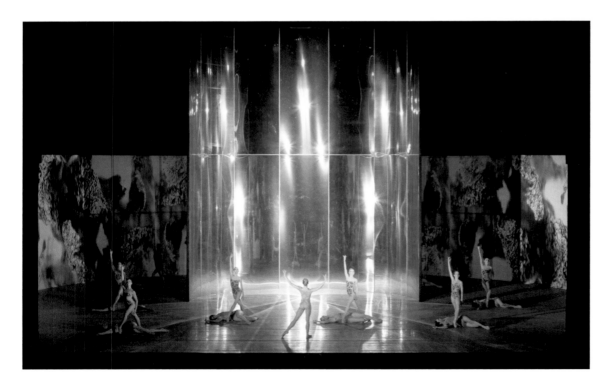

Introduction
Minna Moore Ede

'My intention is to tell of bodies changed / to different forms.' (Ovid, *Metamorphoses*)

On 14 July 2012, the curtain at the Royal Opera House in London went up and three new ballets – *Machina, Trespass* and *Diana and Actaeon* – were premiered. Gasps from the audience greeted each new set as it was revealed, the work of three leading contemporary artists, Conrad Shawcross, Mark Wallinger and Chris Ofili. There was new choreography by Wayne McGregor, Kim Brandstrup, Christopher Wheeldon, Alastair Marriott, Will Tuckett, Liam Scarlett and Jonathan Watkins, and new music by Nico Muhly, Mark-Anthony Turnage and Jonathan Dove. Taking its lead from the visual artists, this new work was an extraordinary feat of collaboration from a remarkable constellation of artists from different disciplines.

What unified them all was a shared sense of purpose, for each of the three creative teams (as they were organized) was tasked with the challenge of producing a new ballet in response to three of the Renaissance artist Titian's greatest mythological paintings: *Diana and Callisto, Diana and Actaeon* and *The Death of Actaeon*. Three days earlier, the National Gallery had opened an exhibition in which Conrad Shawcross, Mark Wallinger and Chris Ofili displayed another body of new work, also in response to Titian's paintings. Resplendent, the Titians were themselves hung at the heart of the gallery's space, displayed together for the first time since the late eighteenth century.

Entitled *Trophy*, *Diana* and *Metamorphoses*, respectively, the new work that the contemporary artists had made for the National Gallery was closely linked with, but independent from, their work for The Royal Ballet. In Shawcross's room was a smaller version of the robot he had on the Covent Garden stage; Wallinger had installed a bathroom in his space inside which was a living, breathing goddess Diana; and Ofili had made a group of ten new paintings (from which seven were selected). Costumes designed by the artists for their ballets were also on display, as were models of their final stage designs; and there was also a twenty-minute film (made by Royal Ballet dancer Bennet Gartside) of the seven choreographers at work on the new ballets in the rehearsal studio. A group of fourteen poets had also been invited to respond to the Titian paintings, and their new poems appeared as a small publication at the time of the exhibition. It was indeed, as the strapline on all the publicity claimed, 'a unique collaboration between the National Gallery and The Royal Ballet'.

The opportunity for these august institutions to work together was in part due to the sense that cultural organizations in London should pull out all the stops over the Olympic summer of 2012 – although long before he took on the task of directing London's 2012 Festival of Culture, Lord Hall, chief executive of the Royal Opera House, earned

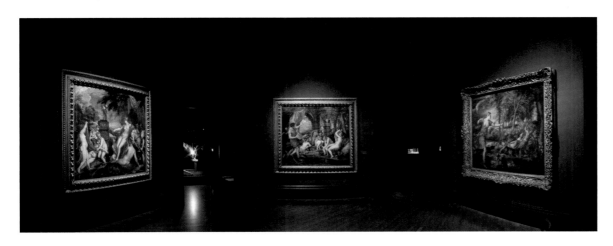

OPPOSITE Marianela Nuñez as Diana in *Diana and Actaeon*; Tamara Rojo and Edward Watson in *Machina*; Melissa Hamilton (centre) and the corps de ballet from *Trespass*
ABOVE Titian's *Diana and Callisto*, *Diana and Actaeon* and *The Death of Actaeon* installed in the National Gallery for the 'Metamorphosis: Titian 2012' exhibition, with Conrad Shawcross's *Trophy* in the background

my gratitude for lending his support to the tentative idea of the National Gallery and The Royal Ballet working together. Embryonic plans were altered once the Gallery was engaged in a campaign to acquire, together with the National Gallery of Scotland, Titian's *Diana and Actaeon* and *Diana and Callisto*, paintings that had been owned by the ancestors of the present Duke of Sutherland since 1793; they were priced at £50 million each. The National Gallery felt that all energies in the year 2012 must be focused on Titian and so 'Metamorphosis: Titian 2012', as it was soon titled, evolved: a project that would celebrate the greatness of these paintings, reminding us of their ongoing importance by commissioning contemporary responses.

One of the rewards of having contemporary artists contemplating a five-hundred-year-old painter is that it reminds us that the so-called Old Masters were themselves modern once and, as Wallinger observed, 'these Titian paintings must have been profoundly shocking in their own time'. By the time the Venetian-born Titian (*c.* 1490–1576) came to paint these works, he was in his sixties, a highly successful artist, in demand across the courts of Europe.

He is often described as the first artist with a truly international clientele. *Diana and Callisto*, *Diana and Actaeon* and *The Death of Actaeon* were part of a series of mythological paintings that he made to send to Philip II of Spain (who became king in 1556), between about 1551 and 1562. *Diana and Callisto* and *Diana and Actaeon* were sent to Madrid as a pair in 1559, while *The Death of Actaeon*, although planned as part of the series, remained unfinished and was found in Titian's studio on his death in 1576.

Unusually, the subject matter of the paintings was selected by the artist himself and is taken from the Roman poet Ovid's epic poem, *Metamorphoses*. A lively account of the lives and loves of the gods, *Metamorphoses* was almost as widely read as the Bible during the Renaissance. A copy of the text, not in its Latin original but in a contemporary Italian translation, was found in Titian's studio after he died. For this project, we elected to use Ted Hughes's lively 1997 retelling of Ovid, appropriately contemporary with a wonderfully vivid and dramatic choice of language. I was impressed that choreographer Jonathan Watkins arrived for every meeting with a copy under his arm.

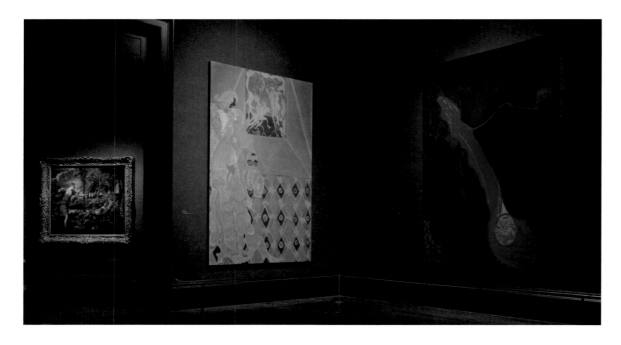

View of Chris Ofili's *Metamorphoses* room at the National Gallery, showing *Ovid-Desire* (centre) and *Ovid-Lust* (right) with Titian's *The Death of Actaeon* in the background

Philip II, Titian's patron, is known to us today as an austere and zealously Catholic king, seen in portraits typically wearing black and who, when he had his monastery palace El Escorial built, is famous for having his bedroom placed adjacent to the high altar. Titian's Diana paintings were intended, of course, to appeal to another side of the King's nature: unashamedly erotic, with a sensational array of naked women, these were objects designed to delight the eye and the senses. There is no record of where the paintings were originally hung; our first reference to them is in 1626, when Cassiano dal Pozzo, the Roman art patron, writes enthusiastically of having seen them in the garden room of the King's private apartments in the Alcázar, the Royal Palace, in Madrid. This was a private space, intended for men only, and given their suggestive nature, it seems likely that they were always intended for such a secluded space. Cassiano further observed that whenever the Queen passed through this room, the nude figures had to be covered by curtains.

Titian's paintings are all about concealing and revealing, watching and being watched, something that Mark Wallinger picked up on so brilliantly in his response. In a letter to the King, Titian described his mythologies as '*poesie*' (meaning literally 'poems'), by which he was claiming them to be the visual equivalents of poetry. These *poesie*, as they are often known by art historians, rank among the most beautiful creations of the Renaissance and have been justly celebrated as such since they were made. The responses by these three contemporary artists are only the most recent contribution to a long history of reinterpretations of the works that date back five hundred years, by artists such as Rubens, Velázquez, Constable and, more recently, Lucian Freud.

'Like a lamb to the slaughter' was Chris Ofili's initial reaction to the challenge of responding to Titian. As the only painter of the trio, the burden of comparison must have felt heaviest, and yet one of the most fascinating developments over the course of this project has been observing the changes in Ofili's working practice that are the result of his close examination of Titian as a painter. In *Ovid-Desire*, one of his new paintings made for the National Gallery, there were patches of unpainted canvas,

Top to bottom Chris Ofili, *Ovid-Stag*, 2012.
Chris Ofili, *Ovid-Windfall*, 2011–12

a bold and entirely new step for an artist who is well known for his use of collage and richly layered surfaces. Ofili spoke of having been affected by the discussion that surrounds Titian's famously unfinished *The Death of Actaeon* and of the power of paint as a tool to 'suggest' rather than always to represent something directly. *The Death of Actaeon* depicts the act of metamorphosis and is all the more effective because it is unfinished, therefore one almost believes that one is witnessing a transformation.

One of my first meetings with Ofili, in 2010, was when *Diana and Actaeon* was off the wall, lying flat for conservation examination and photography in the National Gallery. Together we pored over the painting's surface and he enthused about Titian's virtuoso abilities as a painter – we looked for the areas where one can see how the paint has been manipulated and pushed around the canvas by Titian's brush. For his backdrop for the Royal Opera House stage, Ofili was clear that he wanted it to look like it was painted by hand. It is a daunting task for an artist used to exhibiting in a gallery space to be asked to produce a set for a stage that is thirty-seven metres high. In making it, Ofili remarked how he had never before used his whole body to paint, and of the strangeness of having to work on the backdrop while walking over it flat on the ground (see pages 136–41). His application of paint was deliberately watery and fluid in appearance – he wanted the effect of colours 'bleeding' one into another – and the result, even from a distance, is that of a giant watercolour.

And yet in order to generate his own narrative response to Titian's paintings, Ofili felt the need to liberate himself, and in order to do this he went back to the Ovid text. In the same way that Titian had used Ovid's tale for inspiration but interpreted the story very much in his own spirit, so Ofili did the same. The classical world, according to Titian, was situated in a landscape the artist would have known well: Cadore, Titian's birthplace, is a small Italian town at the foot of the Dolomite mountains. It was instantly apparent from stepping into Ofili's room at the National Gallery, with its hot, vibrant colours that he had, in turn, transposed the Olympian classical world of the gods to Trinidad, where he lives and works. And as the title

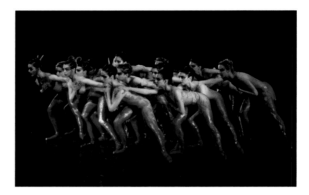

of his National Gallery room, *Metamorphoses*, suggested, this was a world of magic, of shape-shifting, where anything was possible and all things were in flux. It was a world driven by sexual desire; Ofili remarked early on that he felt Callisto and Actaeon's fates were the result of their own lust. In *Ovid-Stag*, the last painting that he made, executed in a single sitting and imbued with an extraordinary Bacchanalian energy, we see the leaping figure of Diana, identifiable by the orange crescent moon on her head, her body bisected by the bow she carries, being chased by Actaeon in the form of a vivid purple stag; according to Ofili, the insatiable Actaeon has returned to have his wicked way with the goddess once more.

Reading through the Ovid text with a friend who is a classical scholar, Ofili learnt that Ovid had given the nymphs names whose meanings had associations with water: 'Rhanis', 'Psecas' and 'Crocale' translate as 'Misty', 'Droplet' and 'Seashore'. This was an important discovery for him, and in his painted backdrop for The Royal Ballet his nymphs, seen on the right, are water creatures, rising up from green, watery depths to draw back the figure on the left who holds up a giant phallus from his/her fate (Ofili always resisted my identification of this figure as Diana, preferring to keep things more open). This green took its inspiration from the unusual colour of the sea off the north coast of Trinidad, Ofili explained, because the Orinoco river from South America flows directly into it. Since he was based in Trinidad, many of the meetings he had with his creative team were via Skype. Jonathan Dove, the composer in his creative team, picked up on this water theme, and one

of the most evocative passages of music in the *Diana and Actaeon* ballet was for the nymphs, whose watery names were sung to a libretto written by Alasdair Middleton (see pages 178–9). This was then given visual form by Liam Scarlett, who was responsible for the choreography for the fifteen female dancers cast as nymphs. Exquisitely feminine and often en pointe, Scarlett's steps suggested creatures made of water, their arms moving as if to shake off droplets; often crossing the stage in unison, they moved like a body of water, ebbing and flowing.

Although it may have felt like unfamiliar territory initially, Ofili embraced the role of set and costume designer wholeheartedly; he designed thirty-two costumes in total, for which he made hundreds of preparatory sketches, and in the latter stages he customized each costume on the body of the individual dancer (see pages 142–3). Working closely with the Royal Opera House's head of costume production, Fay Fullerton, and her marvellous team, as well as the choreographers in his team, he drew with pencil on the dancers' costumes, indicating areas that should be cut away. He surprised me with his boldness but also with his precision. He even turned his hand to make-up and props. Eight hound puppets were requested by choreographer Will Tuckett; Ofili made drawings, each dog different in character, with mouths that opened to reveal sharp teeth. Tuckett brought the dancers who were playing the role of the hounds to the National Gallery to look at Titian; we looked at the way Titian individualizes each dog in his paintings and we read Ovid's text where he both names the hounds and gives them identifying characteristics: 'Pterelas Swiftest in the pack, and Agre The keenest nose'. 'Push the energy through the puppet head', Tuckett called out in the studios as the dancers rehearsed, and their dramatic black-and-white presence on such a colourful stage made an abiding impression. Overall, the project imposed certain restrictions on the artists – the source material was already decided, as were the groups in which they must work – and yet, such filters were for some liberating: 'I could make ten more paintings', Ofili said delightedly as we surveyed the group of paintings he had made for the National Gallery exhibition.

I imagined that since there were three Titian paintings and three visual artists, it made sense for each artist to respond to a different painting. In fact, early on it was clear that they preferred to respond to the bigger, generic themes that ran through all three: lust, betrayal, injustice, fate. The exception was Mark Wallinger, whose set for The Royal Ballet and piece for the National Gallery were in response to a single, pivotal moment depicted by Titian in his *Diana and Actaeon*: the moment of Actaeon's trespass into the wooded glade that was sacred to Diana and her nymphs. This act of voyeurism, the sense of what it felt like to watch and also to be watched, fascinated Wallinger and he began his Royal Ballet collaboration by presenting choreographers Christopher Wheeldon and Alastair Marriott and composer Mark-Anthony Turnage (a friend of some years) with a dossier with the word 'Trespass' written across the front. Long before a step had been choreographed or his set designed, the title of his ballet – *Trespass* – had been agreed.

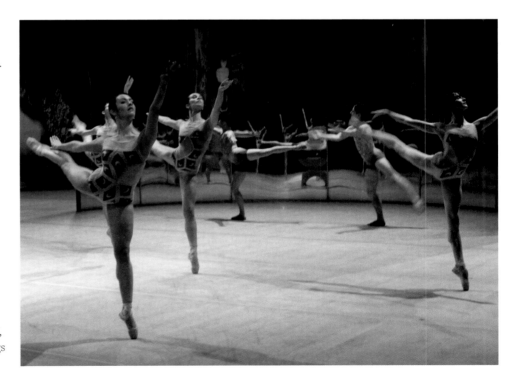

TOP TO BOTTOM A scanned piece of crumpled tin foil used by Mark Wallinger to create the backdrop for *Trespass*; the corps de ballet from *Trespass* in front of Wallinger's concave-mirror stage set and backdrop

17

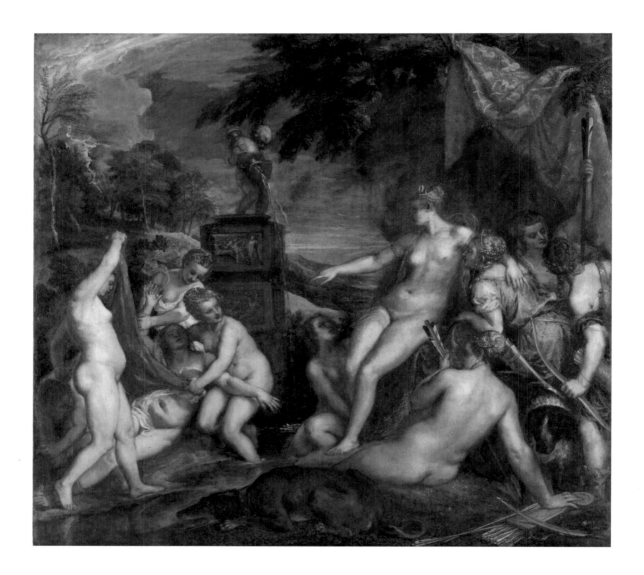

Callisto, one of the virgin nymphs of Diana, goddess of the hunt, was seduced by Jupiter, disguised as Diana herself. Nine months later, Callisto's pregnancy was discovered when she was forced by her companions to strip and bathe. Titian chose to paint the moment of her humiliating exposure and banishment from Diana's chaste entourage.

Titian, *Diana and Callisto*, 1556–9

Tales from Ovid
Ted Hughes

Callisto

... Diana led her company into a grove
With a cool stream over smooth pebbles.
'Here is a place,' she called,

'Where we can strip and bathe and be unseen.'
The Arcadian girl was in a panic.
The rest were naked in no time – she delayed,

She made excuses. Then all the others
Stripped her by force – and with shrill voices
Exclaimed at her giveaway belly

That she tried pitifully to hide
With her hands. The goddess, outraged,
Cried: 'Do not defile this water or us.

'Get away from us now and for ever.' ...

Actaeon

... Actaeon
Stared at the goddess, who stared at him.
She twisted her breasts away, showing him her back.

Glaring at him over her shoulder
She blushed like a dawn cloud
In that twilit grotto of winking reflections,

And raged for a weapon – for her arrows
To drive through his body.
No weapon was to hand – only water.

So she scooped up a handful and dashed it
Into his astonished eyes, as she shouted:
'Now, if you can, tell how you saw me naked.'

That was all she said, as she said it
Out of his forehead burst a rack of antlers.
His neck lengthened, narrowed, and his ears

Folded to whiskery points, his hands were hooves,
His arms long slender legs. His hunter's tunic
Slid from his dappled hide ...

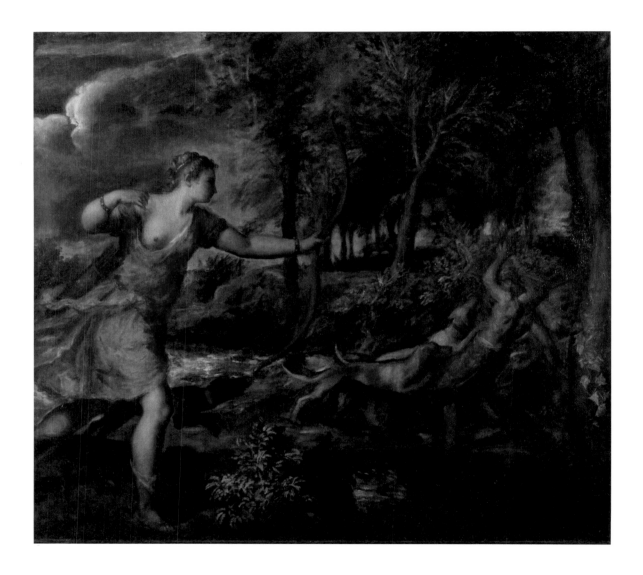

In revenge for surprising her as she bathed, Diana transformed Actaeon into a stag and he was torn to pieces by his own hounds. Ovid describes how Diana splashed water in Actaeon's face and antlers burst from his head, but Titian depicts Diana running after her prey, her tunic flying and bow drawn.

Titian, *The Death of Actaeon*, c. 1559–75

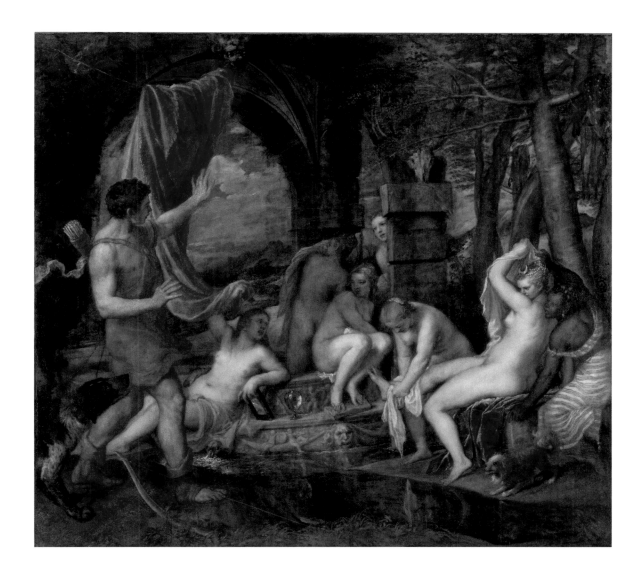

After a day's hunt, Actaeon accidentally stumbled into the wooded glade where the goddess Diana and her nymphs were bathing. As Diana attempts to cover herself, she casts Actaeon a terrifying glance in which his fate is sealed. The stag's skull on the plinth is an ominous portent of what is to come.

Titian, *Diana and Actaeon*, 1556–9

Central to Wallinger's concept was Diana's role as goddess of the moon; in Titian's painting, as is traditional, Diana is identifiable by the crescent moon in her hair. In Wallinger's mind, a parallel could be made between Actaeon's transgression and man's first landing on the moon. As he explained, 'the moon has always been a sacred space and yet soon after the first Apollo landings, footage was released of the astronauts playing golf up there.... It seemed like some sort of defilement.' Having abstracted the lunar idea from Titian, Wallinger presented this different type of narrative to his creative team. His dossier contained material he had sourced relating to the Apollo landings – a copy of a speech written for Nixon should Buzz Aldrin and Neil Armstrong not return, photographs of the astronauts wearing their gold visors – as well as an image of the British Museum's celebrated antique sculpture, the so-called *Lely Venus* (see page 32). As an example of another bathing goddess who is similarly trying to conceal her naked body from prying eyes, the sculpture had relevance to Wallinger, and even before Alastair Marriott had seen the Titian paintings in the National Gallery, he had been to the British Museum to see the sculpture and was excited by its choreographic possibilities for their ballet.

Marriott and his assistant, Jonathan Howells, visited Wallinger's studio and together they experimented with how best to use the concave lunar landscape that Wallinger had created (using tin foil and his scanner). The end result was bold and brilliant: a vast moonscape that used the full depth and width of the Royal Opera House stage, even blocking off the wings (the dancers had to enter through a door at the back). Set within it was a huge vertical concave mirror – its shape and material modelled on the visors worn by the first Apollo astronauts. Conceptually a clever device for a ballet all about looking, the mirror excited Wheeldon and Marriott from the outset because of its choreographic potential (although there was also a worrying moment just before the first stage rehearsals when they feared that the dancers' reflections would distort to an unflattering scale!).

One of the most memorable moments of *Trespass* was when the female dancers, arranged like bathing, crouching Venuses in a pool of light, turned around and as the light

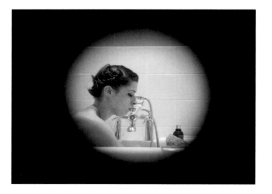

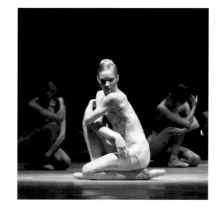

TOP TO BOTTOM Mark Wallinger's *Diana*, installed in the National Gallery; a bathing Diana seen through the bathroom keyhole; Melissa Hamilton in a pose from *Trespass* reflecting the *Lely Venus* in the British Museum

changed, a row of men standing and staring was revealed behind the mirror. 'I wanted to encapsulate the private, absorbed sense of self that they [Diana and her nymphs] would have been feeling. I used the mirror to conjure up a kind of grotto but also to make something that turned everyone in the audience into a voyeur', Wallinger explained. It was a sinister moment in a spectacular ballet that was also full of playfulness. A ripple of laughter from the audience could be heard at Wheeldon's witty 'antler motif' arrangement of upside down legs (see page 63).

Diana, Wallinger's piece for the National Gallery, was an attempt to 'find a contemporary way of depicting Diana at her bath'. And so the artist had a bathroom installed in his room at the National Gallery, inside which was a real, live naked woman who could be glimpsed at her toilet (taking a bath, brushing her hair), through one of four peepholes. Wallinger found (through Twitter) six women willing to 'perform' inside his bathroom, the only criteria being that they had to be called Diana, 'because I felt that anyone named Diana must have had some cause to reflect on their namesake'. We, the viewer, were part of the act; by approaching the bathroom and looking through the peepholes, we became the voyeur, invading Diana's private space, in the same way that Titian depicted Actaeon trespassing on Diana's lair. 'It was always going to be a challenge getting through a major plumbing job ten metres away from the Titian paintings', Wallinger admitted wryly when asked in subsequent press interviews how the National Gallery had responded to his work. And yet Wallinger's 'live art work' became one of the most memorable events of the Metamorphosis project, all the more exciting because it was, of course, ephemeral, existing only for the duration of the exhibition.

When selecting the three artists for the project, it always seemed important for them to be suitably different from one other. Early on in the planning process, Lord Hall had put me in contact with The Royal Ballet's Resident Choreographer, Wayne McGregor, who has a great deal of experience of working on collaborative projects. Right from the start, he was an invaluable source of creative advice, not to mention support, and we agreed that to complement the choice of a painter and a conceptual

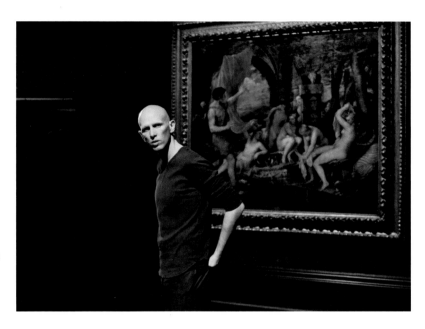

artist, we needed a sculptor who had an almost architectural take on space – an artist who could fill the vast Covent Garden stage with an object.

Conrad Shawcross, an abstract sculptor known for his kinetic sculptures (often on an epic scale) underpinned by mathematical or scientific ideas, was not an obvious choice to be asked to respond to Titian. And yet, the robot arms that Shawcross repurposed for The Royal Ballet and the National Gallery (of the type one normally sees at work in car factories) derived from an extremely close scrutiny of Titian's three Diana paintings. One of the most captivating vistas in the National Gallery exhibition was that of Shawcross's robot between *Diana and Callisto* and *Diana and Actaeon*, its raw steel arm bent in an echo of the goddess Diana's, as she raises it to protect herself from Actaeon's gaze (see page 88–9). Shawcross had been struck by the compositional similarity between *Diana and Actaeon* and *The Death of Actaeon*, in both of which the dominant (and therefore larger) figure strides in from the left, confronting a vulnerable (smaller) figure on the right. He laid the paintings over one another digitally (see page 79), and from this evolved his interest in the dual nature of the goddess Diana – a goddess who was both beguiling and seductive (as seen in *Diana and Actaeon*), but also terrifying and cruel (*The Death of Actaeon*).

Although an abstract artist, Shawcross was responding to the powerful narrative in the paintings, and it was not long after presenting the idea of using the robot arms that we started calling it 'she' or even 'Diana'.

This terminology was, Shawcross joked, probably a step too far for his Royal Ballet collaborators, the quintessentially abstract choreographer McGregor and the Danish-born Kim Brandstrup (although they too began the process of their response by looking closely at the Titian paintings in the National Gallery). Encouraging Shawcross to provide them with a set that functioned like 'an envelope of space' within which they could work, Shawcross designed for the stage a giant steel robot arm, set on a low-slung tripod, several tons in weight. Showing them a timeline he had drawn up (see page 93), the idea was that the robot's software would be programmed so that it performed a sequence of movements alongside and in response to those of the dancers on stage – and all of this set within the framework of the musical score. Mindful of the fact that the music could alter the way the audience interpreted his robot and its machinations, Shawcross flew early on to New York to meet with the group's composer, Nico Muhly.

Shawcross's set was hugely ambitious; not only would the robot need its own 'conductor'– someone who controlled its movements from the wings during the performance – but it soon transpired that it was also a health-and-safety nightmare for anyone wishing to get close to it. The team decided that the robot would have to operate within its own self-contained area and the dancers would similarly move only within their own sphere. In spite of the logistical difficulties of employing such a massive machine on stage (which seemed to reach their zenith the day before the dress rehearsal when the robot's main light cable snapped as the arm rotated), there was a palpable frisson of excitement during the performances at seeing the juxtaposition of this huge, powerful industrial machine against the lithe and dynamic bodies of the dancers. It was the first time that Carlos Acosta had danced McGregor's choreography; no one who saw the ballet will forget the utterly compelling *pas de deux* between Acosta and the robot. No one, that is, except

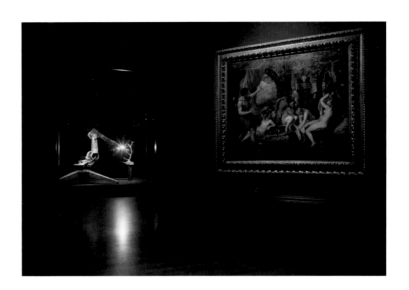

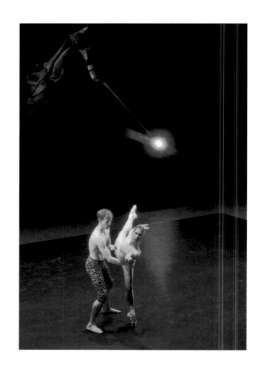

TOP TO BOTTOM Conrad Shawcross's *Trophy* installed in the National Gallery; principal dancers Edward Watson and Leanne Benjamin dancing in front of the *Machina* robot

Shawcross himself who admitted afterwards that he never saw his ballet from the front but spent every performance in the wings, willing the robot not to malfunction!

'A post-mortem on Actaeon's death' was how Shawcross described his piece for the National Gallery. Entitled *Trophy*, a much smaller version of his stage robot could be seen inside a glass case, the light on the end of her mechanical arm presiding over – gloating over – a wooden antler, a symbol of Actaeon and the stag into which he had been transformed. Shawcross was always struck by the cruelty of the goddess Diana's actions, seeking a revenge that seemed disproportionate to the mistakes Actaeon and Callisto had made. By casting Diana as a robot, Shawcross was alluding to the cold sensuality of the goddess. What many visitors to the exhibition did not realize was that Diana, the robot, had carved the wooden antler itself, constructed of a beautiful amalgamation of hardwoods (see page 87); a small blade had been added to the end of the robot's arm and Shawcross and his team had devised software that enabled the robot to carve the antler in his studio – a process that

took two weeks (see pages 82–3). Visitors to the show were beguiled by what Shawcross described as the 'leg-stroking' motion of the robot, stooping as she did to caress her own legs before rising up to confront the antler. And just as in *Machina*, Shawcross's ballet, there was a wonderful visual contrast between the natural wood of the antler and the gleaming steel industrial robot.

There is much one can learn from these wonderfully diverse and multi-layered responses to Titian, by artists from so many different disciplines. This process of metamorphosis – of transforming, reinterpreting and regenerating Titian – is testimony to the richness and inventiveness of the paintings themselves, but is also a vital principle of art itself. As such, it is fitting to conclude by paying homage to Dame Monica Mason, former Director of The Royal Ballet, without whom Metamorphosis: Titian 2012 would never have come to fruition. Presented with an idea, she embraced it with enthusiasm and warmth, had faith that in spite of its many risks it would be wonderful, and nurtured and guided it to a glorious end.

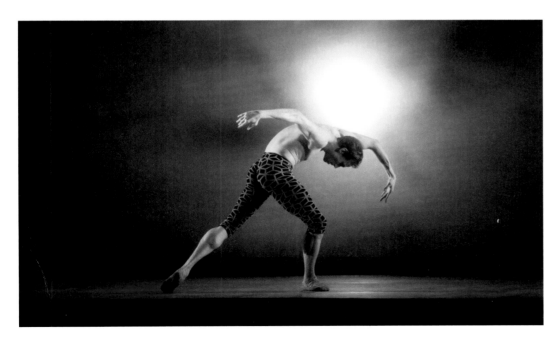

Edward Watson on stage with the robot during a performance of *Machina*

Mark Wallinger

Diana | **TRESPASS**

Choreographers *Alastair Marriott, Christopher Wheeldon*
Composer *Mark-Anthony Turnage*

In Conversation
Mark Wallinger

Minna Moore Ede *You've engaged with National Gallery paintings before in your work. I loved your piece* Ghost, *for instance, in which you took a black-and-white photograph of Stubbs's three-metre-high equestrian portrait* Whistlejacket, *and then took the negative of the photograph and added a unicorn's horn, metamorphosing what was a quintessentially naturalistic image into something quite mystical and supernatural. What prompted me to think of you as a potential artist for this project was the show you curated at the Hayward Gallery in 2009, 'The Russian Linesman', in which you displayed an X-ray of Titian's* The Death of Actaeon *as an example of a threshold or boundary object and then used the negative of the photos. It was such a different way of thinking about an X-ray.*

Mark Wallinger That's right. And I suppose, in a way, the work for the ballet relates to both *Ghost* and the Titian X-ray. I like the idea that there's a secret life of paintings or a history waiting to be revealed. And because *The Death of Actaeon* was famously left in Titian's studio when he died, one presumes it must have been a favourite of his; at the same time, it seems like it remains unfinished, so it makes you want to find out more and to get inside the psyche of Titian himself – the X-ray is a token of that. And I think the monochrome nature of these things has stayed with me all the way through to this project and perhaps pushed me towards having a monochrome stage set.

MME *Did you think that you might use the X-ray again in some way as your response to the Titians? Was that your starting point?*

MW I think my focus was always going to be on *Diana and Actaeon* and *The Death of Actaeon*, and the key to my approach was always going to be some kind of transposition, because of the narrative arc that these two works describe. Titian tells the story with such a wonderful economy in that the pictures have this flipping motion in which the two main protagonists swap places, compositionally speaking, but certain things remain common. So Diana's pose of raised arm and her coy-becoming-aggressive look is exactly the same as Actaeon's gesture as he's being turned into a stag. But for a half-hour ballet, it's rather difficult to tell the whole story, so I needed to abstract something from these works and turn it into a different kind of narrative or a different time and space. And so I started to think about the idea of Diana as moon goddess.

I read around the subject as much as I could. I went back to the Ovid text and Ted Hughes's translation, and then once I had established the lunar connection, the name of the ballet, *Trespass*, came to me quite quickly. I was thinking about how the moon was some kind of ancient, mysterious, mythical spirit of the feminine and muse for poets down the ages; and then about the Apollo landings and how the missions went from being the most incredible human triumph to being about playing golf shots off the lunar surface – it was like we had defiled it. We've retreated from the moon since then and not gone back. So I saw it as a sort of trespass or transgression and that became the key notion

Mark Wallinger working on his costume designs in the Royal Opera House costume department

for the ballet, with Diana and her nymphs being trespassed upon, defiled, by this encroaching male presence.

MME *Because of the way The Royal Ballet works, you had to start producing ideas and designs and talking with your collaborators about two years ahead of the production. You were working with the choreographers Alastair Marriott and Christopher Wheeldon and the composer Mark-Anthony Turnage. For a conceptual artist whose modus operandi is very much working alone, it must have been quite a new experience, working as a group.*

MW Well I suppose I'd had a head start in this collaboration with dance in that I had worked with Wayne McGregor before on *Undance* for Sadler's Wells. And I'd also worked with Mark-Anthony and already had a rapport with him; we're both from similar backgrounds and pretty much the same age. And I've been coming to The Royal Ballet since I was a child. I've seen Fonteyn and Nureyev, so it wasn't alien territory exactly. But working in a collaborative way is very different. As an artist, I'm used to working to a deadline and that's the opening of a show, whereas in this case before anything can happen the music has to be written. That meant I had to produce enough ideas and concepts to which the choreographers and composer could agree before Mark-Anthony could start work.

So I gathered together a whole load of texts to do with the moon and with trespassing, ranging from Shelley poems to Philip Sidney, through anecdotes about astronauts, to the address to the nation that was written for Richard Nixon in case Armstrong and Aldrin perished on the moon. Then I gave the creative team this little dossier of material, and on the front it said 'Trespass' and there was a picture of Sir Peter Lely's *Venus* in the British Museum, which shows her trying to cover her nakedness. As Neil MacGregor said, one revolves round and round the figure trying to catch sight of whatever it is she's trying to cover up.

MME *But you never do.*

MW No – and so that became a motif for the piece. I then began to fill lots of notebooks with stuff related to the moon and celestial bodies, to the gaze and to looking in general: various quotes, images, my own thoughts; and in my studio I set up a wall of some of the things I was coming across, just to get some ideas going. And soon all of these different thoughts began to coalesce around the central theme of a parallel between Actaeon's encroachment onto Diana's lair and the Apollo landings on the moon.

Then came the set, which I struggled with for a fair while. But in the event it was truly collaborative. Alastair and his assistant Jonathan Howells, in particular, were instrumental in moving everything along. They gave me confidence to use a pretty abstract language. Christopher was away a good deal of the time because he lives in Brooklyn, but he came over for key meetings and was very certain about some aspects, which really helped things along as well.

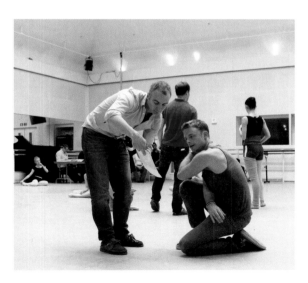

Alastair Marriott and Christopher Wheeldon in the rehearsal studio

In myth & folklore the full
moon is given name.
 NASA version:
January WOLF MOON
February SNOW MOON
March STORM MOON
April PINK MOON
May FLOWER MOON
June STRAWBERRY MOON
July BUCK MOON
August STURGEON MOON
September HARVEST MOON
October HUNTER'S MOON
November BEAVER MOON
December COLD MOON

APOLLO 8 Christmas Eve
broadcast 1968.

1:18 → 44 = 26 seconds

In the beginning God created
the heaven and the earth.
And the earth was without form,
and void; and darkness was upon
the face of the deep. And the spirit
of God moved upon the face of the
waters.
And God said, Let there be light:
and there was light.
And God saw the light, that it was
good: and God divided the light
from the darkness.

To : H. R. Haldeman

From: Bill Safire July 18, 1969.

IN EVENT OF MOON DISASTER:

 Fate has ordained that the men who went to the moon to
explore in peace will stay on the moon to rest in peace.

 These brave men, Neil Armstrong and Edwin Aldrin, know
that there is no hope for their recovery. But they also know that there
is hope for mankind in their sacrifice.

 These two men are laying down their lives in mankind's
most noble goal: the search for truth and understanding.

 They will be mourned by their families and friends; they
will be mourned by their nation; they will be mourned by the people of
the world; they will be mourned by a Mother Earth that dared send two
of her sons into the unknown.

 In their exploration, they stirred the people of the world to
feel as one; in their sacrifice, they bind more tightly the brotherhood
of man.

 In ancient days, men looked at stars and saw their heroes in
the constellations. In modern times, we do much the same, but our heroes
are epic men of flesh and blood.

and valued at 6000 ecus. On the dispersal of Charles's art collections during the Commonwealth, it came into the possession of the painter & connoisseur Sir Peter Lely, from which it derives its name. Two years after Lely's death it was re-acquired from his collection for the Royal Collection. It was housed in the Palace of Whitehall at the time of the fire which destroyed that palace on Jan 4th 1698, and was rescued from the flames.

It is clearly influenced by the 4th Century BC Greek Sculptor Praxiteles. The nudity symbolises a turning point in the culture, as previously only male statues were made

Transformation Scene, important element in the English <u>pantomime</u>. An instantaneous change of part of a scene, such as a shop-window or a house-front, was usually done by the use of <u>falling flaps</u>, a variant of which was the chassis à développement. By the use of the earlier <u>carriage-and-frame</u> or <u>drum-and-shaft</u> methods, the whole scene could be changed, the <u>backcloth</u> and side <u>wings</u> being drawn off simultaneously to reveal new ones behind. For the swift changes needed for the pantomime a more spectacular method, made possible by the <u>flies</u> found in newer theatre buildings, was the <u>rise-and-sink</u>. A quick change could also be achieved by the use of scruto (thin strips of wood fastened to a canvas backing so as to form a continuous flexible sheet); by the <u>Fan Effect</u>, in which sectors of the back scene, pivoting centrally at the foot of the scene, sank sideways upon each other like collapsing fans, revealing a new scene behind; or by placing rolls of painted canvas like columns across the stage, with lines top and bottom, which when pulled drew the new scene across the old. Various <u>traps</u> were used to enhance the illusion. With the advent of more sophisticated <u>lighting</u> the usual method of effecting a transformation scene became the transparency, which when lit from the front was as opaque as canvas, but faded from sight when lit from behind.

Trespass

Convex mirrors reflect light outwards, therefore they are not used to focus light. Such mirrors always form a virtual image since the focus of the centre of curvature are both imaginary points inside the mirror, which cannot be reached. CONCAVE MIRRORS reflect light inward to one focal point. They are used to focus light. Unlike convex mirrors, concave mirrors show different image types depending on the distance between the object and the mirror.

The key to it in the end was coming up with this half-pipe, concave mirror as the central structure on the stage. I wanted to conjure up something to do with a grotto or a sanctuary, but also to create something rather exciting with light and with people's reflections, to suggest something rather like a waterfall or bathing. And I was inspired by the shape of Armstrong and Aldrin's visors on their helmets – you know, those famous photographs they took of each other where you see them reflected in each other's visor. And the gold leaf used to protect their eyes from the glare also gave me the motifs of gold and silver – the male dancers' costumes are predominantly gold, for example.

Then Colin Maxwell, the production manager, saw how we could make this 'mirror' out of a material that would become transparent when backlit. That was very exciting because it meant that it wouldn't obliterate half the stage, and we could use the effects of its opacity or transparency in different ways within the dance. That then encouraged the idea of using this sweeping circle as the backdrop, which is concentric to the half-circle that the mirror describes in plan. I'd been messing about making images on my scanner using just screwed-up bits of kitchen foil and then I found one that I could reverse quite appealingly. In the end, we found this arc that was half the height of the mirror and it just seemed to come together formally. It was supposed to look like an abstracted lunar landscape, but also feel exclusive, so that it was Diana and the nymphs' territory – as soon as we see the men appear, we know that they're not really meant to be there.

MME *And you completely changed the shape of the Royal Opera House stage by doing so. You didn't use any of the wings, which was quite unusual.*

MW No, but it had more width and depth than normal.

MME *There is obviously a big difference between exhibiting your work in a gallery space and then suddenly on a stage that is thirty-seven metres high. Were you worried that the set might fight with the choreography?*

MW *Undance*, the first collaborative piece I did with Wayne McGregor and Random Dance, had a filmed element that ran alongside the live dancers. This time I decided I didn't want any moving parts and hoped that the mirror would provide a different kind of dynamism by reflecting the dancers and then becoming transparent. I felt it had enough possibilities.

MME *So by then you had come up with your overarching concept for the ballet. Did Mark-Anthony Turnage make the score at that point?*

MW He had been working on that for some time. In fact, we heard the music the same night that we made some key decisions about the set. We listened to what's called a 'Sibelius' version of the score, which is like an electronic kind of rendering of it, which we all loved.

Selected pages from Mark Wallinger's *Trespass* notebooks

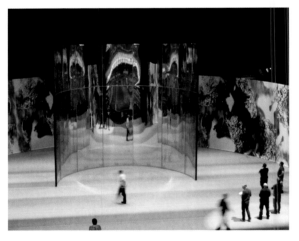

ABOVE AND OPPOSITE The production team testing different light effects on the 'mirror'

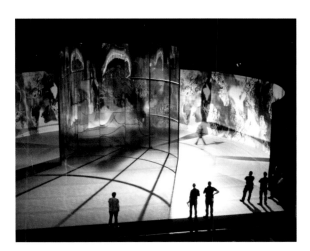

MME *And were Alastair and Christopher already coming up with ideas for the choreography? The mirror is such a creative device for the choreographers – it gives you multiples, for instance.*

MW That's right. We don't have a single Actaeon; we have several Actaeons. It's more aggressive, but it gave more possibilities for the whole piece. Oh yes, Alastair and Christopher were really excited about the potential of the mirror and ran with it. I must say that the dynamic between the two of them was great, because they had been students together through The Royal Ballet School and had known each other for years. It was really impressive to see them working together in a rehearsal room.

MME *And they were unusual because they choreographed together sitting side by side in the studio. It means that your ballet has a very cohesive feel to it. You mentioned the use of the gold motif earlier, but could you say a little bit more about the costumes? The design of those came quite late in the process, is that correct?*

MW Frankly, my first costume ideas were terrible and …

MME *What did you come up with?*

MW I'm not even going there. For the finished women's costumes, I wanted to continue the moon motif. One day I was just searching around and came across a couple of images of the tiled floor of Siena Cathedral, which is rather beautiful with yellow crescent moons on a blue lapis lazuli. And I decided to use that diamond pattern for Diana and the nymphs. Working closely with Alastair and Jonathan Howells again, I found the right scale of tile that would look rather flattering on the female form. And then we played with variations where we would lose some of the tiles on some costumes to distinguish between the dancers. I mean there was Diana and then there were two sub-principal dancers, and then there was the corps de ballet, so it was a rather traditional way of indicating that hierarchy – and Diana had to be the 'naked' one of course.

MME *Naked but bejewelled.*

MW Bejewelled, yes – so her costume still retained the diamond structure, only with fewer tiles. The male dancers' costumes were meant to be a counterpoint to the natural beauty of the women's outfits. They reference circuit-board diagrams and technological things like that. I was thinking about the way people always marvel at how primitive the computers were that landed the lunar module compared with mobile phones today. I wanted something that was wholly to do with science for the men, so that there would be a stand-off between technology and mythology – and perhaps

a bit of East–West as well in that there's something Islamic about the crescent moon.

MME *And were the dancers interested in the concept behind the piece?*

MW Very much so. They were really receptive to the whole thing, and I think they really had fun with it.

MME *It was clear that your concept drove the response of the whole creative team. Mark-Anthony Turnage entitled a section of his score 'O Moon', which derived from the Sidney poem you gave them at the beginning. And that piece of music was then used by Alastair Marriott for a duet so acrobatic that the lights had to be dropped down in order for the dancers to get out of it gracefully!*

MW Well, there were three moments that Alastair describes as musical-box moments, but there were also three rather ambitious lifts and holds in which they slowly revolved – it was really rather beautiful.

MME *And turning now to your installation for the National Gallery, like* Trespass, *it responds to that key moment in the story when Actaeon stumbles upon the wooded glade sacred to Diana and her nymphs and casts his eyes upon the naked goddess. It's a fully functioning bathroom, approached through darkness, with four peepholes through which you can glimpse a real, live, naked Diana at her toilet.*

MW Well, yes, that is the moment when Actaeon's fate is sealed. The story is the classic fable of voyeurism, and I was trying to think of a way of making it anew – and also within an institution that is full of paintings of naked women, of nudes. 'Nude' is a polite word for men looking at paintings of naked women. What I think it needed was something a bit more transgressive, a bit more of a trespass, or something that actually threw back onto the viewer the nature of that gaze. And of course there's another famous Diana who was spied upon, intruded upon, followed, hounded, more than anyone else one can ever remember, so in my piece there's something to do as well with the prurient gaze that's very much part of tabloid culture and of the English psyche in general. I was also thinking through the history of voyeurism, and how the twentieth century almost sanctioned it as our chief mode of entertainment. Sitting in a darkened cinema, we are engaged in an act of mass voyeurism; we're pitched into other people's lives and we're spying. And then, once the bathroom idea came, I wanted to ask people called Diana to participate. Anyone who had that name would surely wonder about its origin. So that would mean that there was something intrinsic to them that they could bring to the piece.

MME *And you found six Dianas who were willing to take part, through Twitter ... it's a very contemporary way to look for your main protagonist.*

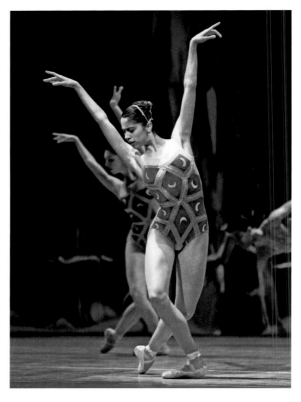

ABOVE Beatriz Stix-Brunell in *Trespass*
OPPOSITE, TOP TO BOTTOM The floor of Siena Cathedral; Steven McRae being fitted for one of the male dancers' costumes; one of the circuit diagrams that inspired the design; a scene from *Trespass* showing the male and female dancers' costumes designed by Mark Wallinger

Diana and the nymphs' costumes are decorated with crescent moons that I've based on designs from the tiled floor of Siena Cathedral, which have an almost Islamic feel. The male dancers are wearing more aggressive, angular patterns derived from circuit diagrams, which are my nod to the astronauts.
Mark Wallinger

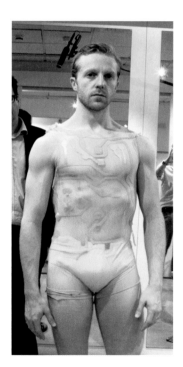

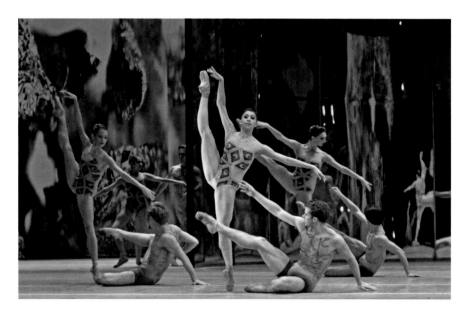

You interviewed all of them, but the only criterion was that they were called Diana. So we've got all sorts: there are older Dianas, younger ones. We don't know how old the goddess herself was, of course. Did you give them any specific directions for when they were inside the bathroom?

MW No, none at all. But things began to emerge that ... I mean someone started cleaning their teeth at one point and we felt that that was perhaps not ...

MME *... very goddess-like!*

MW Probably not ... not too many wine gums in Arcadia. Anyway, beyond keeping fairly active and preening themselves, they didn't have to do very much. There was hot and cold water plumbed in. It was rather nice when you could hear the water because it introduced the notion of the grotto from the myth before you saw inside. You just arrived in a darkened room and the thing's slowly being revealed.

MME *I have to ask you, because I know it has been part of your thought process, about the most famous work of art about voyeurism from the last century: Duchamp's* Etant Donnés, *now permanently installed in the Philadelphia Museum of Art. This piece, which Duchamp worked on secretly for the last twenty years of his life, is a three-dimensional tableau, visible only through two peepholes in a wooden door, of a nude woman lying on her back with her face hidden and legs spread against a landscape backdrop. I know you're a great admirer of Duchamp's, and he's affected much of your work.*

MW Yes, and I had to pay due respect to this work or cite it in some little way, so there was a chequerboard floor on the bathroom and the peepholes of course, both of which match *Etant Donnés*.

MME *With the peepholes, it was important to find the right number so that you didn't see too much or too little – you ended up with four.*

MW It meant that one could peep in all four sides, which felt like the right thing to do. The act of looking also became a bit addictive because you wanted to get an all-round view. I think people did circle the piece a great deal because you got little scraps of visual information, and human curiosity made you want to see more, to complete the picture.

MME *There's a nice touch, which people may not have picked up on, that when the piece was first assembled you were concerned that people could look through the two-way mirror and see others looking through the pane of the window opposite, so you introduced a Venetian blind.*

MW Well, occasionally things become serendipitous when you're faced with a problem. There were two peepholes that looked through

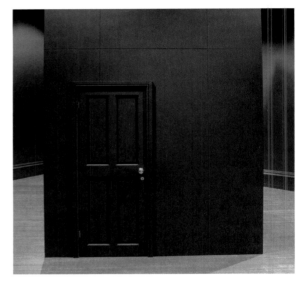

Exterior of the *Diana* bathroom installed at the National Gallery

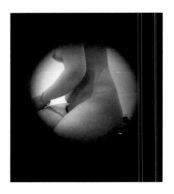

A view of one of the Dianas through the keyhole

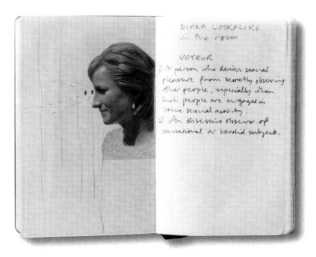

Selected pages from Mark Wallinger's *Trespass* notebooks

Marcel Duchamp, *Etant Donnés*, 1946–66

Marcel Duchamp, *Etant Donnés*, 1946–66

a double-sided mirror, so sometimes one got a rather startling but beautiful view of Diana making herself up. But looking through it, one could sometimes apprehend other people looking through the frosted glass on the opposite side of the bathroom, which disturbed the quiet solitary contemplation of Diana's reverie. So on the morning of the press opening, we put up a blind – and of course it's a Venetian blind, which is rather apt. The piece is also colour-coded with Titian colours, with the walls and the towels, but it also references popular cinema as well – there's *Blue Velvet*, *Psycho*, *Porky's* even – all of which have become archetypal of a more recent history of voyeurism. But also some of the effects were not entirely intentional. At the opening, the woman in the bathroom wore some jewellery – rather appropriately a crescent-moon necklace – which made the naked seem more naked.

MME *There was a real frisson of excitement when that first Diana went into the bathroom, but one of the things that amazed me is that you don't actually see that much. It's very subtle. It reminded me a lot of Degas's bathers, but actually you see more in the Titian paintings. I think Titian was trying to paint the female form from every angle, but you don't … were you aware that the balance could be tipped by making the crack in the glass too big?*

MW Absolutely, absolutely. There's spying and there's ogling and there's …

MME *There's a fine line.*

MW There are lots of names for looking with intent, and to be surprised by our own feeling of apprehension actually makes us stand outside ourselves and think about what we would do if we ever found ourselves in that situation – would we continue looking?

MME *Duchamp was very interested in the idea of the spectator completing the work. How important is the spectator in your creation of this piece?*

MW I feel absolutely the same. I like to think it's to do with a preoccupation with perception that runs through all my work, whether it's single-point perspective or whatever. I like to reduce things to the ocular but of course one can't see with a completely innocent eye. There's some kind of shock that makes one recognize how these different things determine the way we look at someone else, and whether we feel comfortable or uncomfortable doing so.

MME *Have you talked to the Dianas about what it feels like to be watched? Because obviously there is us, the spectator, in Actaeon's position and then there is Diana – and this piece is about both watching and being watched, after all.*

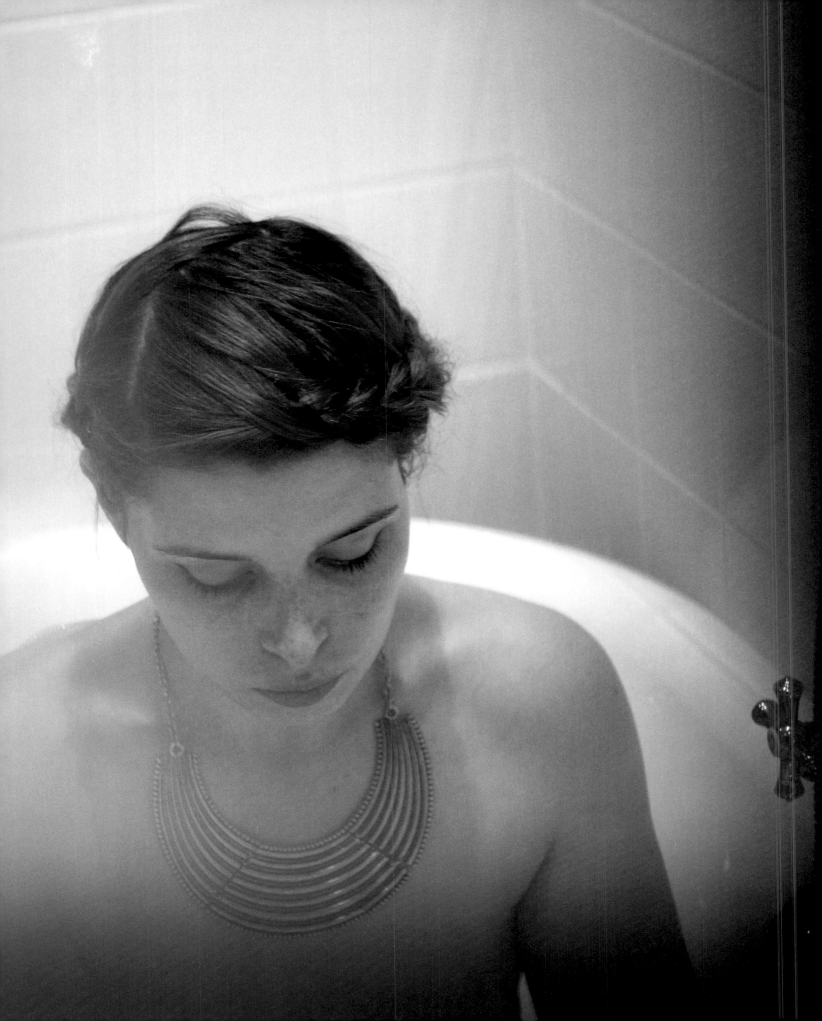

MW I think they enjoyed being insouciant to that gaze, and they felt empowered by the fact that they didn't care. They were naked but there was something strangely distant about them. I think it added a little bit of magic.

MME *And were you surprised, amazed, appalled by the different spectators' responses?*

MW Every individual encounter was different and quite revealing and obviously that changed if the room was empty or contained a large group. People were generally tolerant of others' curiosity because they were about to perform the same rite. I think it is also because we understand instinctively the possibility of Diana's returning gaze, the moment the viewing subject becomes objectified, found out. To see ourselves as others do. In Ovid's story, there's a moment where Actaeon glimpses his transformation into a stag in a reflection in the water; becoming alien to himself is part of his punishment for voyeurism.

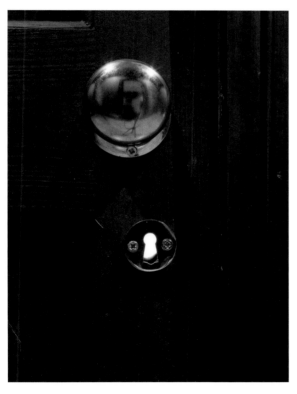

Above The keyhole viewpoint into the bathroom
Opposite A view of Diana through the cracked window

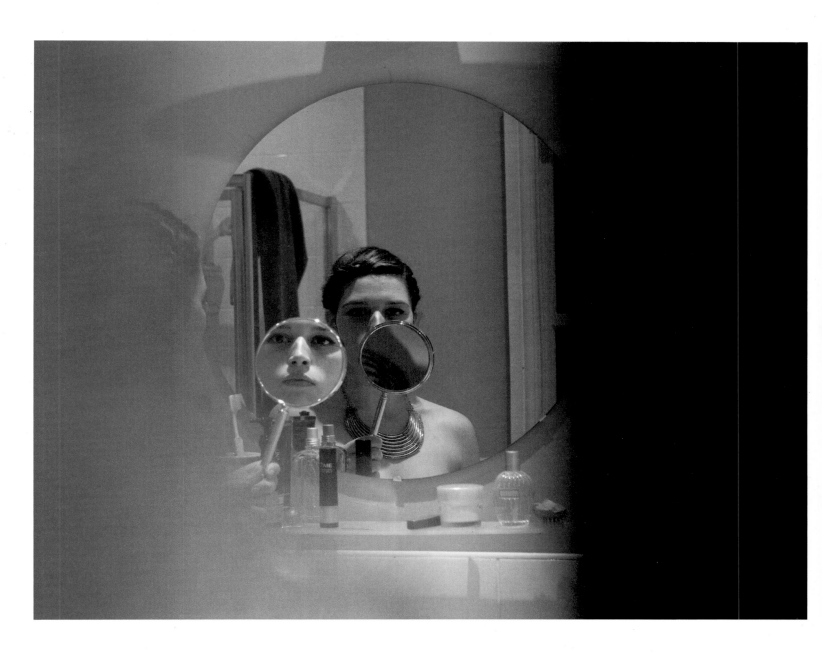

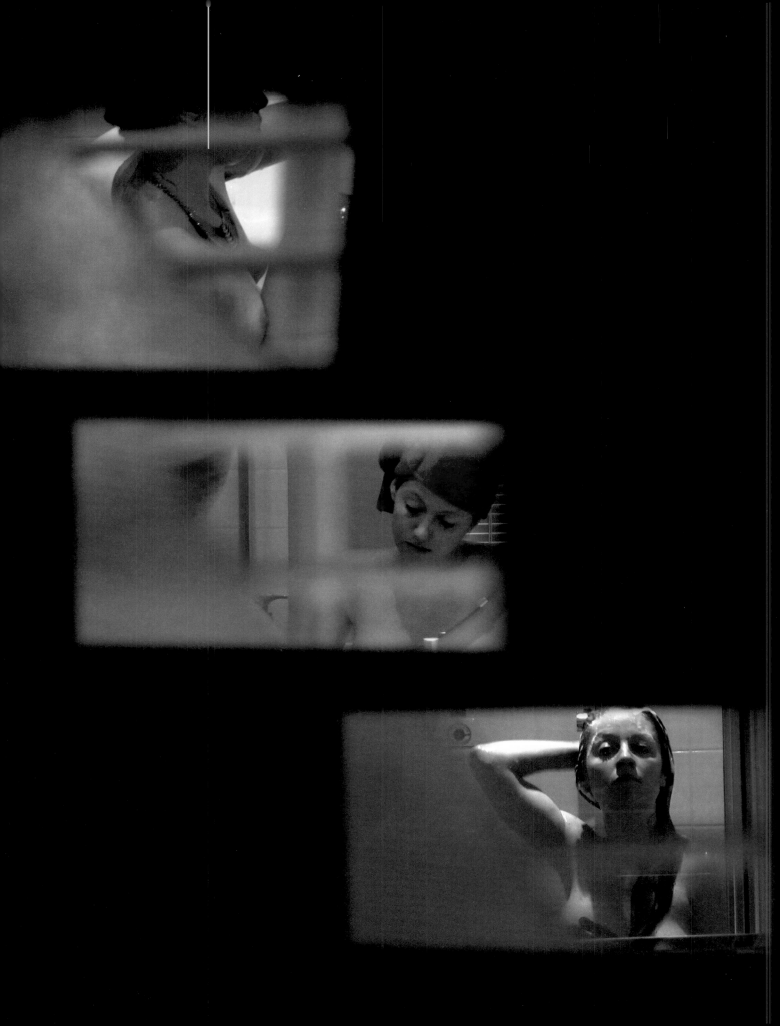

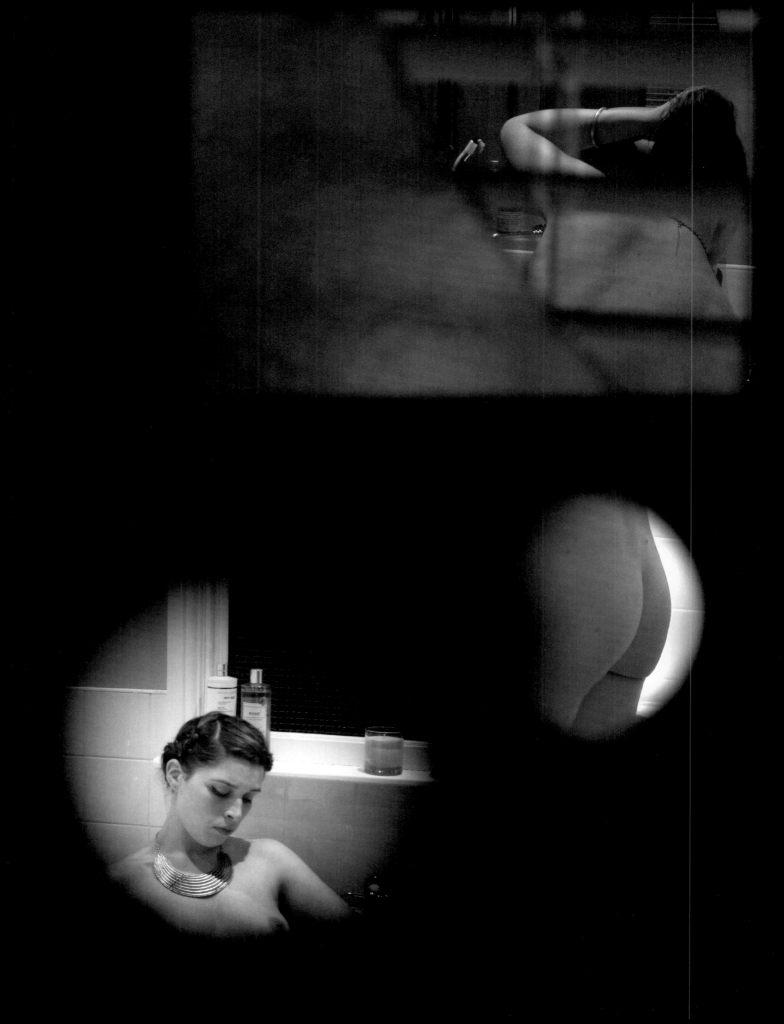

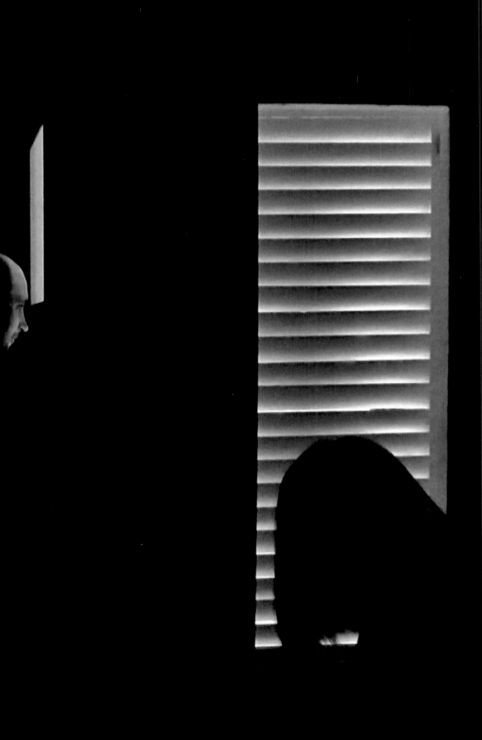

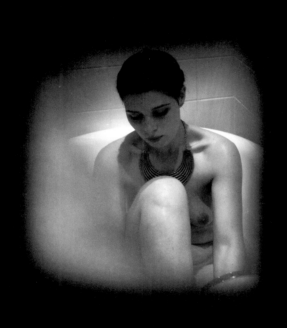

It seemed impossible at first. I was concerned that there would be too many opinions as to which way to go. But Chris and I both loved Mark Wallinger's idea, and it's helped that we were friends from dance school. We are both classical choreographers, so it was not as difficult to cope with as working with someone with a very different style. Because we were both in the rehearsals, if one of us did a step that the other quite liked, we sometimes incorporated it into our own choreography. You really wouldn't know where it came from, which is interesting to us. Even I've seen bits of the ballet that I could have sworn I'd done but hadn't!
Alastair Marriott

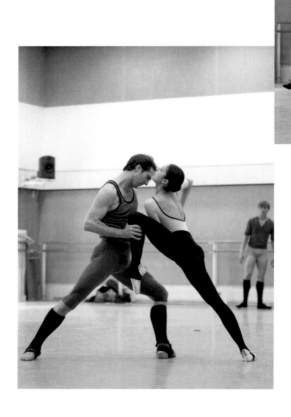

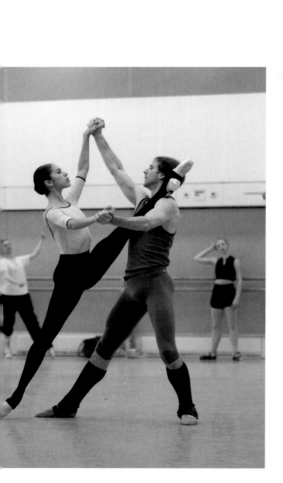

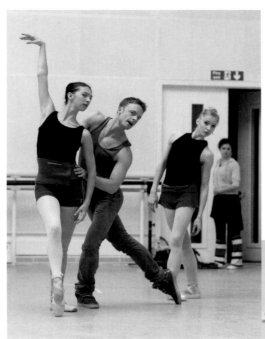

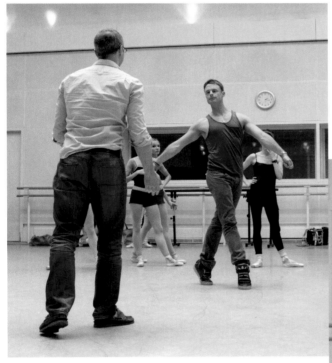

Alastair and I listened to the music together and decided who would work on which section. We were eager to use this as a true choreographic collaboration to see how each other's ideas might fire our own individual sections. We did three movements together, and each took two to work on alone. Alastair's *pas de deux* is very celestial and moonlike, while mine has earthier qualities, including the image of the men being turned into stags.
Christopher Wheeldon

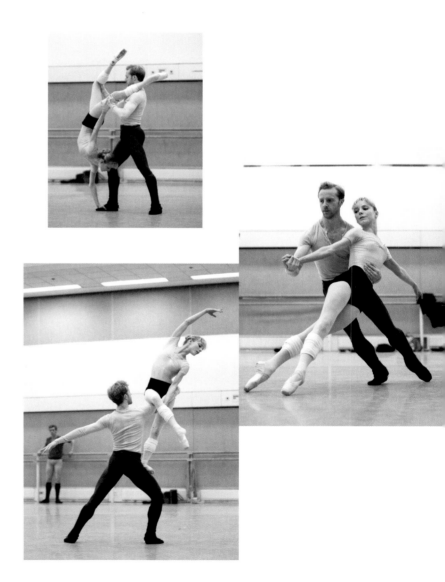

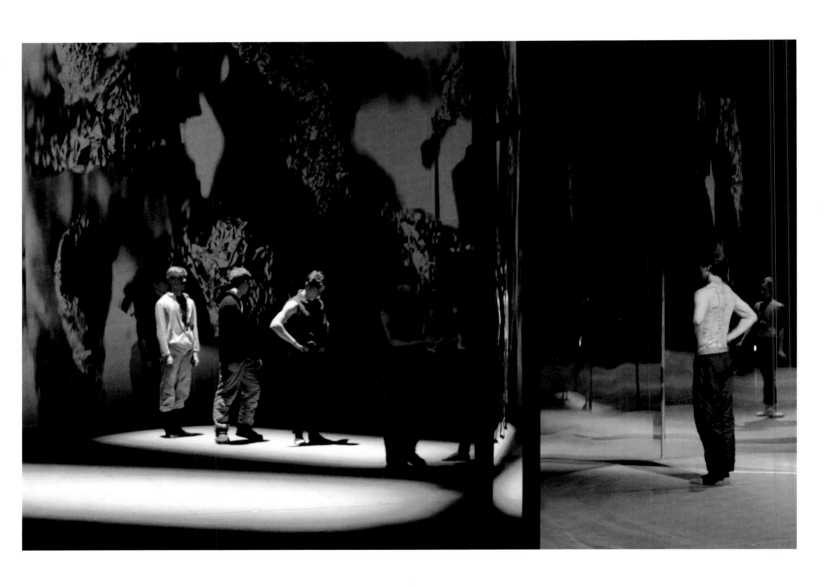

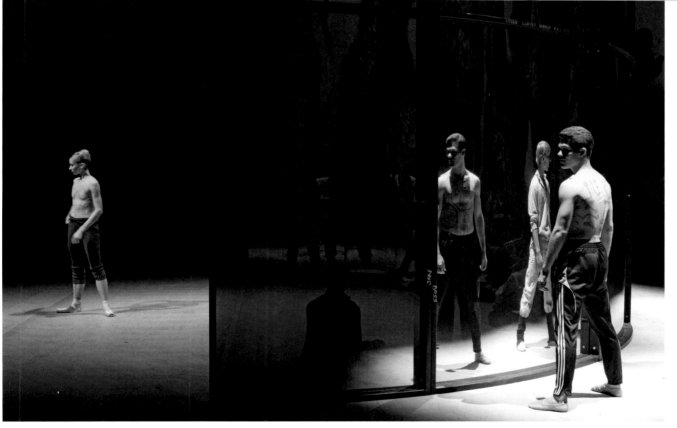

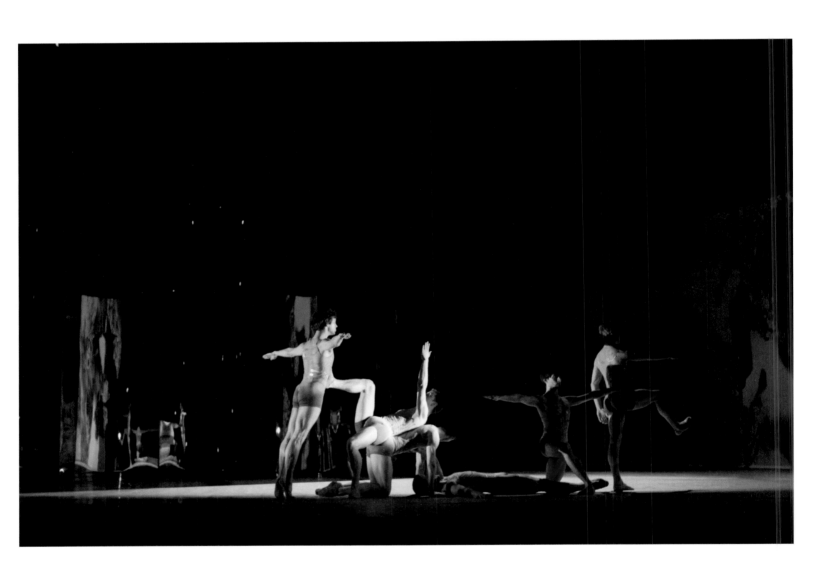

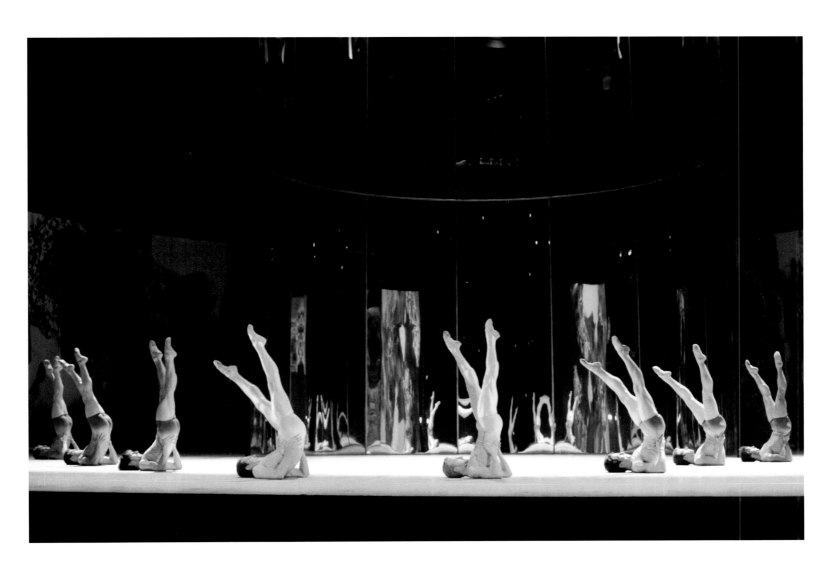

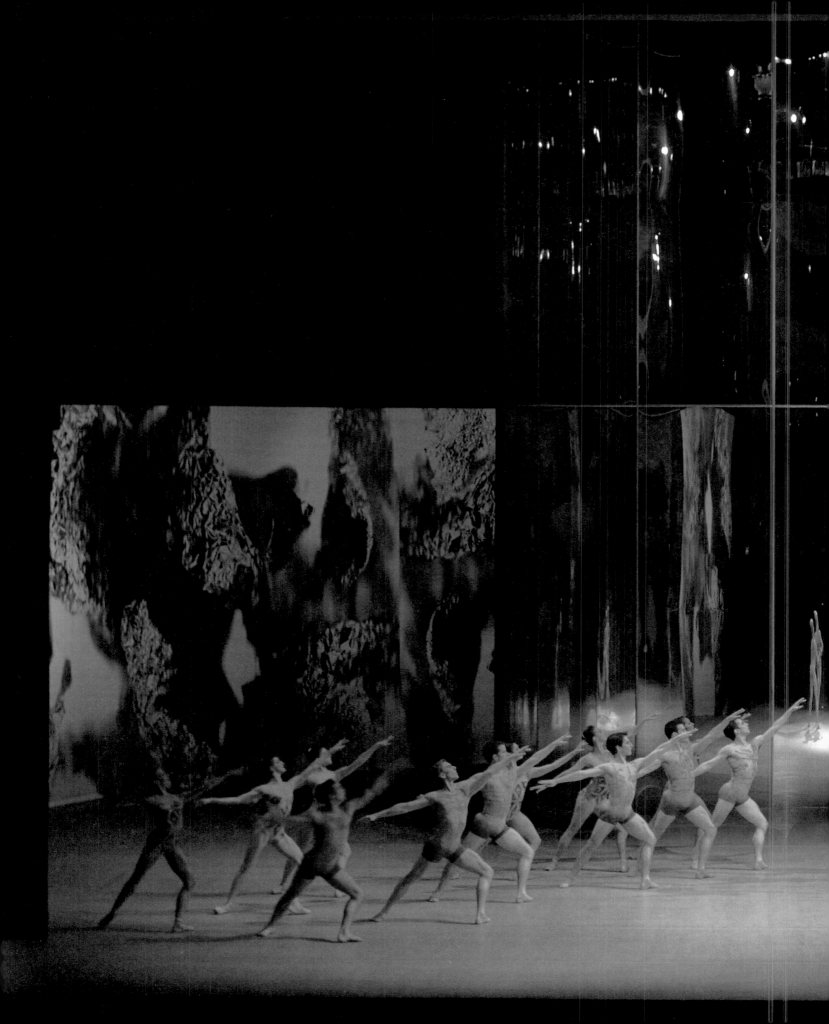

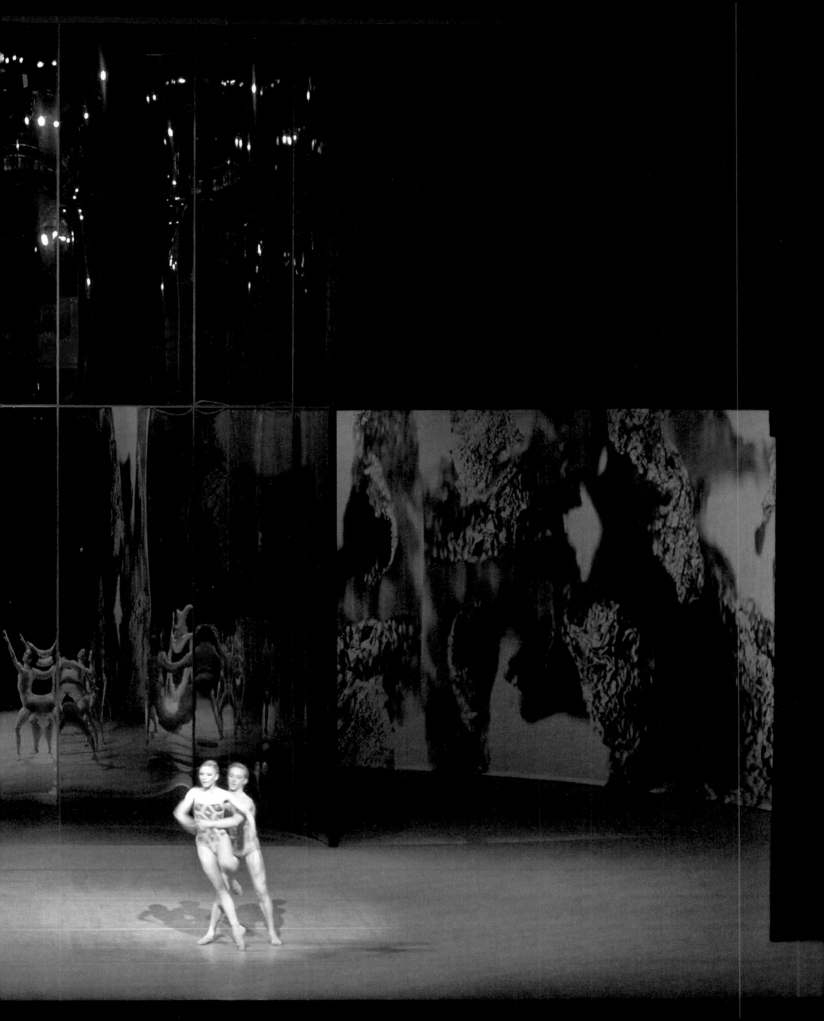

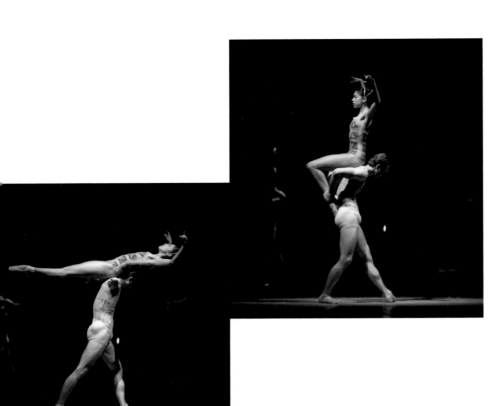

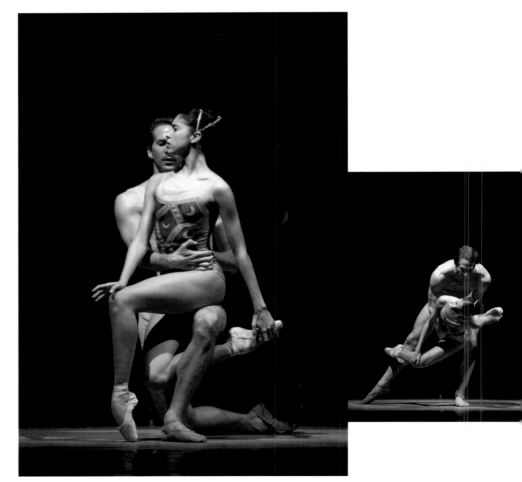

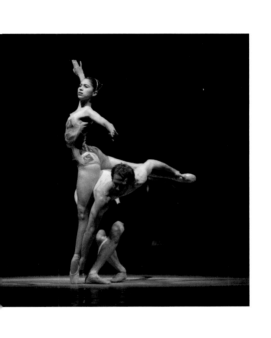

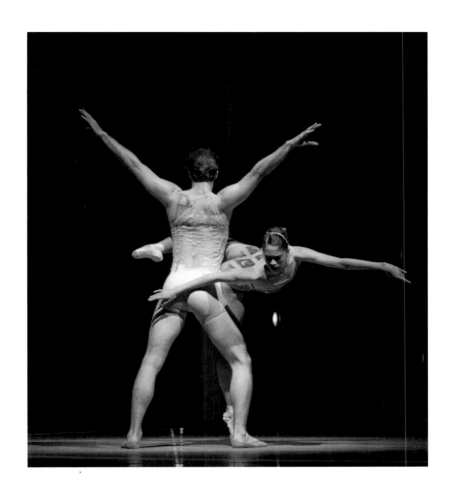

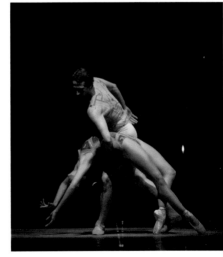

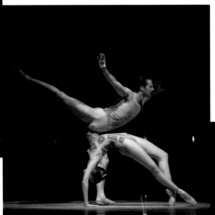

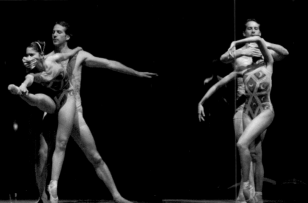

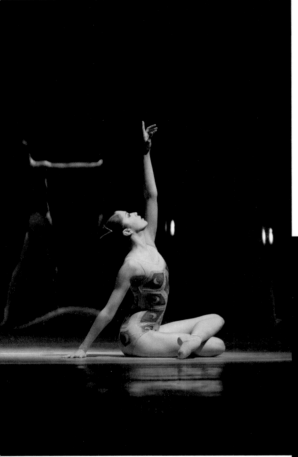

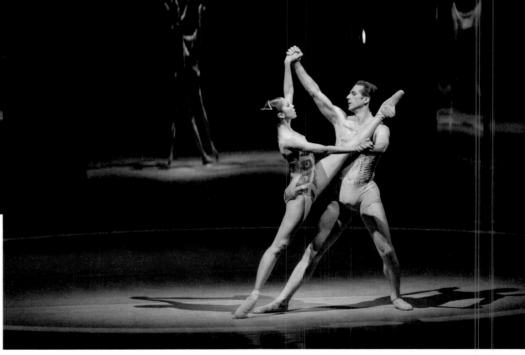

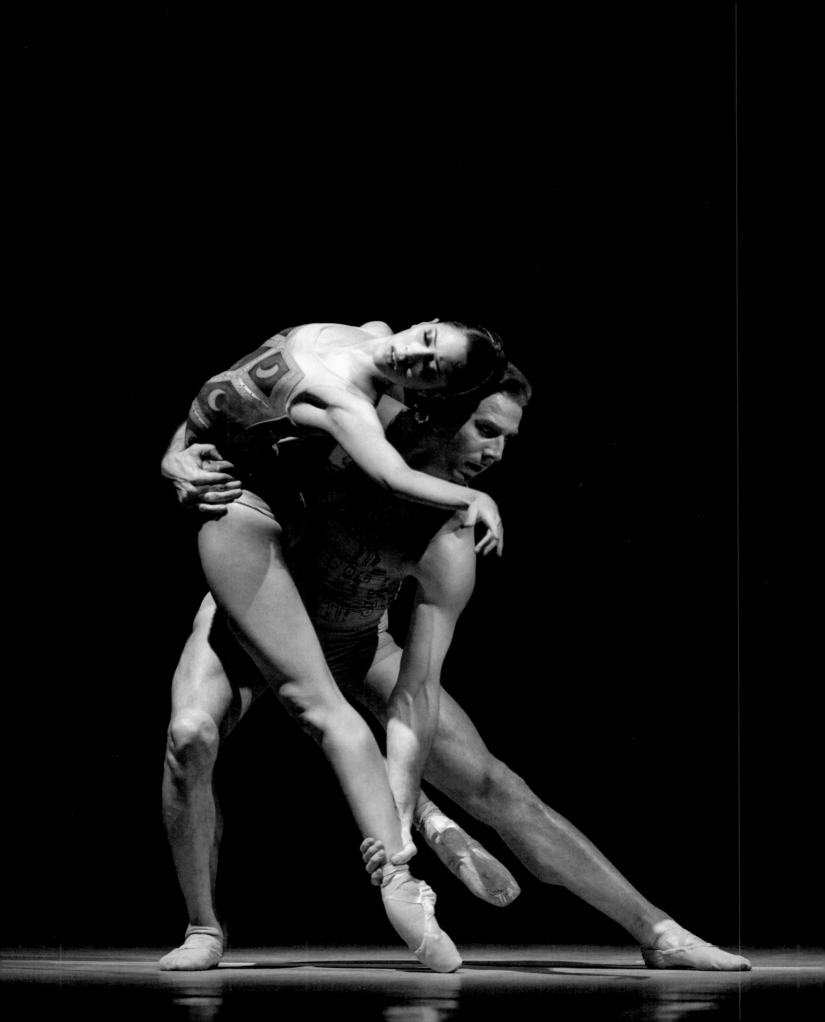

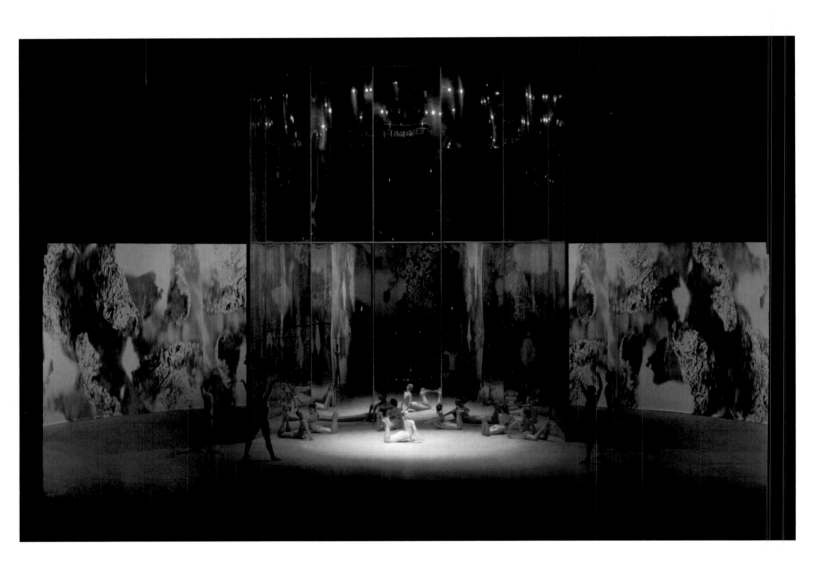

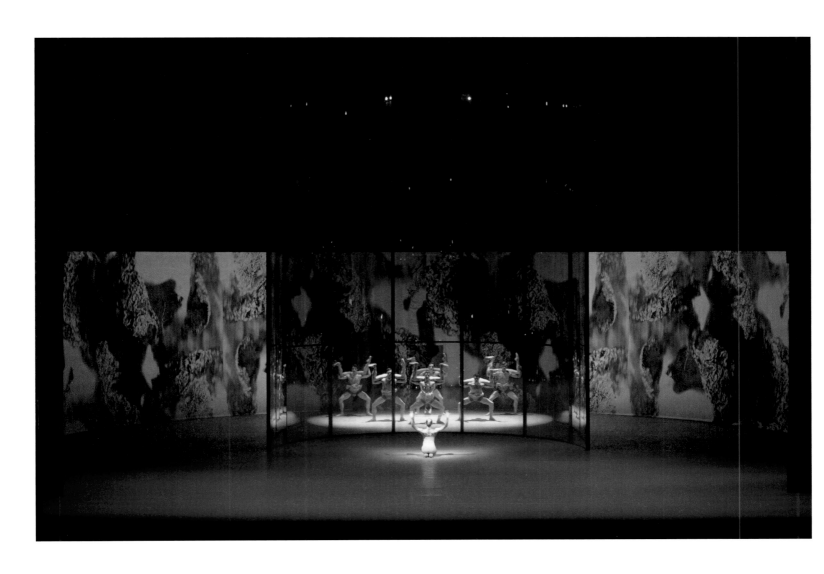

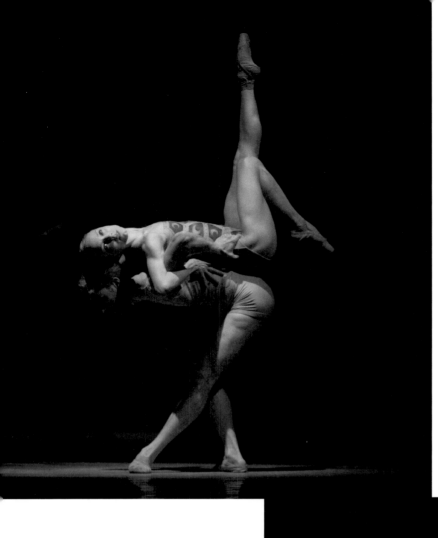

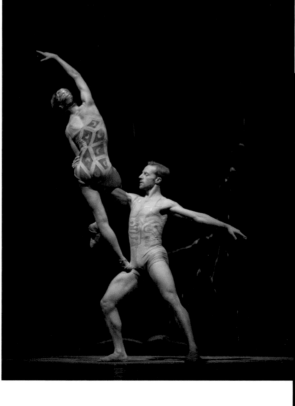

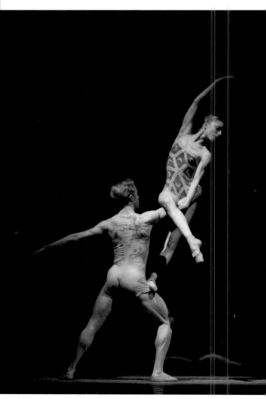

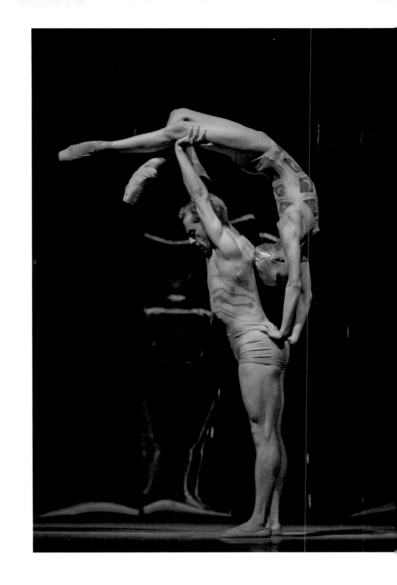

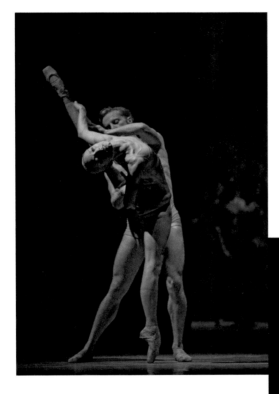

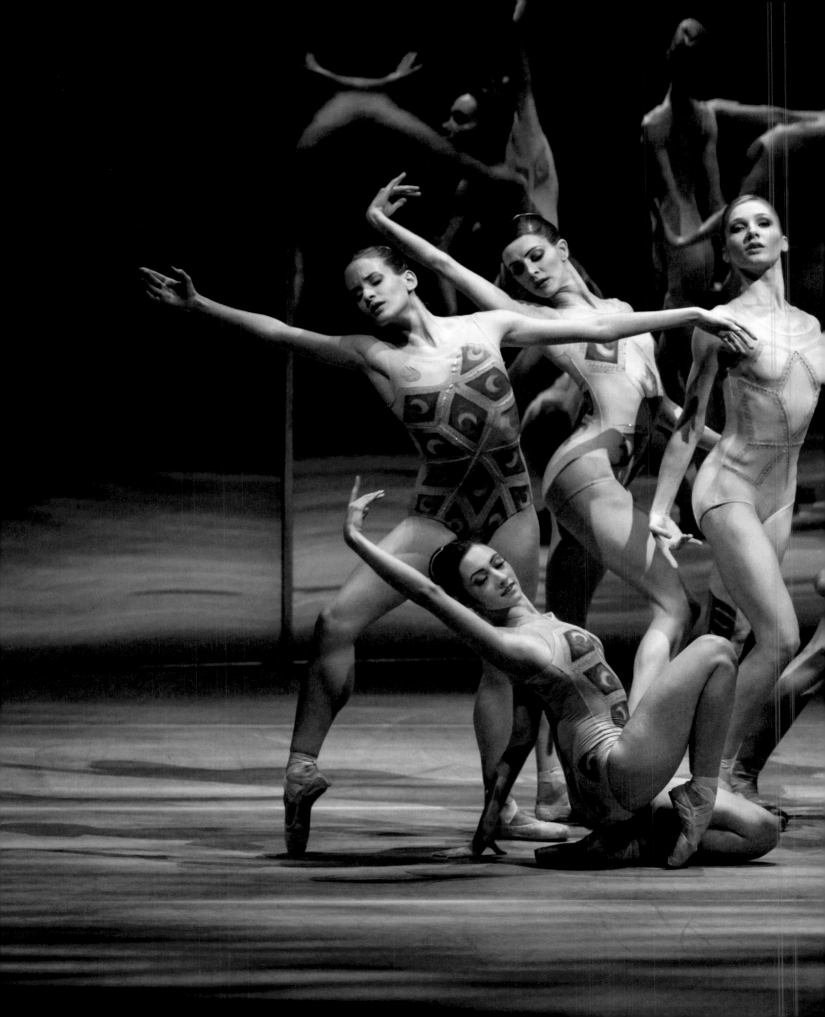

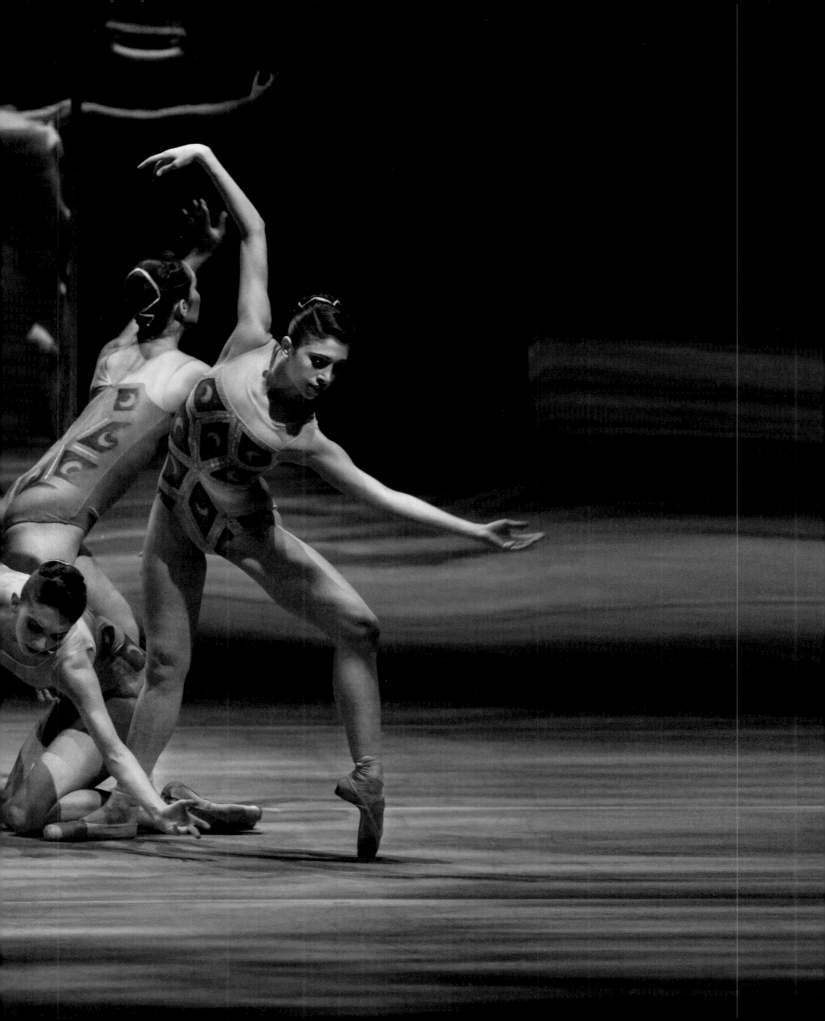

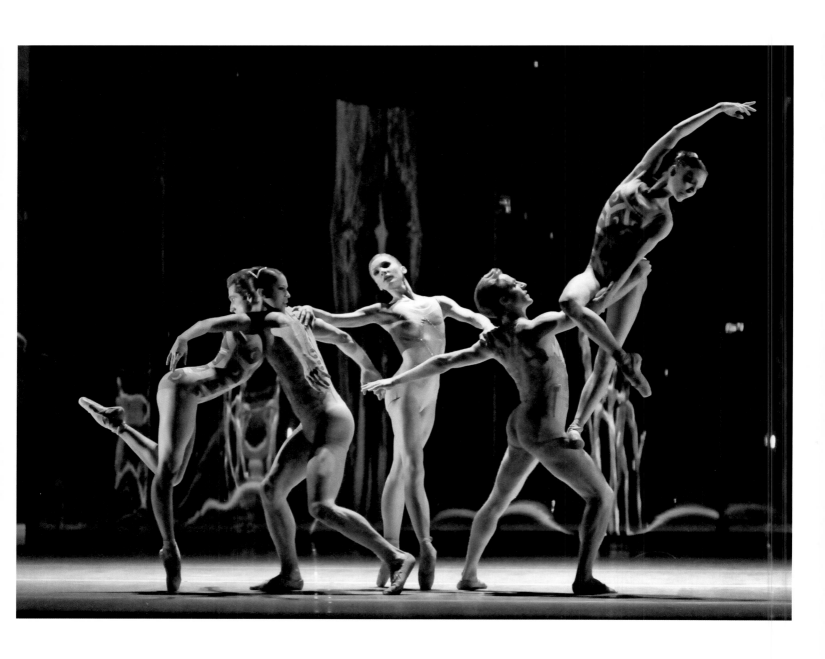

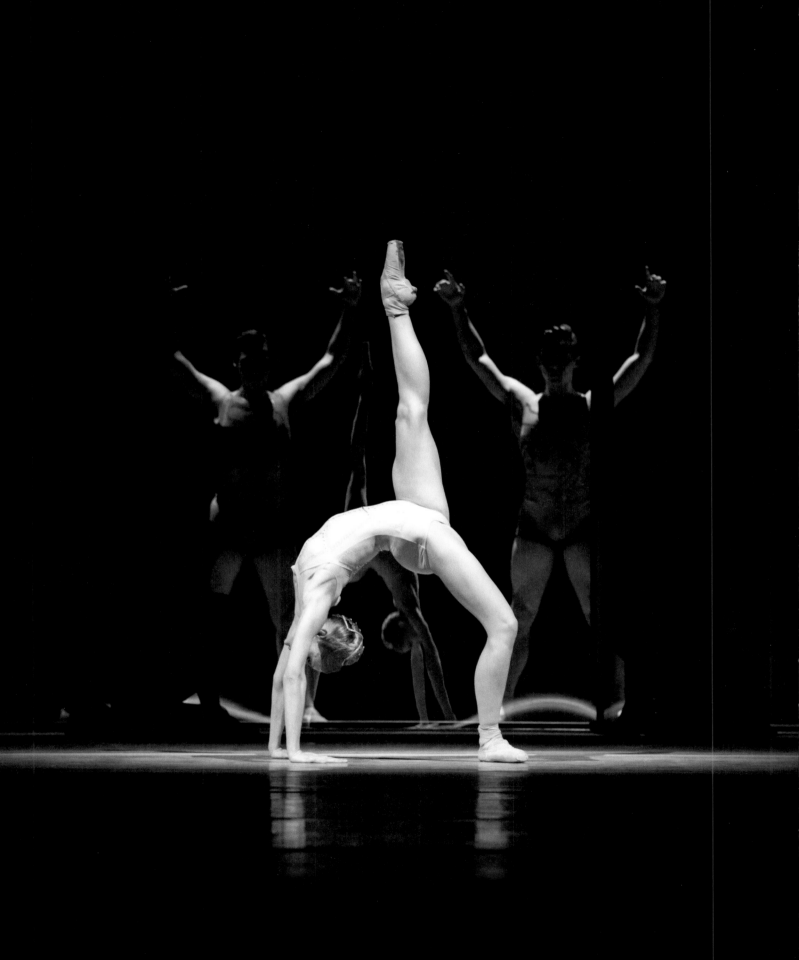

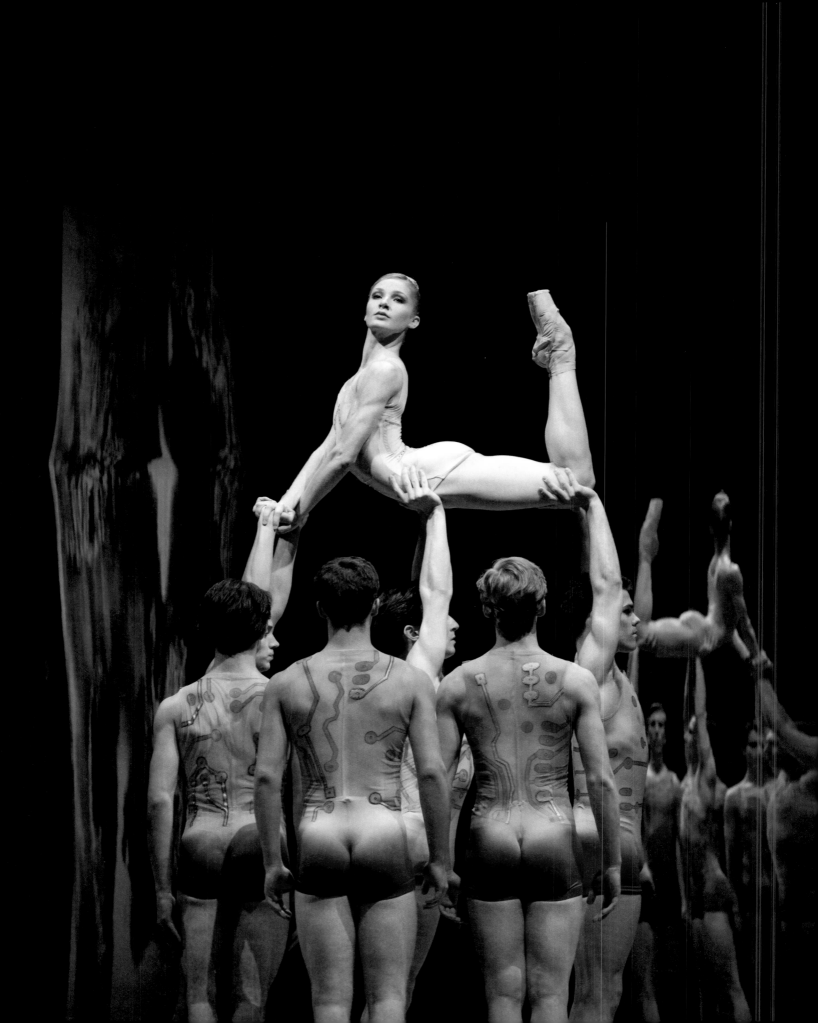

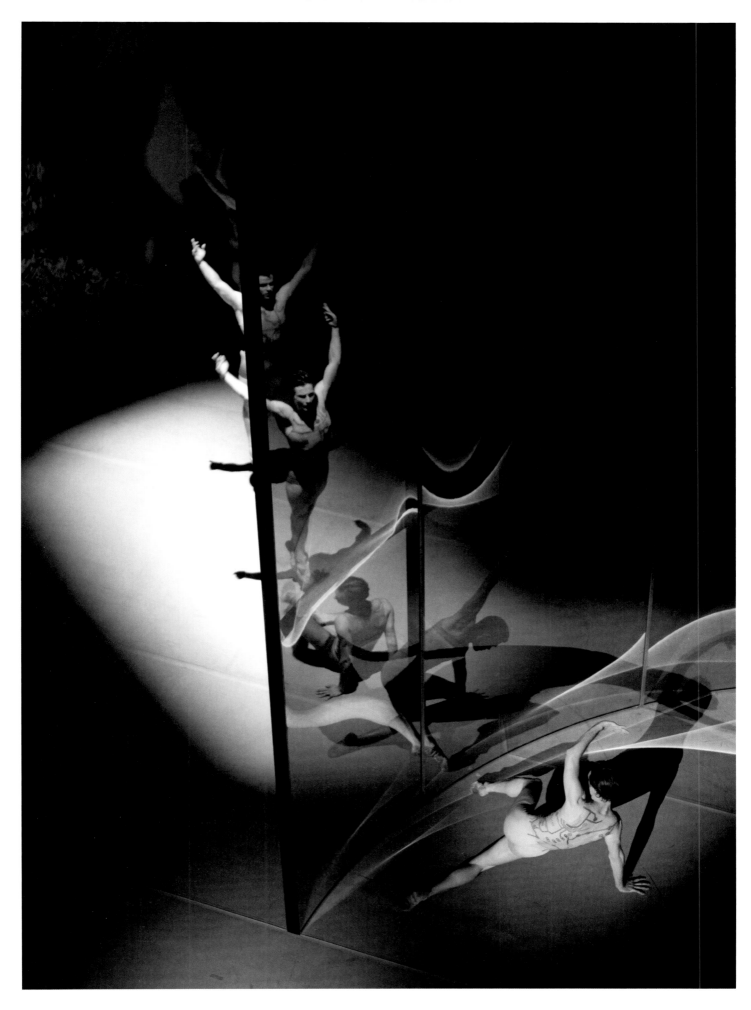

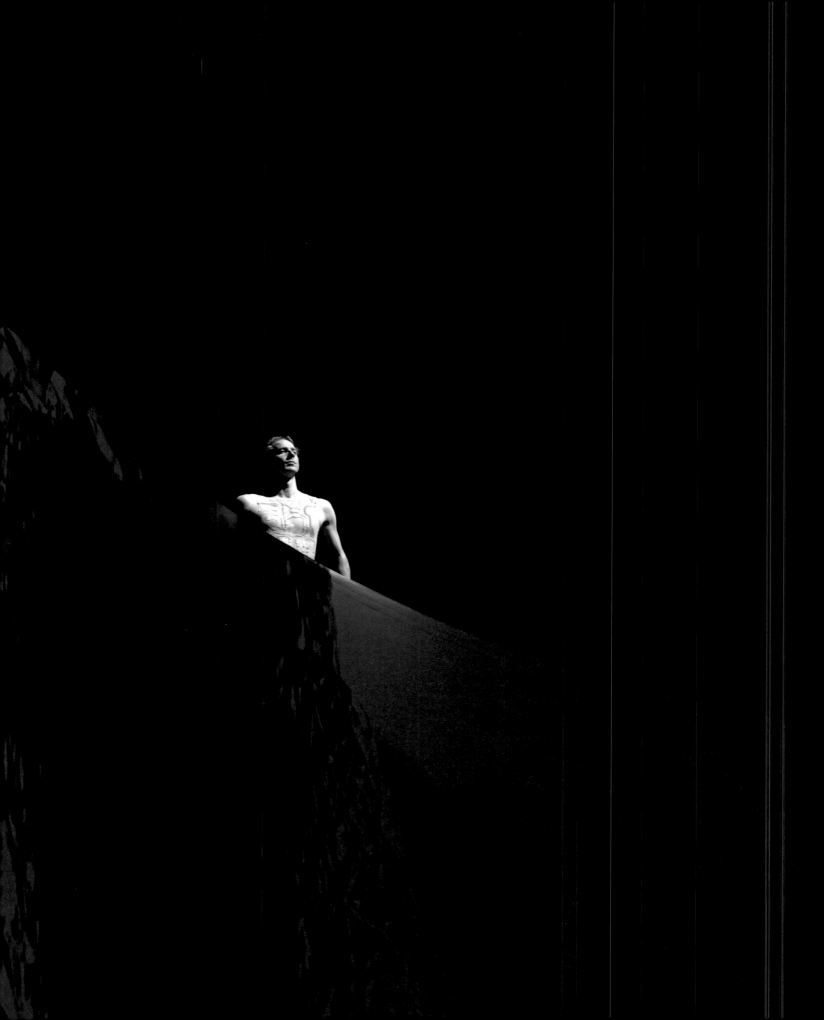

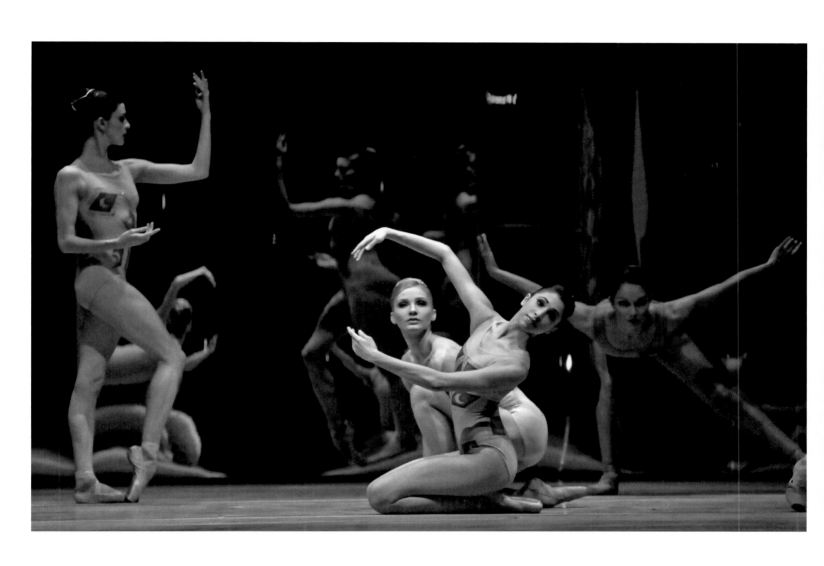

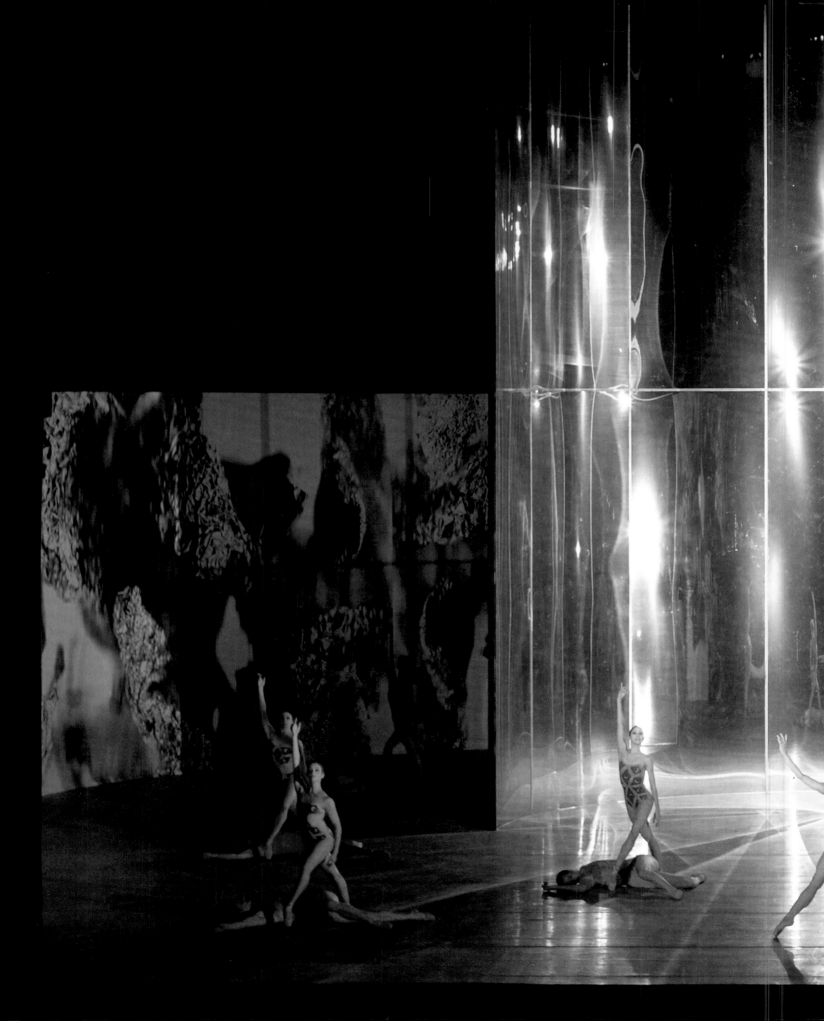

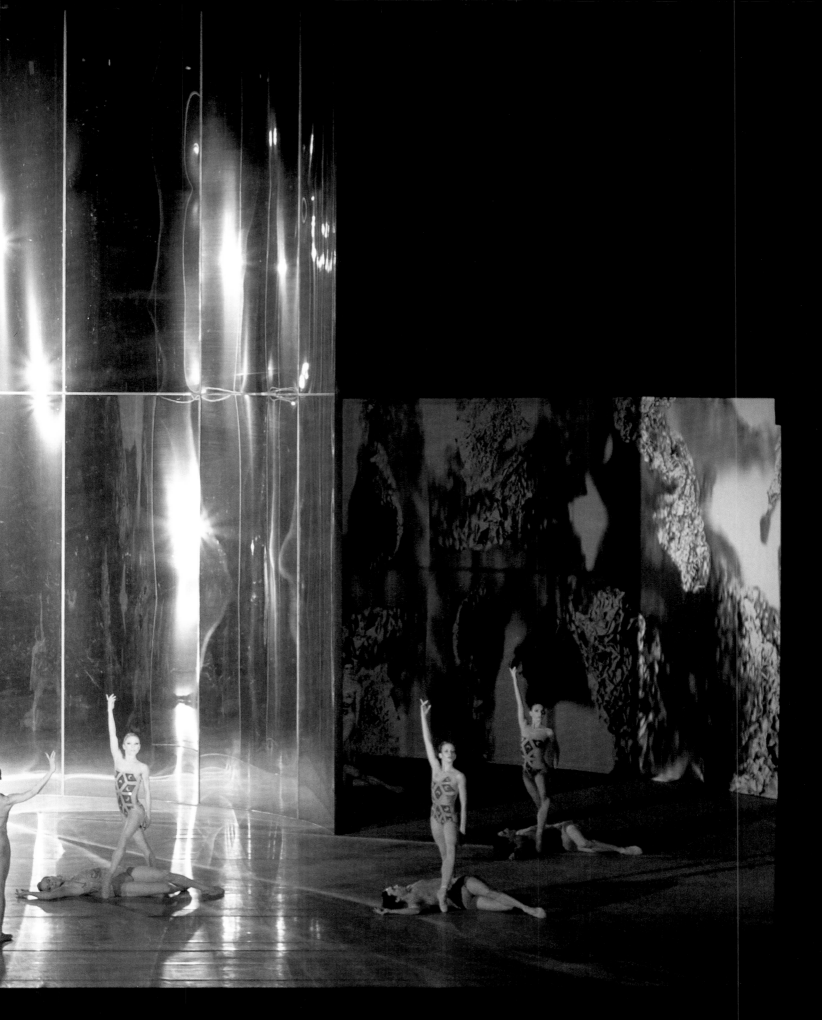

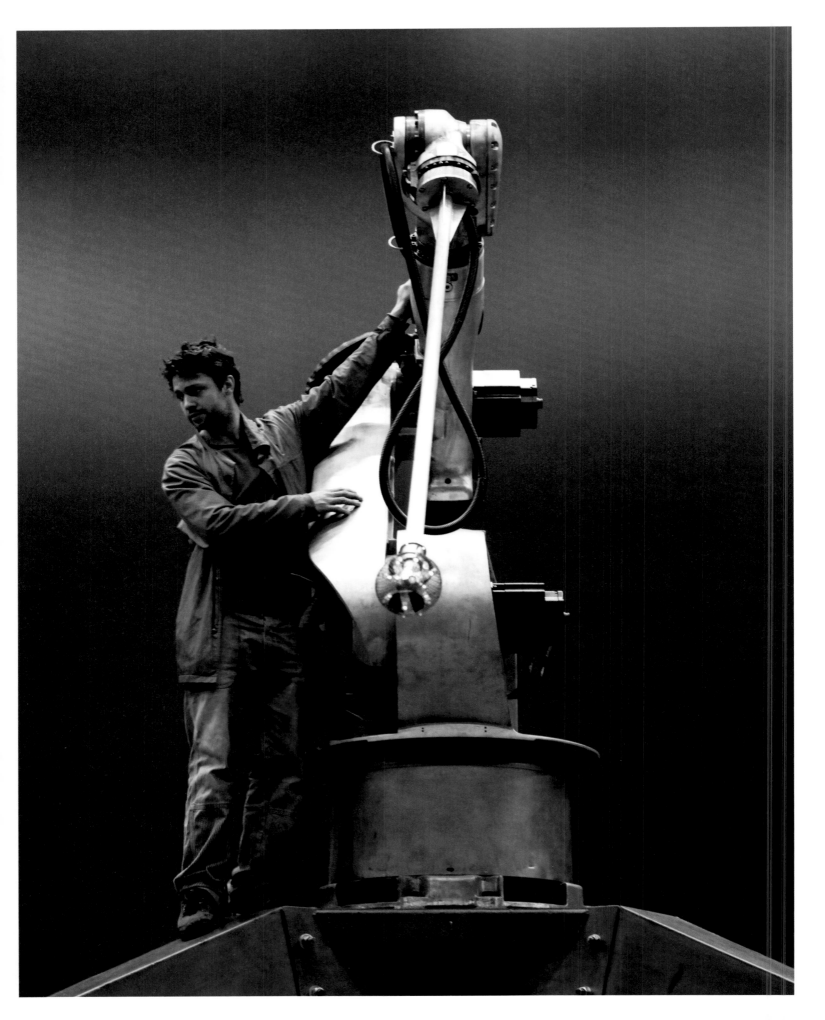

Conrad Shawcross

Trophy | MACHINA

Choreographers *Kim Brandstrup, Wayne McGregor*
Composer *Nico Muhly*

In Conversation
Conrad Shawcross

Minna Moore Ede *You are an artist who is well known for making machines – large-scale kinetic sculptures – that explore mathematical, philosophical and scientific ideas and our relationship with technology. I think it's fair to say that we imagined you would take Titian somewhere into the future, but what did you think when you were first asked to take part? How did you start?*

Conrad Shawcross The first thing I saw was the potential in the story. It's such an incredible tale, and everyone responds to it immediately. And of course that's what Titian was responding to. So the story itself was the most important thing, and its essence was at the core of everything I was trying to achieve. At the same time, I didn't want to ignore the paintings. Strangely, I thought that because I was a sculptor I would be more able to respond directly to the pictures than if I had been a painter.

I began by looking at the structure and the formal relationships in *Diana and Actaeon* and *The Death of Actaeon*. In the first painting, Actaeon is stage-left and Diana is stage-right. Titian uses scale and light to convey power, so Actaeon is larger than life, while Diana is small and falling backwards. She is meek and sheltering, beginning to recoil and protect herself from his advances as he stumbles across this hidden glade. But then conversely, with the second painting, the positions are reversed. It is as if they have shifted roles so that she is now the dominant one and he is submissive. And if you lay the two works over one another, you see that they are actually the same compositionally, or very similar, with the figures in near identical poses and a diagonal shooting across the canvas between them. When I saw that, I decided to combine the two episodes of the story, to splice them together. And in both the National Gallery work and on stage, I used that diagonal structure. In the gallery vitrine, where I've cast a large robot as Diana and the smaller carved antler is Actaeon, there is the same sense of dominance and ownership that you see in the Titians.

MME *Given that you are an abstract artist, it is interesting that you rooted yourself very closely in the narrative and in Titian's depictions of it. I remember that when you were given the commission, you went up to Scotland to see the paintings for the first time and you sent me a postcard saying, 'The growth of antlers is now on my mind.' So the seed of your whole work was there straight away. But how did it evolve? How did the idea of repurposing a robot come out of those paintings?*

CS Well I've worked with machines for a long time, as you said, and the thought of using a robot was there from the start. I remember seeing one of these machines and having a very primeval reaction to it. You stop in your tracks and survey this thing to work out whether it is a threat or benign, whether it's a friend or foe … it's as if you were coming across a wild boar or a bear in a forest – you just have to stop and look at it. It moves in such a beguiling, such a human way, and even

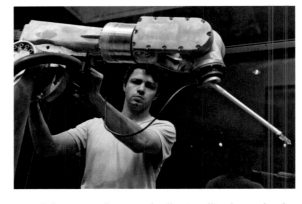

Conrad Shawcross in the National Gallery installing the *Trophy* robot

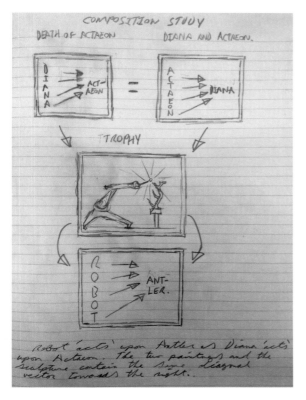

An early sketch showing how the diagonal compositions of *The Death of Actaeon* and *Diana and Actaeon* were translated into the form of the *Trophy* robot carving an antler

Conrad Shawcross's overlay image of *The Death of Actaeon* and *Diana and Actaeon*, showing the similarity of composition of the two paintings

FOLLOWING PAGES Early sketchbook studies for *Trophy*

though it is an abstract inanimate form, it's an arm essentially. It's got this anthropomorphic potential and I really wanted to explore that.

But there was another motivation as well. The National Gallery is a very different context than anywhere I'd shown before. One thing that unifies everyone on display here is that they are all masters of the medium of painting, whereas I'm not a master of any medium. While I love to make things, I don't spend eight hours a day doing one specific thing. I do a bit of welding, I do lathe work, I draw – lots of different things. I was thinking about all of that when I first saw the robot. While I had this visceral response to it, seeing it as a quite human, organic, living object, I was also quite threatened by it as an artist. This thing can carve (I saw it in a fabrication studio). The National Gallery's invitation had already made me question myself as an artist, because I'm not a master, and now I was facing this machine that could carve. So I was asking myself what am I? Am I artist as maker, artist as artisan, artist as thinker? And then I thought it would be interesting to play out some of these questions in the gallery, to have this object be the sculptor in the gallery. One of the things with the National Gallery is that because the works are so, well, old, there's a danger of forgetting that they were once contemporary and once deeply shocking or extraordinary or sensational or controversial. Artists have always had to embrace new technologies to create the works of the day, whether that's mixing eggshells or using lapis lazuli from Afghanistan, like Titian did. Venice was a hotbed of new ideas, new processes. And so this robot, while it might look weird in the gallery, is no different.

MME *And when did this idea of the robot being Diana – because we've been talking about it as a she for a long time – evolve? Why was it that you wanted to make her the machine, when it would seem to be more of a masculine object?*

CS I'm not sure when I decided that Diana would be this cold machine precisely, but it was early. I was interested in exploring this duality inside the vitrine, this tension between dominance and victimhood. Diana is supposed to be the victim, but then she is the one who survives, and it is Actaeon who perishes. The antler, which obviously represents Actaeon, is carved out of twelve hardwoods: there's apple and pear and teak and afromosia and walnut and American walnut. In all, there were around 350 blocks of wood, all about 40 mm wide and glued together to form this big, pixellated antler, which we carved very slowly in the studio. One of the original ideas was that the robot would be programmed to whittle away at this block just as a sculptor would, slowly creating Actaeon over time from the materials of the forest. It's quite allegorical. And so I was conceiving it as a sort of kinetic novel that would take place over eighty days. You would walk in at the beginning and there would be this big block, and then you would come back at the end of the show and it would be a perfectly formed antler.

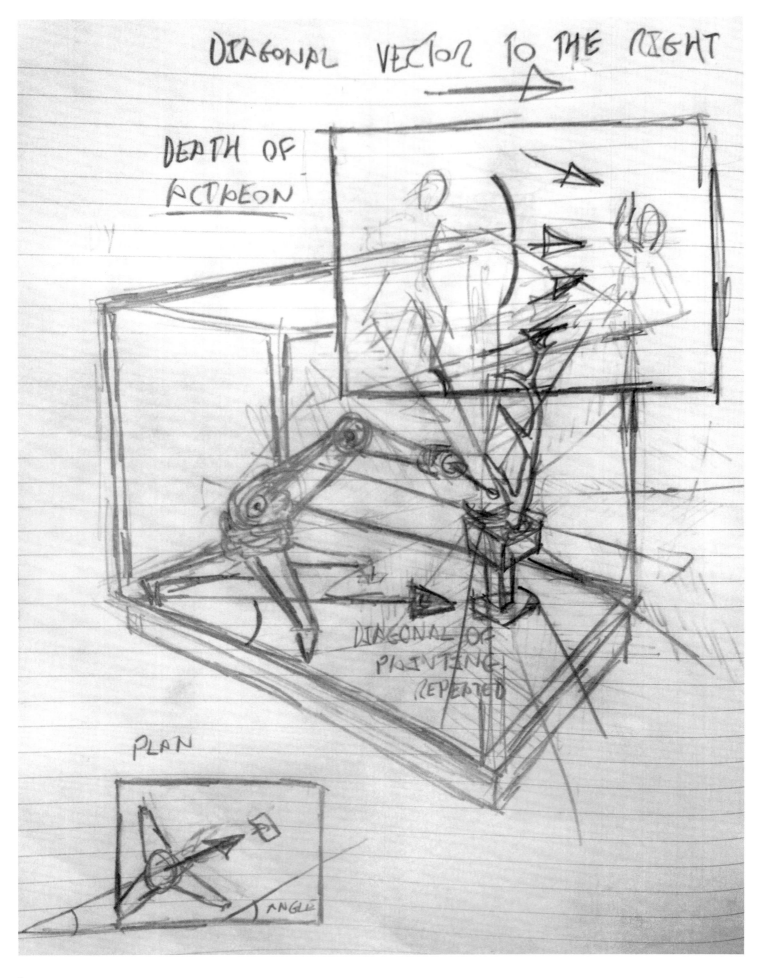

DIAGONAL VECTOR TO THE RIGHT

DEATH OF
ACTAEON

DIAGONAL OF
PAINTING
REPEATED

PLAN

ANGLE

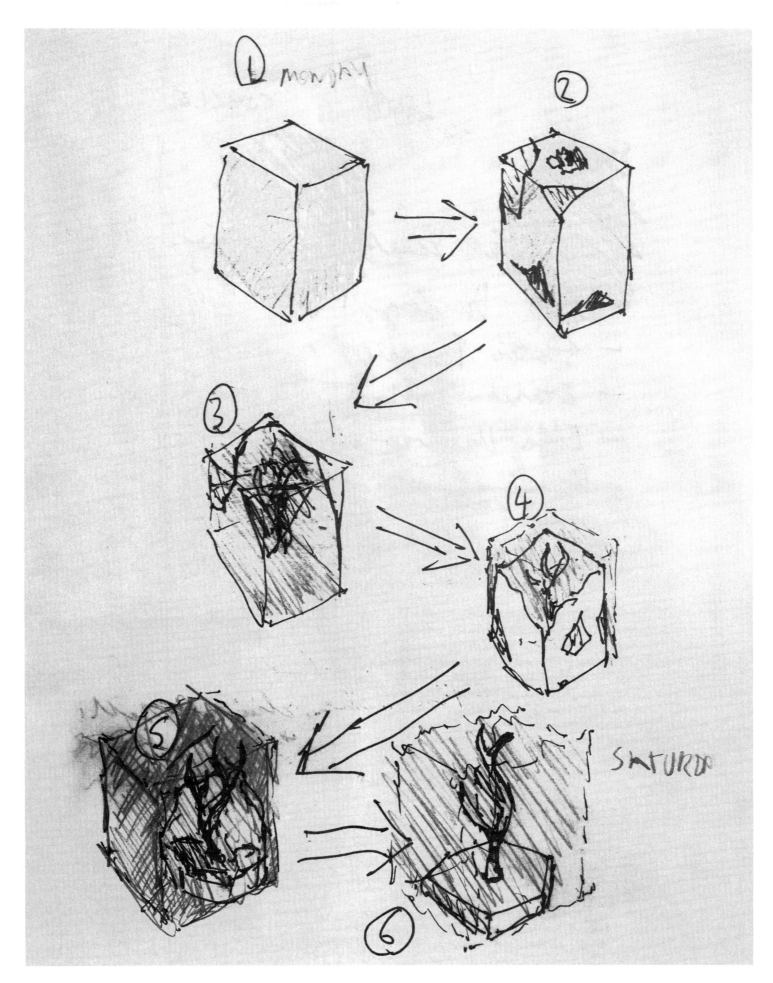

① monday

②

③

④

⑤

⑥

SATURD

But one of the problems was that most people come in to see the exhibition only once and so get just a five-minute snip of this novel – no one would really see the whole process from beginning to end. So quite late on, we decided to use the antler that we'd carved as our test run as the finished thing, and to create a much shorter choreographed loop where Diana goes from grooming herself and sensuously stroking her own legs to surveying the antler, her prize. She moves in this toroidal knot, which was based on one of the drone chords from Nico's score for the ballet. And then she strokes the antler, almost polishes it. The piece is called *Trophy*, and it's a kind of epilogue to the story, for it is only in the last line of the narrative, when Actaeon is dead, that Diana is sated and calmed and returns to her glade once again. But we're also going back to the beginning of the tale, because in *Diana and Actaeon* there is a stag's skull on a pedestal close to Diana's head.

MME *Yes, as a portent of Actaeon's fate.*

CS That's right. And in my piece I wanted it to be just a solitary antler because I felt that to treat it as a singular form, almost like a sapling, made it stranger and more vulnerable.

MME *And there's a lovely contrast between the naturalness of the wood and the industrial machine. How do you think the piece changes now that the robot is not actually carving the antler, that it doesn't have a practical function?*

CS I think it's better. Usually, I build my own machines and I pay careful attention to detail. I try to make them as pure design so that they're art works cloaked in the veneer of the rational and the designed, but beneath that veneer there is a complex metaphysical or philosophical idea or set of ideas in disguise. Duchamp is often described as the first artist to disguise art works as something else, and other things as art. And my machines have that same sense of the readymade. But with this machine here, we've replaced its original spindle and router bit with a light, so negating its functional purpose and reducing it to a feminine, moonlike object (the light referring to the fact that Diana is the goddess of the moon, as well as of the hunt).

MME *Where did you actually source the robots?*

CS Well there are two robots, of course: the one in the gallery and the one on stage. The one used in the ballet is much, much larger – it weighs three tons with its legs. The one in the gallery is much smaller. It came from Poland originally, and I bought it via a second-hand robot dealership in Spain. They're very difficult to track down. It's a bit like *Blade Runner*, where you have to meet in car parks in the pouring rain with people with peroxide hair and smoking roll-ups – it's a very strange underworld. But we managed to get this robot eventually.

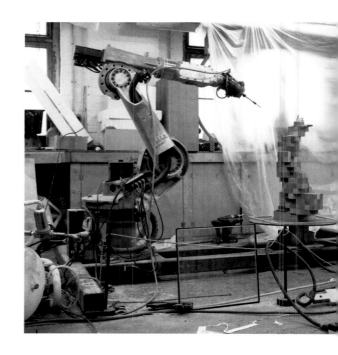

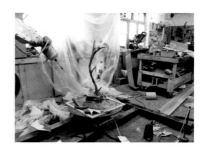

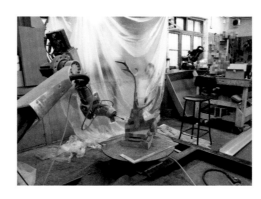

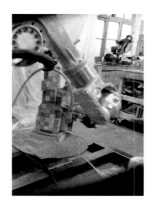

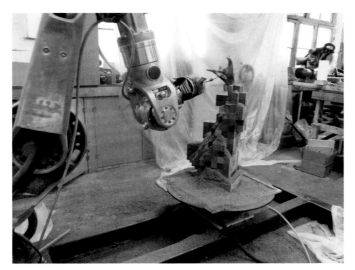

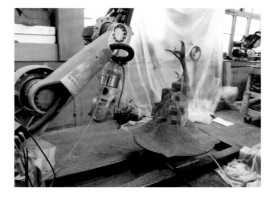

This spread Time-lapse images of the *Trophy* robot carving the hardwood antler in the artist's studio

Following spreads The construction of *Trophy* at the National Gallery and the completed installation

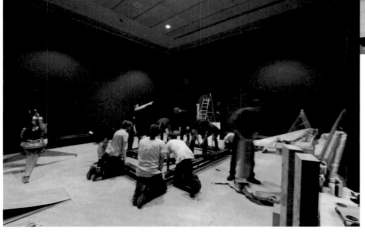

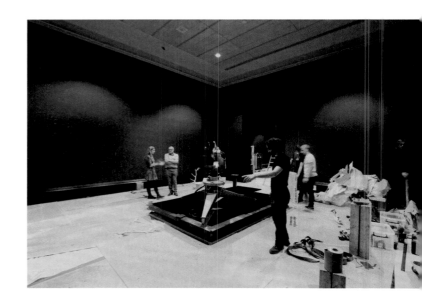

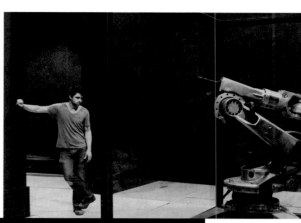

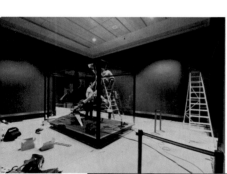

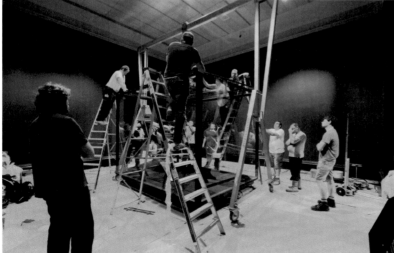

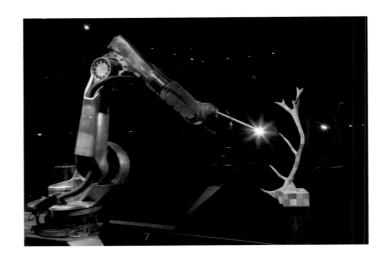

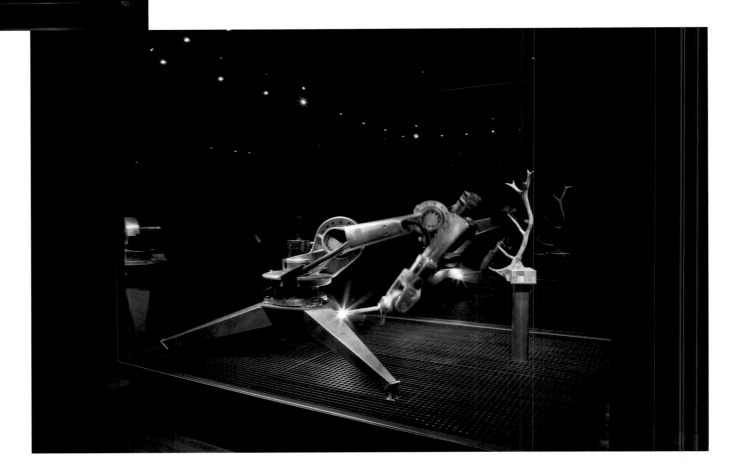

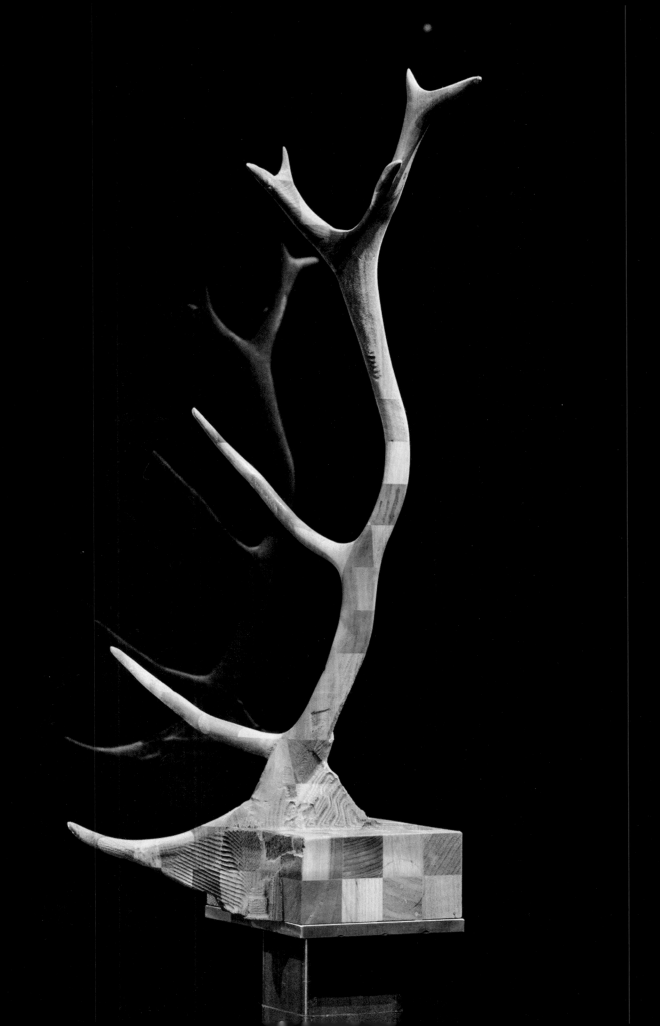

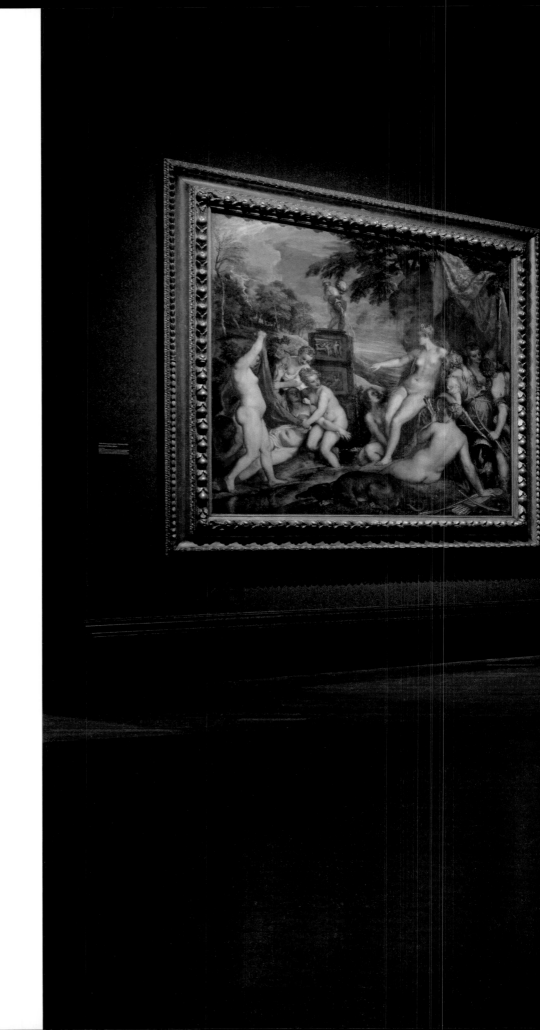

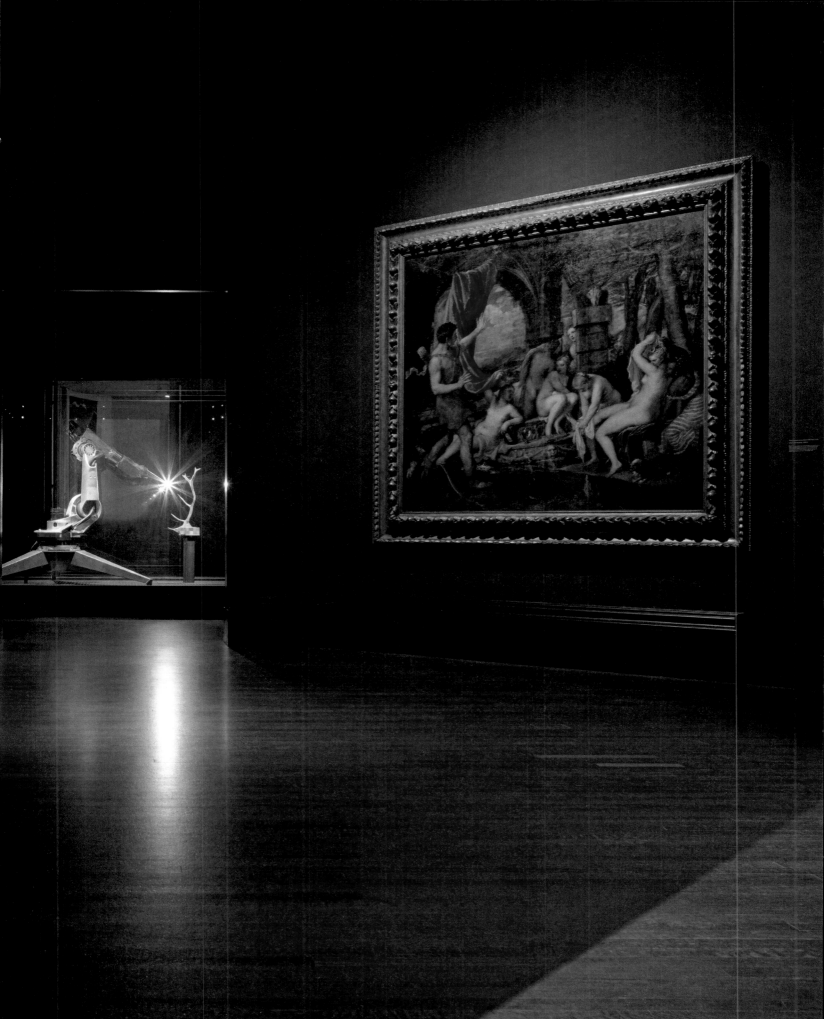

MME *But it didn't look like this at first. When I saw it two years ago, it was bright orange.*

CS That's right. It was very bright orange, very industrial looking. We stripped it of lots of elements. We dwarfed some of the limbs – I don't know if that is the right term – we shrank some of the limbs and elongated others. We completely changed the geometry of it, removed all the paint, polished it and then added this sort of tripod. Both of the robots, on stage and in the vitrine, are linked by this same kind of tripod, which is spread very wide and purposefully acts as a practical solution to spreading the load and making the thing stable. At the same time it seems quite a feminine motif.

MME *Interestingly, Jacob Epstein's* Rock Drill *is almost exactly a hundred years old and obviously has many formal similarities with your robots, and yet is very masculine. Do you see yourself in relation to that historical work?*

CS I didn't directly, at least not when I was conceiving the tripod, but afterwards I did think about my work in relation to the *Rock Drill* because that is such an epitome of masculinity and male virility. But I think I'm using the tripod form much more in the vein of a Louise Bourgeois spider. Maybe it's just the angle of the legs; maybe if it were more upright it would suddenly become very male.

MME *Someone said it looked feminine because of its lovely tapering ankles.*

CS Well, we made so many different models and maquettes, but none of them was quite right. I wanted it to go down very slenderly to the floor. The one in the gallery is about the twelfth version we made.

MME *People are fascinated that the same robot that they see gloating over the antler, over the 'trophy', is the same one that actually carved the antler in your studio.*

CS It had a very fast spindle and blade on it that span at 20,000 rpm and carved the antler shape bit by bit very slowly. In order to know how to do this, we had to go up to Cirencester and do a course called 'Robot Master'. We stayed in this pub called The Luddite. It was all very stressful. There was a lot of local antagonism towards us, for some reason. Anyway, we did this two-week course and learnt this complex program where we could communicate with the robot. It's been a very steep learning curve to develop the skills. But what's really

LEFT Concept drawing for the *Machina* robot

nice about it is that the machine is quite analogous to the human arm in that it can move sideways and up and down, and it has an elbow, and a wrist that rotates perpetually, and then it can flipper up and down. But it also has a finger that can rotate constantly – so it's superior to the human arm in some ways. But while I can move my own arm up and down and it's a very simple operation, I actually have no idea how I do it. I'm completely divorced from the process. So to get these machines to do something as precise as this has been a headache, but it's also been very rewarding because it makes you constantly aware of how your own body works.

MME *That leads on to your seven-metre-high robot for the stage of the Royal Opera House. For the ballet, you were working with the choreographers Wayne McGregor and Kim Brandstrup, and the composer was Nico Muhly. How did they react when you first told them about your plans with the robot?*

CS I think they were a bit shocked at first. The whole thing was already a bit fraught because the two choreographers weren't quite sure to begin with how they were going to work together. That was, I think, the biggest challenge of the ballet. As a set designer, what you're supposed to do is give the choreographers an envelope within which they can work – a foil that remains constant and to which they can respond. While they liked the idea of the robot in principle, the problem was, I think, that the main feature on this fairly minimal stage set was going to be a moving machine, which was essentially another choreographed piece, so there was no constancy for anyone to work against. It was quite difficult for them to get used to the idea.

I provided them with a timeline of mood. I was showing how the energy of the piece could metamorphose over the twenty-five minutes. The idea was that it would have two very different halves and that there would be this clear moment of change, of realization, halfway through that represented the point in the Titian painting when Diana recoils. This would be a watershed moment where things became quite nasty and violent. I went to see Nico in New York, and he was on board right away with the idea of the score changing at the midpoint to reflect this shift. I was still endlessly talking about 'Diana' and 'Actaeon', and the robot 'being' Diana and so on. But I quickly learnt that I had to stop talking about characters because it was not the way that Wayne and Kim liked to evolve their choreography.

MME *You called your ballet* Machina, *which is obviously related to the word 'machine', but why did you choose that title?*

CS I was thinking of calling it *Machination*, because it seemed that this machine had quite a sinister purpose, but also because I was always quite empathetic towards Actaeon. I didn't feel that Diana treated him particularly well. To tear apart a peeping Tom is a bit tough.

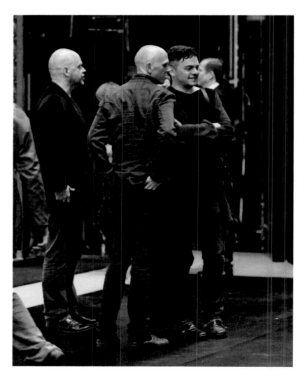

Kim Brandstrup, Wayne McGregor and Nico Muhly at rehearsals for *Machina*

Collaborations are always risky, especially when you are commissioning new work and you have so many artists working together. There are going to be tensions, but that makes the process extremely dynamic. And we had a very clear point of departure. We had these amazing stimuli that you can approach and look at in different ways. It's the paintings that have really driven this project.
Wayne McGregor

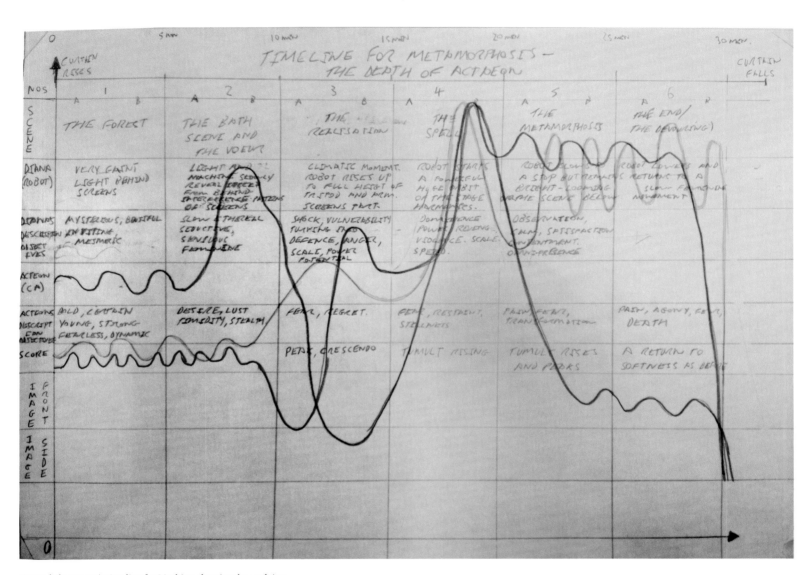

Conrad Shawcross's timeline for *Machina*, showing the evolving mood and energy of the ballet

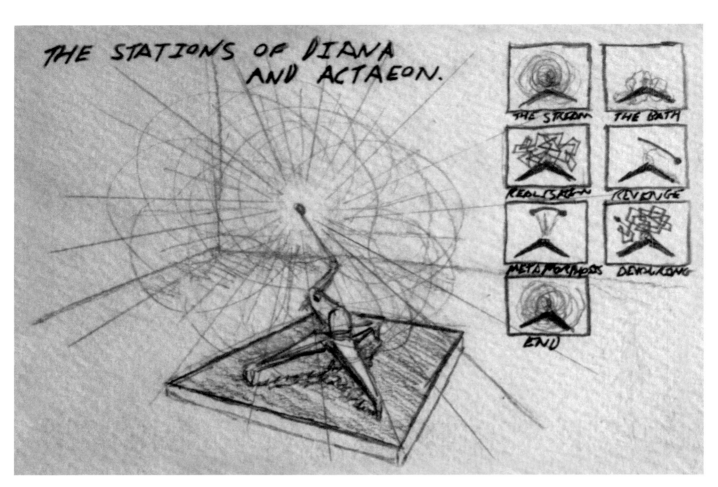

THE STATIONS OF DIANA AND ACTAEON.

THE STORM — THE BATH — REALISATION — REVENGE — METAMORPHOSIS — DEVOURING — END

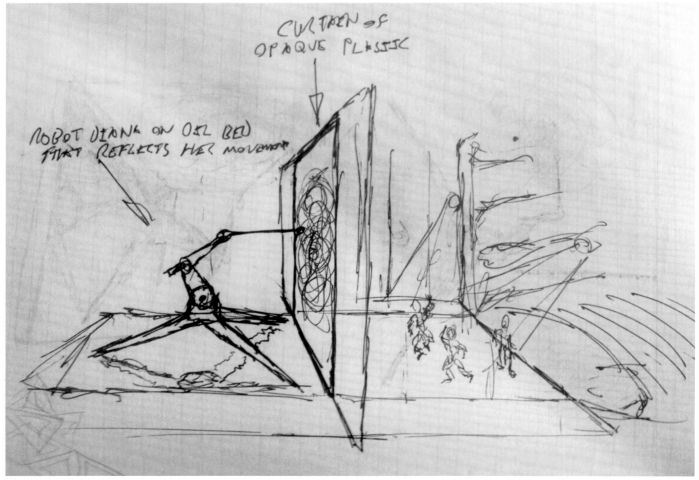

CURTAIN OF OPAQUE PLASTIC

ROBOT DIANA ON OIL BED THAT REFLECTS HER MOVEMENT

MME *That was one of the things you wrote in your postcard to me: 'Diana was pretty cruel.'*

CS So I wanted to insinuate a certain cruel intent. And obviously 'machination' has the word 'machine' in it. But it was just a bit of a mouthful. Then I was talking to my mum [Marina Warner], who speaks Italian, and she suggested '*machina*', which is a feminine noun in Italian. I offered both options to Wayne and Kim, and they both really liked *Machina*, and so it was decided.

MME *At one point you said that you were worried that the music would greatly affect the way the audience would read your set – so if the music were terrifying, your piece would seem terrifying; if it were happy, then your piece would feel happy too. Did Nico come up with the music before the choreographers started to work?*

CS Everything was done in parallel, but really the music came first. My feeling was that it would be the music that everyone would respond to, and that was why I had to go to see Nico early on. I wanted to impart this timeline to him and how this sense of building up would work. He then created two halves of the score with two very different moods. There was an ethereal, trancelike beginning and then it got much more frenetic, active and responsive. But the score also had a symmetry to it, because the rather baroque-sounding section at the start was repeated at the end, with a contemporary passage in the middle, which allowed both Kim and Wayne each to devise a *pas de deux* to the baroque part. For me, I really liked it having the same beginning and end because it fitted with this idea of Diana bathing at the start when everything is calm, the forest is all at one and at peace, and she is minding her own business, grooming herself behind the screen, and you can't make her out. And then suddenly all this drama happens: Actaeon stumbles upon her, flees, and then is transformed into a stag, set upon and devoured by his own hounds. But all of that is over in a moment and then the page is turned; normality and peace returns and Diana forgets all about what's just happened. So the structure of the score fitted very well. But most of that three-and-a-half-minute section at the beginning and at the end was added only very late in the day. It was quite extraordinary.

MME *One thing you did, with the robot, was to get involved in the process of choreography – your robot was an interactive piece of set design. Tell us about the motion-capture process that took place at Imperial College.*

CS Wayne had done some motion-capture before, in America, and he lent us some files so that we could try out a few ideas. We did some tests, which were quite successful. And thanks to one of my software engineers, who had a link with Imperial College, we were able to use the motion-capture suite there. Essentially, what we did was to use a technique where you cover all the nodes of the body – the elbows

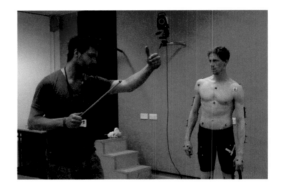

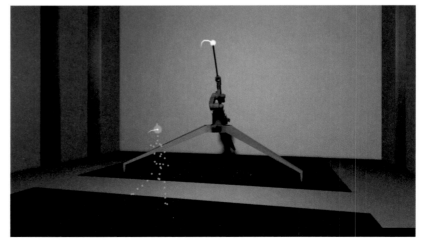

and fingers and hands – with reflective ping-pong balls, and then use cameras to record its movements. You export that to the computer – it's just a series of dots – and then it can be used in lots of ways. They use it especially for special effects in computer games and animation. In the film *The Planet of the Apes*, for example, they recorded the features and movements of a human face and imported those onto a digital rendering of a monkey's face to make it look human. What we did was to record Edward Watson's dance moves, with which we then programmed the robot's movements. Towards the end of the ballet there is a sequence that Ed performs with Carlos Acosta, but then the robot takes over. Ed was very gallant about it, because we were recording his movements and then removed him from the dance altogether. The robot was Ed and then the robot was dancing with Carlos being Ed, so there was a sort of dialogue between them. And then in another section the robot was mimicking Ed, mirroring him, so we were using different techniques at different points.

MME *How did it work with the conductor in the pit? Obviously the robot wasn't responding to him, but how was he keeping time? The robot had a choreographed sequence, but who was leading it?*

CS That was one of the very tricky things. Tom Seligman, the conductor, told us that with live orchestras timings can change by five per cent every night, so our robot had to have fixed cues. We had nine different cueing points so that the robot would come on when a dancer arrived on stage. The conductor would cue from when, say, Tamara Rojo turned a shoulder, knowing that her scene was about to start, and the guy who was operating the robot from the side of the stage would cue at the same moment. Johanna Adams Farley, the stage manager, who was on the cueing mics, would cue both of them. But then Tom was also using the robot at some points as *his* conductor. So the robot would start and he would be conducting and the robot would be conducting – so the robot was the conductor of the conductor.

MME *It was like having another dancer on stage. What did you think would be the reaction to this mechanized object with its own very particular energy in conjunction with a human body and its energy? What did you think when you saw Carlos Acosta, who has got this amazing animalistic quality to his movement, juxtaposed with a robot?*

CS My big fear was this thing was going to compete with everything the dancers did – and I think it was the choreographers' concern as well, because ballet is about the dancers and it always has to be about that. I think the danger of artists working on stage sets is that we are egos in our own right, and we're not necessarily going to be subservient to the dance. With some of these spectacular sets created by artists, you just don't have enough eyeballs to look at everything.

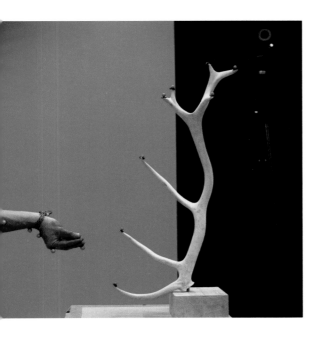

THIS SPREAD Wayne McGregor, Conrad Shawcross and Edward Watson in the motion-capture suite of Imperial College, London, with a still from the captured motion file (bottom far left) and computer simulation of the dancer with the robot (bottom left)

OVERLEAF Wayne McGregor choreographing Edward Watson's movements in the motion-capture suite

Everybody has a physical signature and that signature is very literate. You can recognize somebody absolutely by the way that they move. And this motion-capture process captures some of that information and then translates it into maths, and then gives that maths to the robot to make it able to move in that way.
Wayne McGregor

I was really trying – and sailing close to the wind at times – to get it right, to be a foil to the dancers and complement the dance, not to be a distraction or rival. It's a very fine line, but I think we got it right. There are moments – for instance when the screens peel back at the beginning – that allow breathing time for the dancers to build up and gain their identity on stage.

MME *It was very well paced. Sometimes the robot was quite dormant and seemed to be waiting while the dancers were centre stage, and then it reversed completely and took over the action.*

CS But you always need to have a sense of both the machine and the dancers at once. You need to see the details of the dance and the robot operating behind it, making its various patterns and with its different sense of scale, rhythm and pace. Sometimes she is very angry, and at others she is soft, seductive and sensual. Hopefully, I've managed to make this industrial machine convey all these very different psychological states.

ABOVE A concept drawing for the costume designs for *Machina*
OPPOSITE, CLOCKWISE FROM TOP LEFT Edward Watson and Tamara Rojo performing a *pas de deux* from *Machina*; Tamara Rojo in *Machina*; computer simulation of the robot moving in relation to a chord from Nico Muhly's score; detail of Tamara Rojo's costume based on the same pattern; Carlos Acosta and Leanne Benjamin in *Machina*

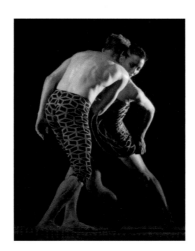

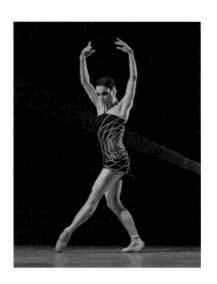

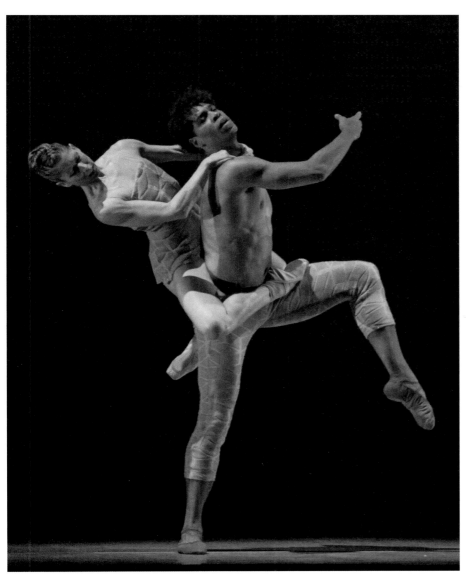

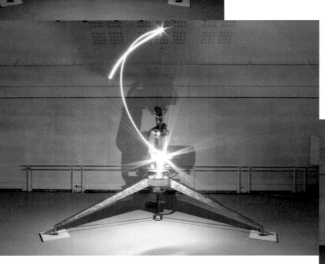

As a set designer, I was supposed to design a fixed envelope for everybody to work in, but instead I gave them another thing that's in flux. It was a hell of a ride, but through adversity comes great things.
Conrad Shawcross

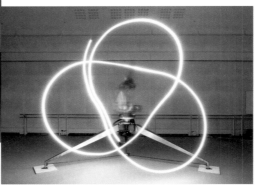

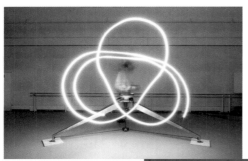

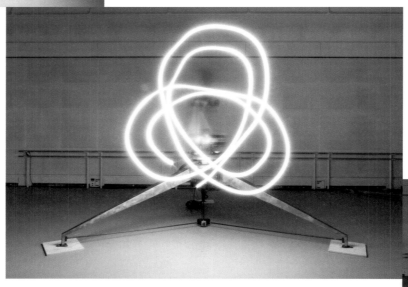

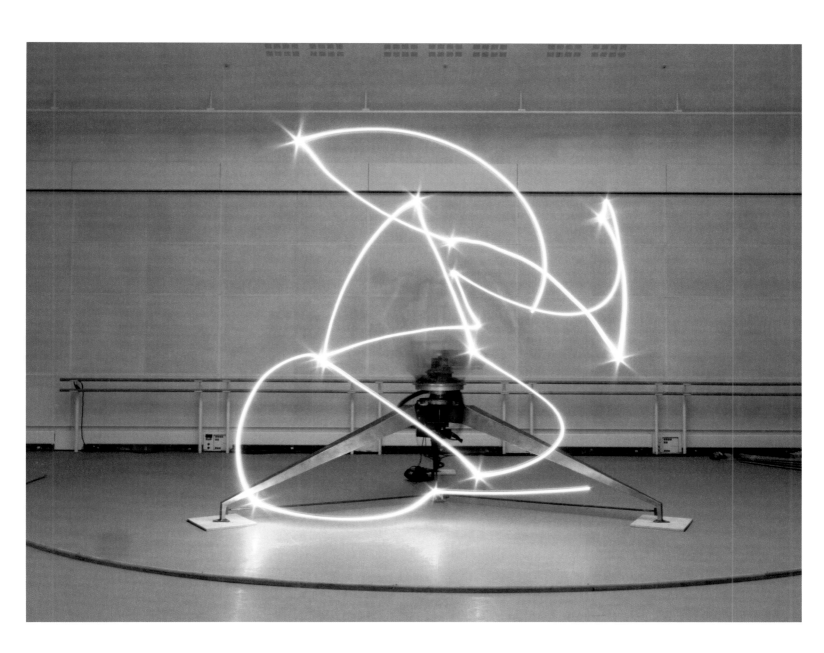

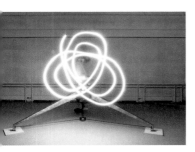

Both the challenge and the excitement of *Machina* was how to negotiate such different artistic voices: Conrad's industrial mobiles versus Titian's sensuous flesh, Nico's rhythmically propelled music versus William Bird's hymn, and Wayne's physical language alongside mine all seemed at first sight to be incompatible. But possibly because we decided not to 'smoothen the edges', the fact that each of our languages was allowed to stand hard against the others, gave the piece a tension and dynamic life that none of us would found on our own.

Kim Brandstrup

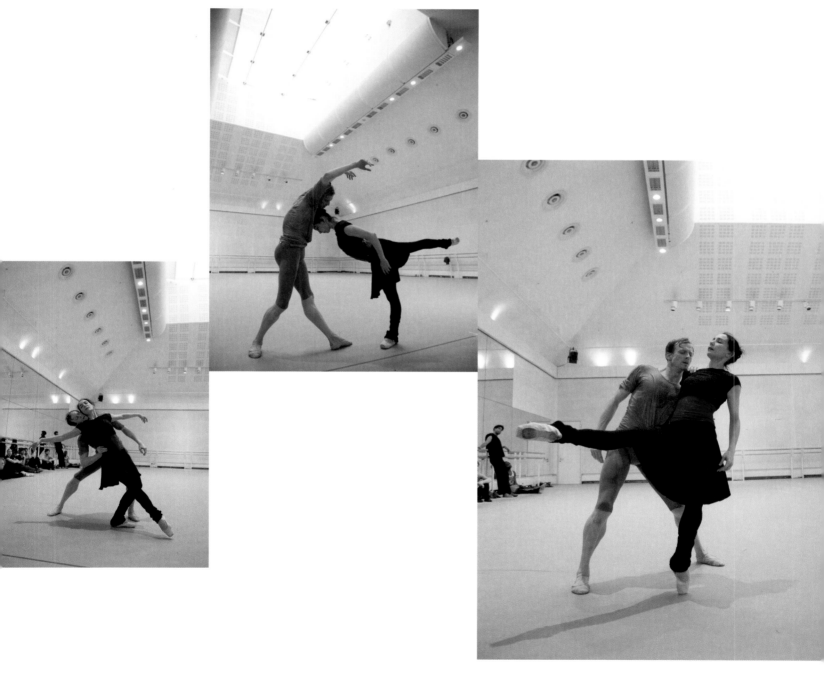

I spent time looking closely at the Titian paintings, almost in a forensic way. I traced the accents of red in one of the paintings and that redness elicited a certain feeling that I tried to work with. Shadows are also very important because what shadow does is to shape the space. In the paintings, there is a sense in which the space is in transformation, it's a space you can't quite get hold of, and you absolutely see that in the way shadow works within the theatrical context.
Wayne McGregor

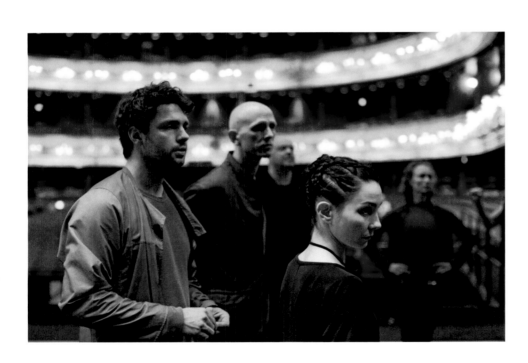

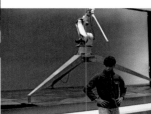

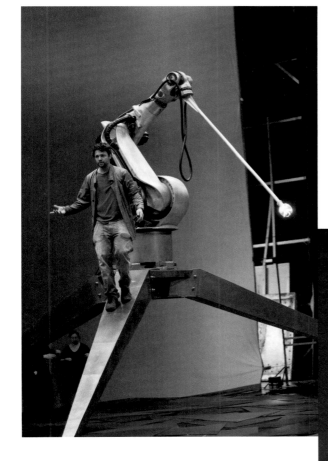

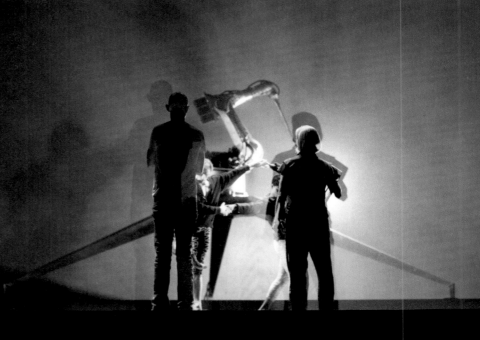

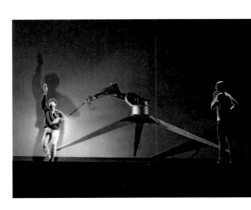

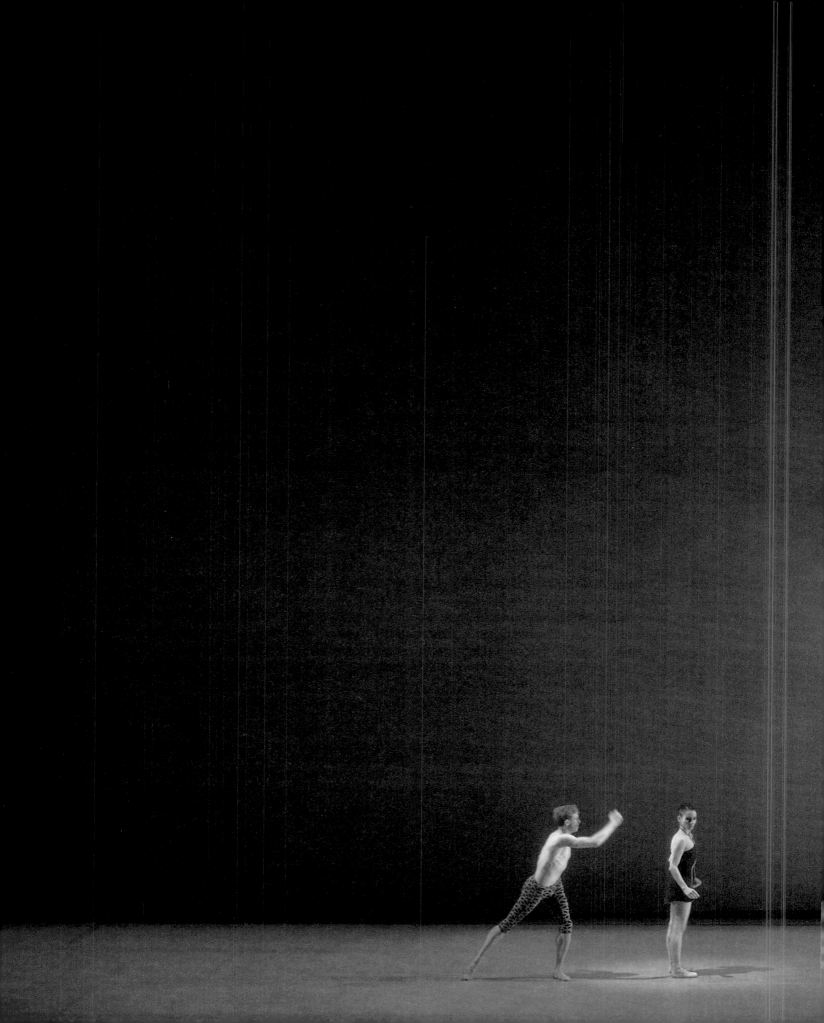

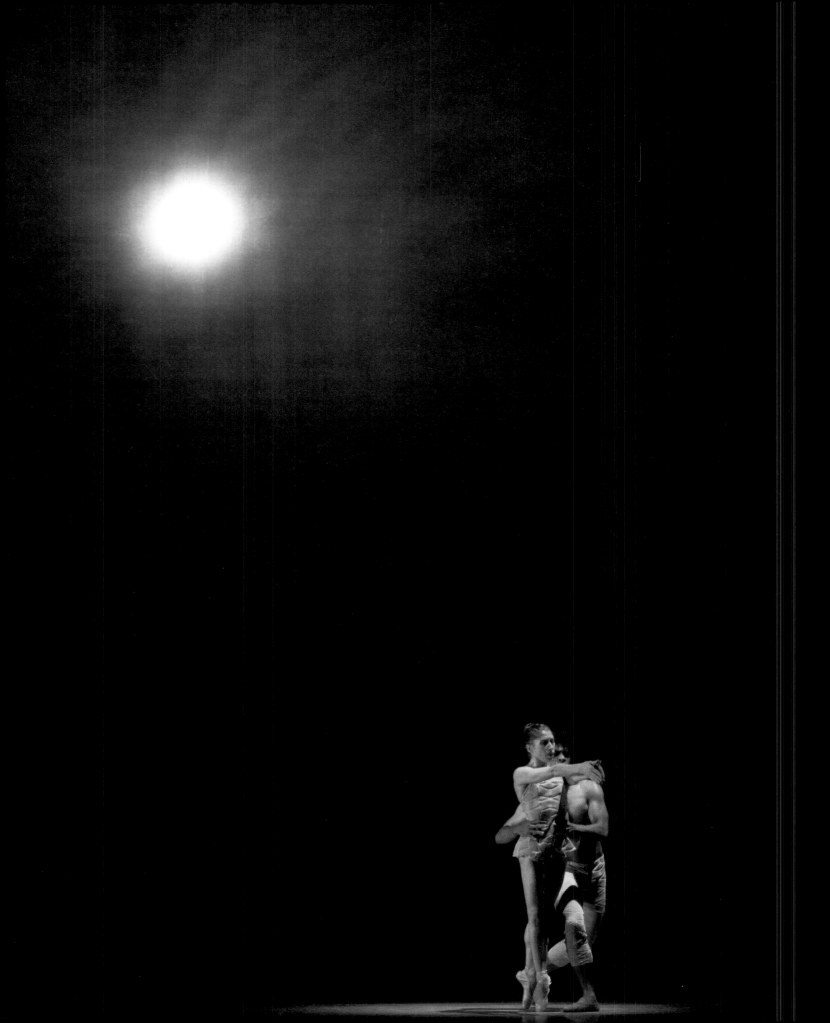

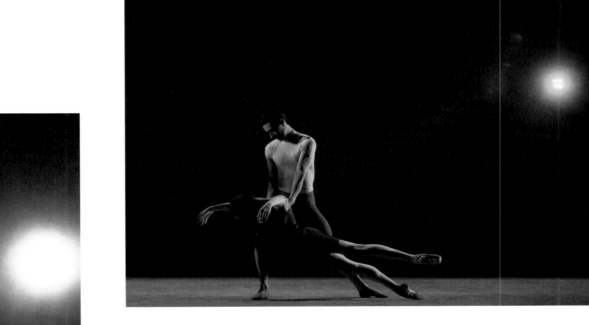

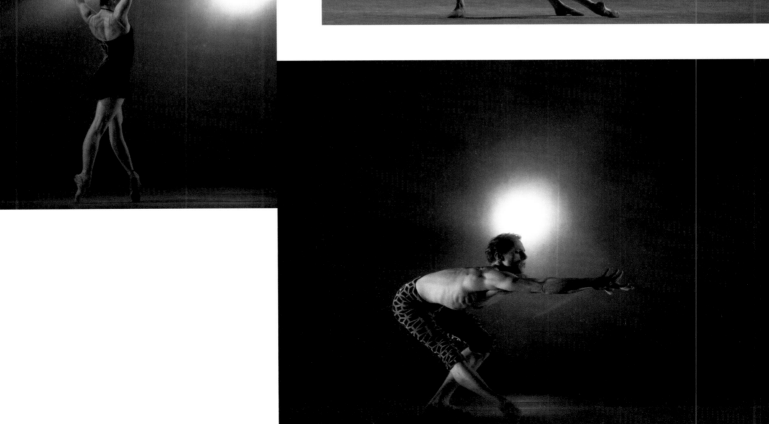

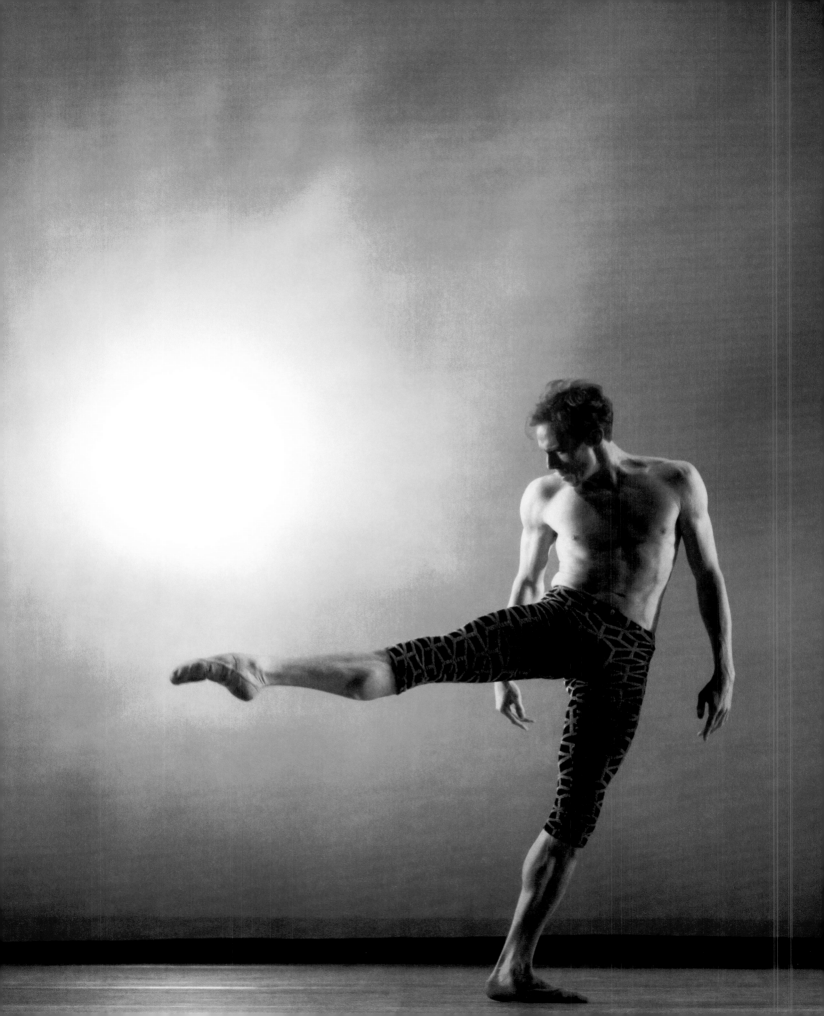

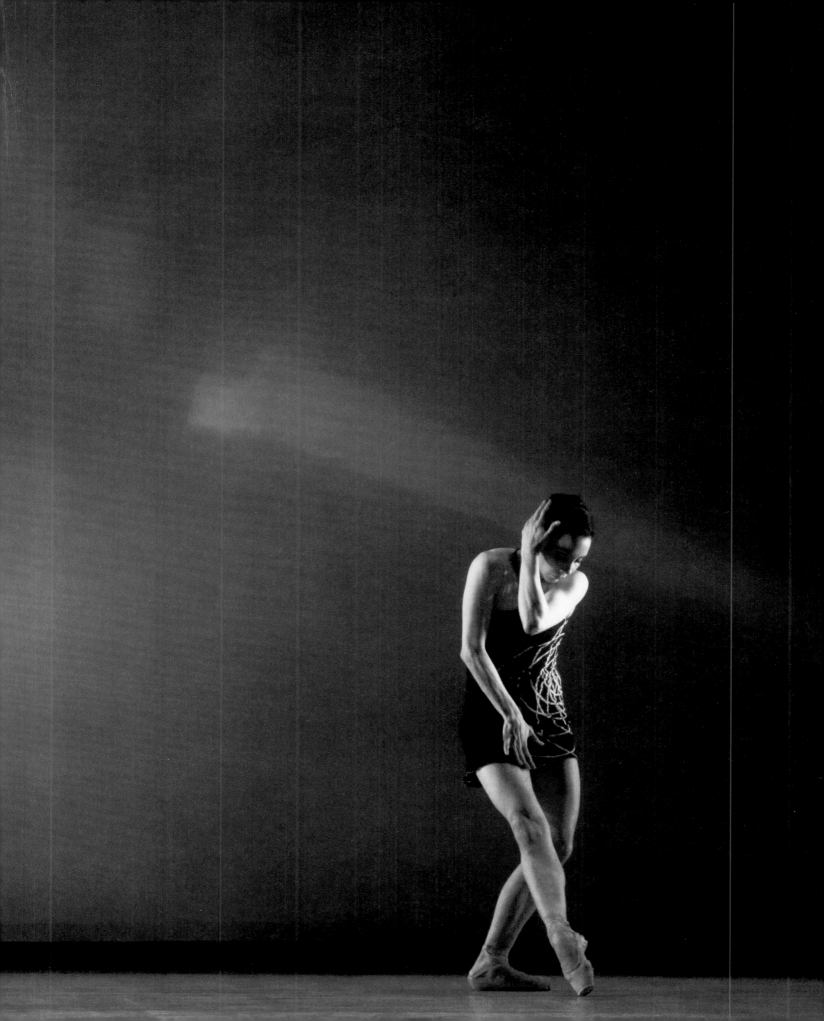

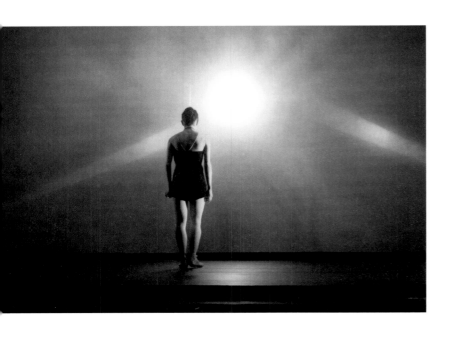

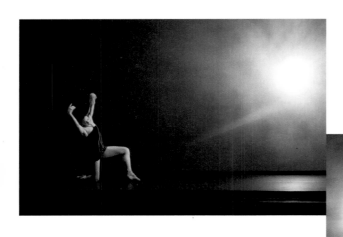

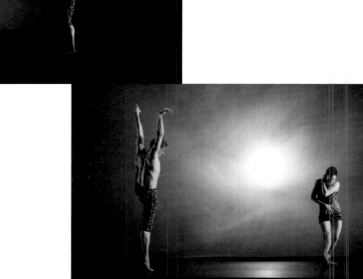

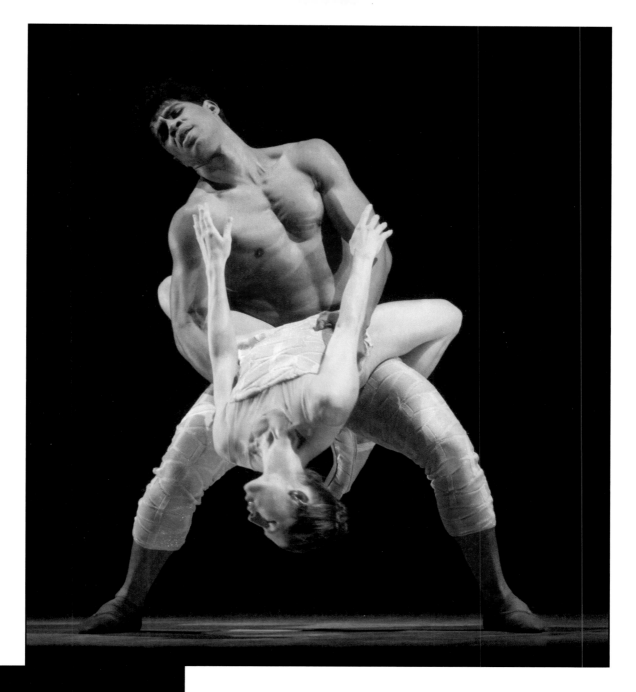

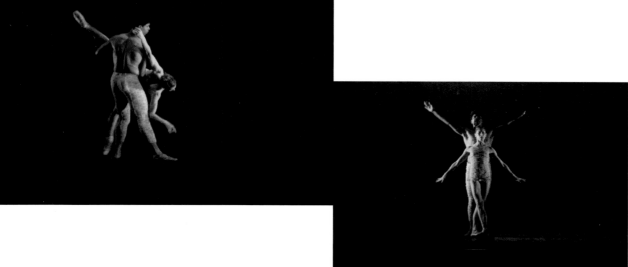

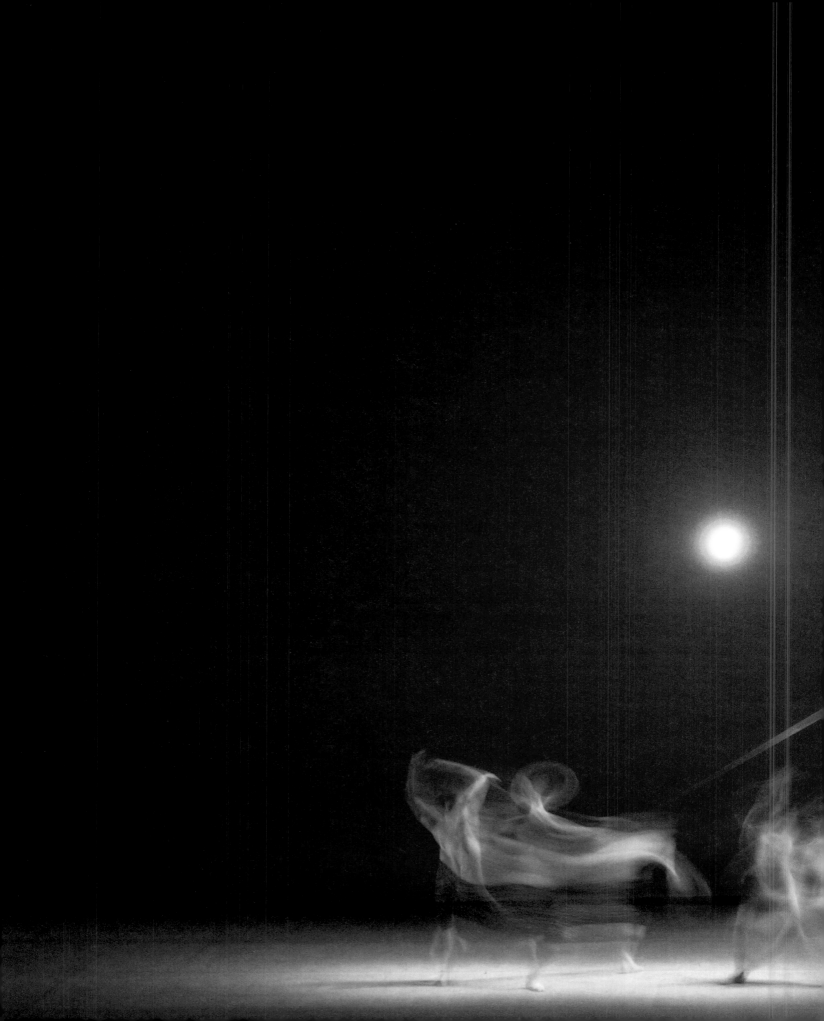

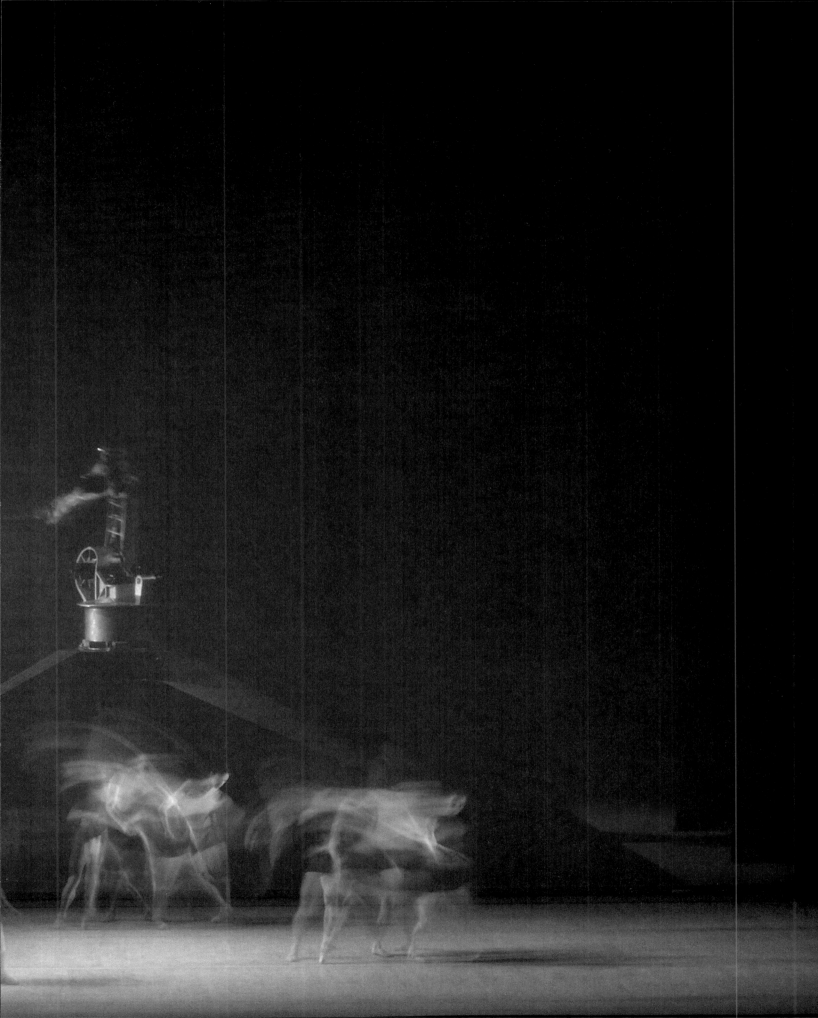

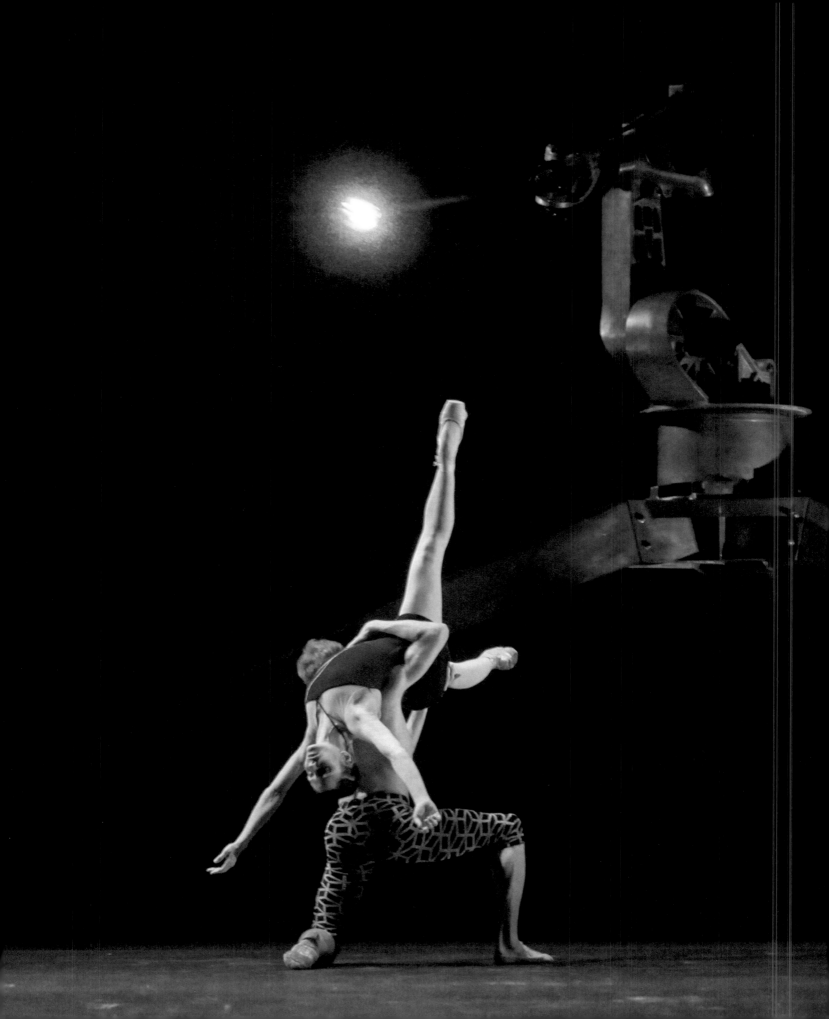

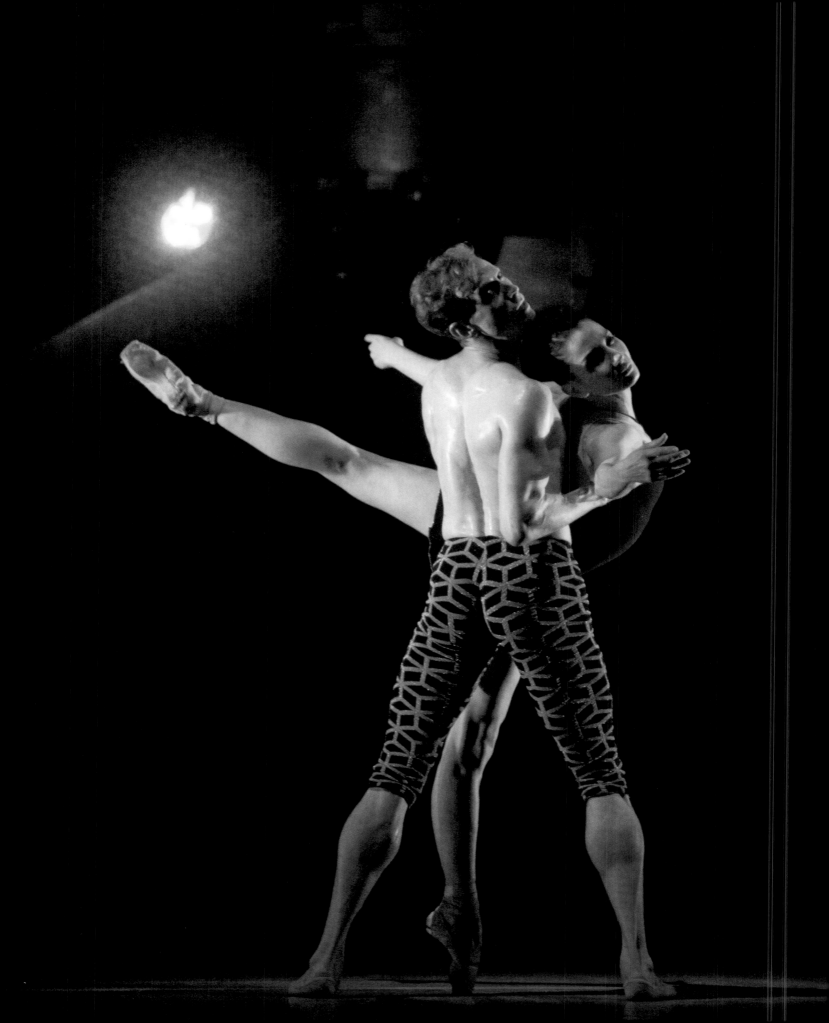

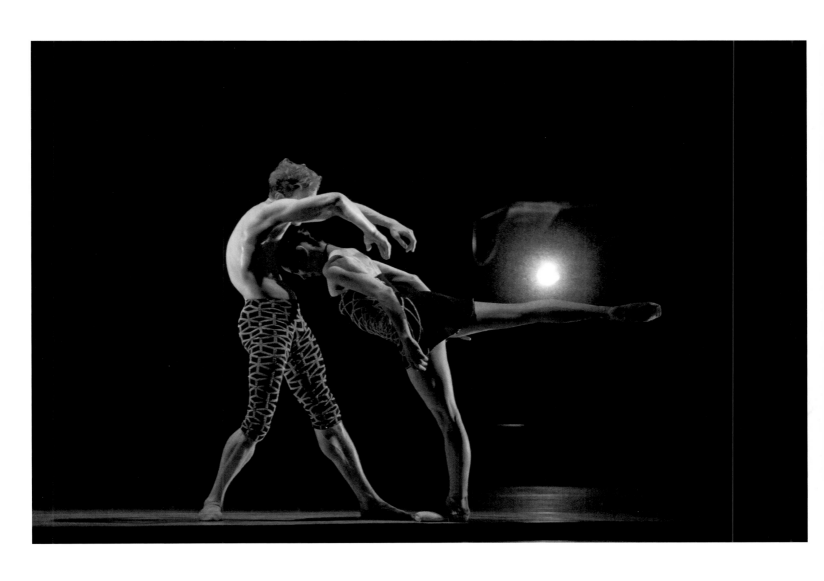

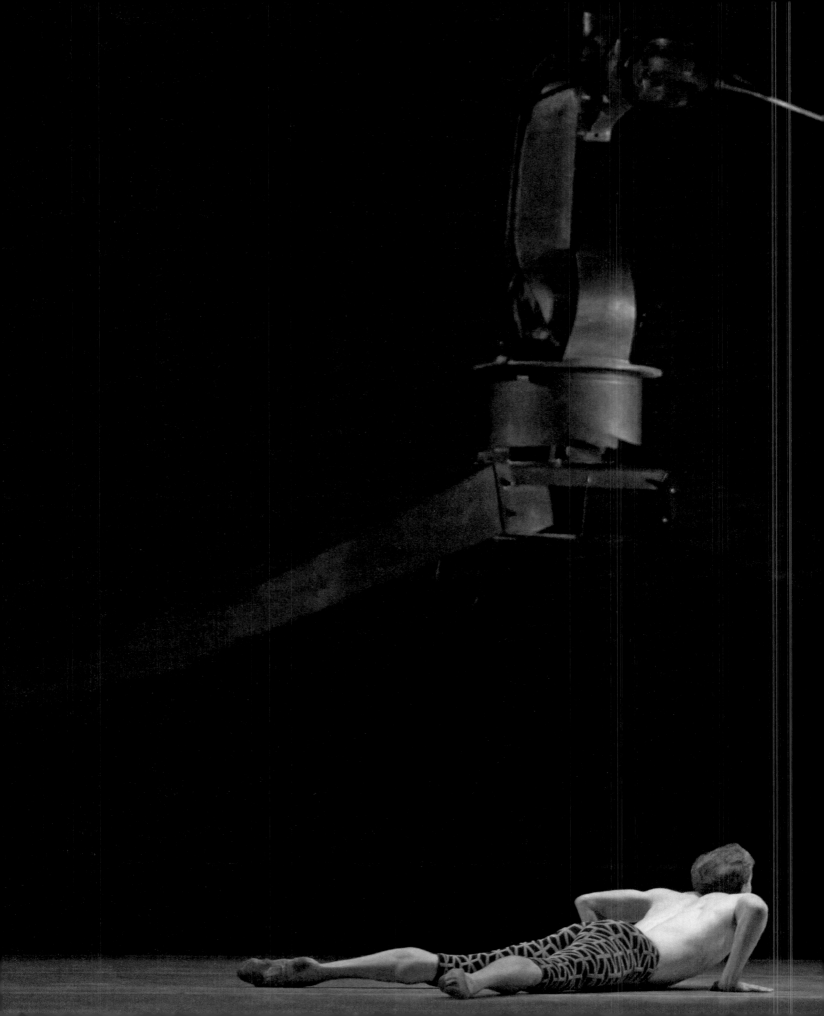

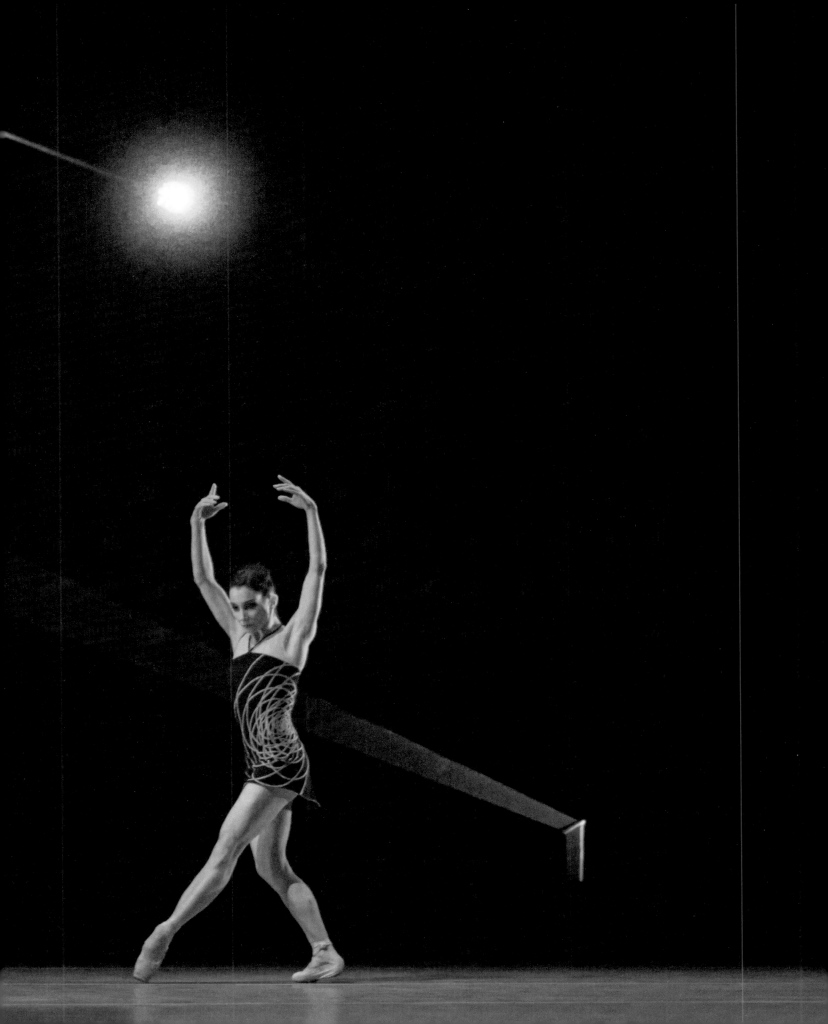

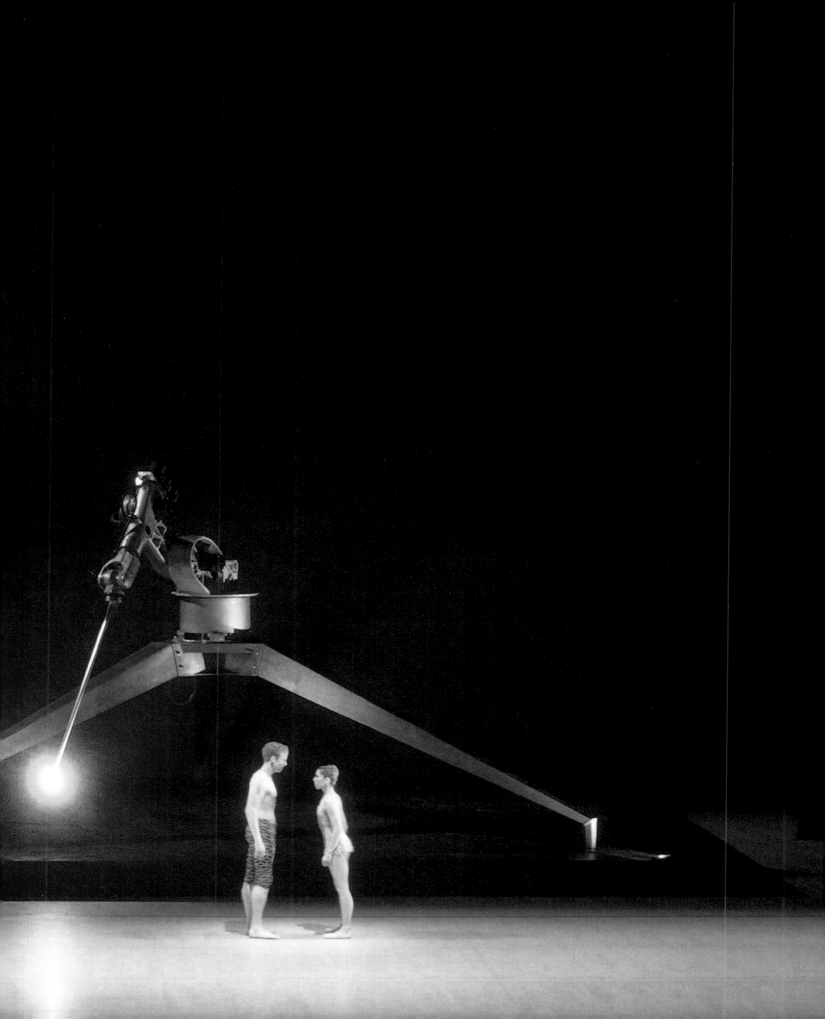

Chris Ofili

Metamorphoses | DIANA AND ACTAEON

Choreographers *Liam Scarlett, Will Tuckett, Jonathan Watkins*
Composer *Jonathan Dove*
Librettist *Alasdair Middleton*

In Conversation
Chris Ofili

Minna Moore Ede *When I was conceiving this project, I knew that we needed a painter as one of the trio of artists because Titian was himself a virtuoso painter who loved his medium. You're an artist who has worked on a large scale and who doesn't shy away from tackling narrative subjects. What was your reaction to being asked to participate?*

Chris Ofili I was quite surprised, because I hadn't had anything to do with dance or theatre before and I'd never really considered working for that kind of world. But then I was also surprised by how close the subject matter was to the concerns of my own work, so I could see the fit, particularly after the recent works I had just exhibited at Tate Britain [January to May 2010]. It seemed like a natural transition from the efforts and concentration of that show. Those works derived from my trying to immerse myself in Trinidad. I felt like I just had to introduce a few more elements into the vein I was already working in. It meant delving into the Ovid text, which was quite liberating for me because I was genuinely afraid of the comparison with Titian. If anything, that's what slowed me down at first – reading the text very closely grounded me. I didn't feel that I could accept that head-on challenge with as genius a painter as Titian. I felt like a lamb being led to the slaughter because I didn't believe that the way that I thought about and approached painting measured up to and compared with Titian.

MME *Did you know those Titian paintings well?*

CO I knew *The Death of Actaeon*, or it was the one I remembered the best, which surprises me because it's the darkest in hue. The other two seem friendlier to me now and easier to access, but at first they seemed so finished and to do with a kind of Renaissance painting I have never been drawn to. Perhaps because it's unfinished and fragmented, but *The Death of Actaeon* seems like the most liberated and the most personal of the paintings. Maybe Titian just thought it was never going to reach King Philip, so to hell with it, just paint it.

MME *One suggestion as to why that painting was never finished or sent to Philip II was because it is so dark, whereas the other two show the sunnier side of love.*

CO And the prettier side as well. All those wonderfully curvy lines that happen to be on all those lovely curvy women. But *The Death of Actaeon* shows what happens if love doesn't go according to plan.

MME *Thinking about your response to Titian for The Royal Ballet, Monica Mason gave your creative team the specific task of making a narrative ballet, didn't she?*

CO She did, but I couldn't imagine approaching the ballet any other way. The text is so rich and I think I was just so involved in the reality,

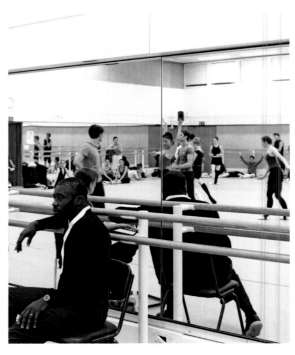

Chris Ofili in the studio during rehearsals for *Diana and Actaeon*

or the unreality, of the story that I didn't want to move away from it or abstract it. I think I'm lucky that Monica suggested that the three choreographers approached it in that way too. We met at a perfect crossroads.

MME *How did you collaborate with your three choreographers, Will Tuckett, Liam Scarlett and Jonathan Watkins, and your composer, Jonathan Dove?*

CO There was a long period of not knowing where to go. This whole project was flooded with imagery – the three Titian paintings and the imagery that comes to mind when you read the Ovid text – and the Titians are considered some of the greatest images that mankind has ever created. At that earliest stage, I didn't feel that I could present yet another image. So I did a lot of reading and a lot of talking to Robert, my classicist friend here in Trinidad, who explained what classical poetry was and how it functioned in its time. People were entranced by listening to these poems being read out loud. And that made it more accessible and something that I could translate into current times and understand on my own terms. I think one of the key points for me was that Ovid didn't invent the narrative himself; it existed already and the text was his interpretation of that narrative. It changes and shifts and mutates in time, and that resonated with the title itself, *Metamorphoses*. So then I felt that I wasn't being excluded from that process and relegated to the position of just pure admiration.

When I met up with Will, Liam and Jonathan for the first time, it really boosted my confidence because they were also really keen to go back to the original Ovid. Right from the start, we got on well and agreed what were the most important elements of the story.

MME *So it was like you were part of an ongoing reinterpretation of the story?*

CO Yes, it was an invitation to interpret an ancient text – and it meant that I wasn't prevented from, to use Mark's title, trespassing in the sacred ground of the classics. What is so incredible is that this centuries-old tale still has meaning today. All of its themes – desire, temptation, pride, beauty, the joy of the kill – continue to be relevant. And so the project got into my veins as a story. I knew that I wanted shape-shifting to run through everything. I wanted all the characters and elements to go through some form of change.

I started to see inspiration all around me in Trinidad, where I live. One day, as I was about to get into my jeep to leave a friend's house, I noticed him looking for something behind a tray leaning against a wall. When he found it, he handed it to me: it was a bullet-like larva, with a surface like carved polished wood, high gloss. And then it occurred to me that Ovid's metamorphoses, which are those of decline from human to animal, usually as a form of punishment, are the opposite of the blossoming of the larva's transformation into a butterfly.

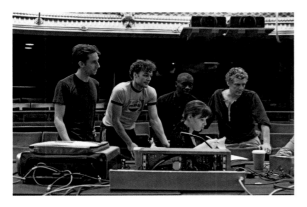

Jonathan Watkins, Liam Scarlett, Chris Ofili, Anna Trevien and Will Tuckett at the stage rehearsals for *Diana and Actaeon*

MME *How did you handle the vast scale of the Royal Opera House stage? The backdrop is sixty by thirty feet, yet you chose to paint it yourself. Most artists working for the stage design their sets but leave the actual painting to professional scene-painters; very few make it by hand.*

CO Before I got to that point, I did lots of drawings: figures, faces, landscapes. Water was a key element because I live on this island and I'm surrounded by water. There are inland waterfalls, beaches and coastline. We have two seasons: the dry season and the rainy season. It's pretty humid, lush and green. Water is part of my everyday existence. I really felt that I could work with the Ovid story being set here in Trinidad. Eventually, I made a small watercolour that I scaled up to the enormous size of the backdrop. It took several days to paint the canvas, which was laid out on the vast floor of the production centre in Purfleet. The scale was the main challenge because I'd never worked anywhere near that size. I began by 'lining in', drawing the outline of all the forms with black paint from the scaled-up version of the sketch. I'm used to working with the wrist, elbow and shoulder, but working on that huge scale involved the whole body. When drawing the outer arc of the crescent moon, for example, I found I'd be drawing a continuous line for thirty seconds to a minute – I never draw one line for that length of time, so that was quite liberating.

MME *Did you know that you wanted to go for a simple, bold composition, something that would work when seen from a distance?*

CO I went to the Royal Opera House and to the Metropolitan Opera in New York time and time again to see large stages with people moving around on them as much as I could. Every time the curtain went up, I got butterflies in my stomach. I tried to familiarize myself with that feeling of the curtain going up and seeing people no more than six foot tall in front of the backdrop. I wanted to see how the audience would look to the set to convey some idea of what was happening, or the way it allowed the audience to project their own fantasies or imagination into this box. I realized also that you do see the lights and the strings, you see the seams, and yet you still buy into the idea of make believe.

MME *I remember Liam Scarlett saying to you that you didn't need to tell the whole story, that the choreographers could help you with that.*

CO We were talking about how to convey the splashing of water, the moment of transformation in the ballet, and how to make Actaeon look like a stag – does he need antlers? When he said that they could do that with choreography, it was liberating. It allowed me to wander back into the forest of suggestion and nuance.

ABOVE *Diana (Study for Diana & Actaeon)*, 2011, charcoal and pastel on paper
OPPOSITE *Diana (Study for Diana & Actaeon)*, 2012, charcoal on paper

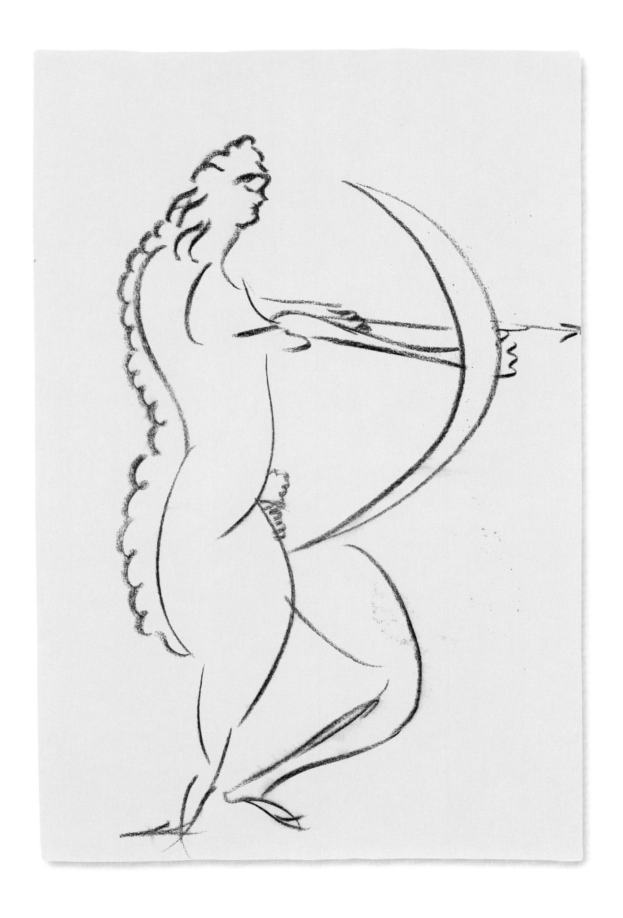

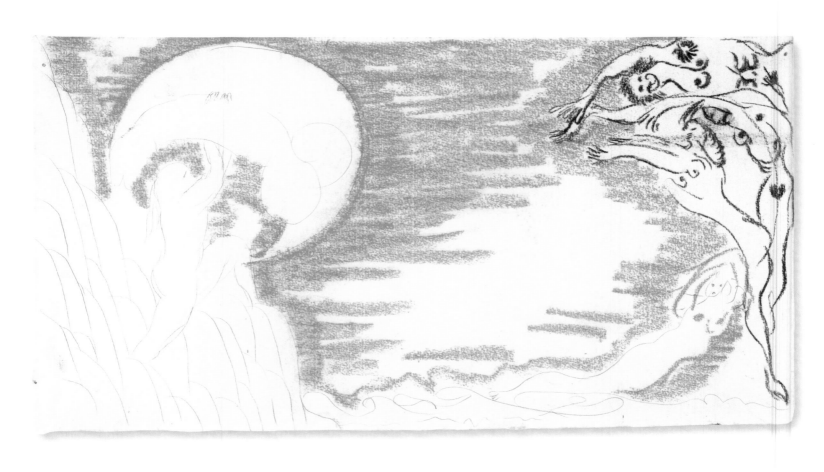

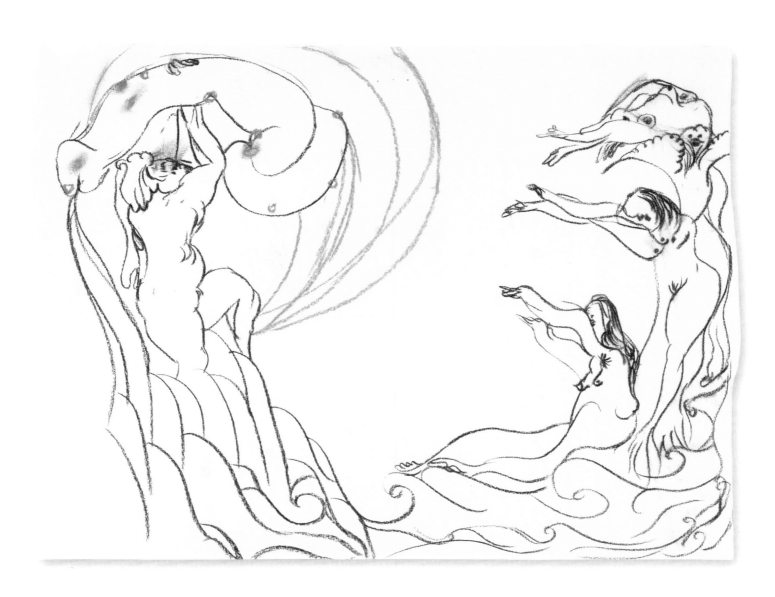

Opposite, top *Backcloth* (*Study for Diana & Actaeon*), 2011, pencil, charcoal and pastel on paper
Opposite, bottom *Backcloth* (*Study for Diana & Actaeon*), 2012, charcoal and pastel and watercolour on paper
Above *Backcloth* (*Study for Diana & Actaeon*), 2012, charcoal and pastel on paper

My interpretation of the entire story is told in the backdrop. We have water flowing from the burden of male desire, the phallus, which is held up triumphantly by a Diana figure and cuddled by the orange crescent moon. The nymphs are born from that water. They're not purely human; one of them has wings. All of them are gesturing towards the phallus, which I call the Big Dipper and forms a constellation of stars. That's a reference to Callisto, who in Ovid is transformed into The Great Bear. Then the other elements on the right are Gargaphie, Diana and the nymphs' lair, and the rest is forest. The figures, the landscape and the symbolism all metamorphose fluidly into each other – like they do in William Blake's imagery, which I love.

MME *The ballet has four main parts, doesn't it? The first takes place in the forest and includes Diana's appearance, Actaeon's arrival and the hunt. There are several layers of vines and trees, which have large 'female' roots whose forms reflect the movement of the dancers. The second part – Actaeon's discovery of the bathing Diana and her splashing him with water to start his transformation – occurs in Gargaphie. In the third, we see Actaeon changing into a stag and being attacked by his hounds. This takes place back in the forest, Diana's lair having been transformed from a place of a comfort into a battleground. And finally, we witness the lament for the dead Actaeon against the backdrop. The opening forest setting is the most complete, so that when the audience first sees it, it contains everything: all the vines, trees, flowers, everything. The Gargaphie set-up is hidden within it, and the progression is one of reveal / conceal, where trees are moved to show Gargaphie, and then come back for the second group of forest scenes, and finally everything flies off stage, and at the very end you're left with just the backcloth and the dancers in the black space.*

CO Initially, the design was going to be just the backdrop and a very clear stage so that the dancers would have lots of space to move around. We didn't have any choreography at that point so we didn't know how much space they would need. But when we saw the clear stage, it was obvious it was a bit bare, a bit barren, and it wasn't the setting in Ovid's text, so I added a lot more vegetation, mangrove-like trees. I thought of Actaeon journeying through the forest, hearing the sounds of the bathing women, and seeing the trees transformed into feminine form, hints from a distance of what was about to greet him. Gargaphie is signified by flowers, so it's quite a youthful, fertile area. In the Titian painting, it's more ominous … there are skulls, and things to warn you away. Mine has tropical orchids dangling down and is as I imagine somewhere women would like to bathe. And here I added the orange crescent moon based on a song by Erykah Badu, relating to Diana's costume, and a purple tree that relates to the purple of Actaeon. The purple tree is actually a flower, but I see it as a tree because of its scale. It links to Actaeon and grounds him … he's a lot more connected with the earth than the goddess Diana.

Chris Ofili 'lining in' the design of the backdrop for *Diana and Actaeon* at the Royal Opera House's production facility at Purfleet, Essex

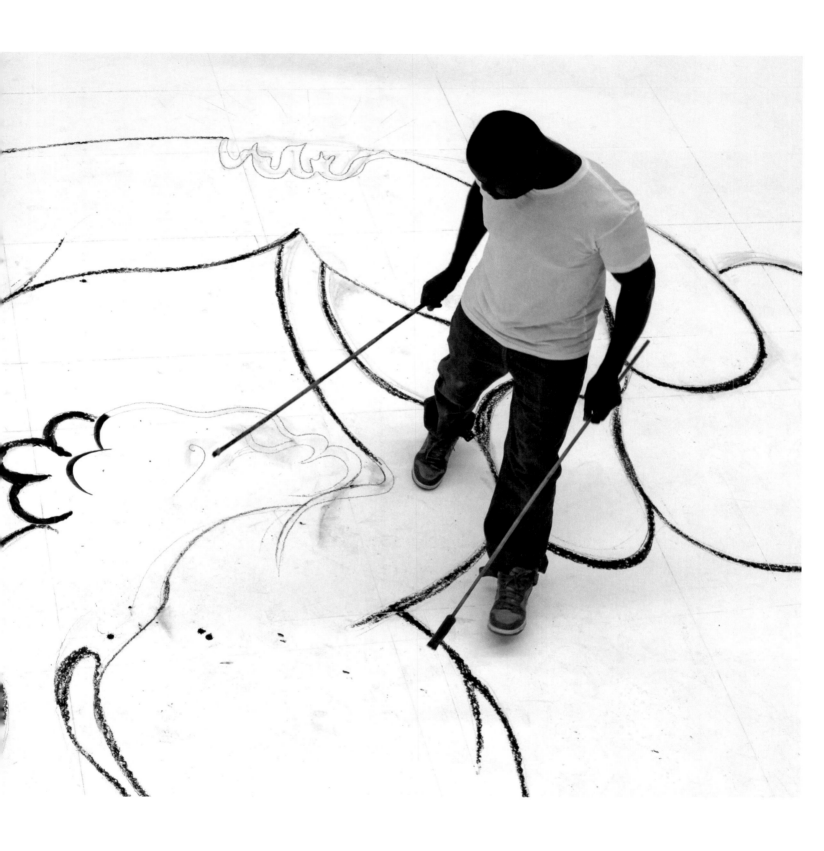

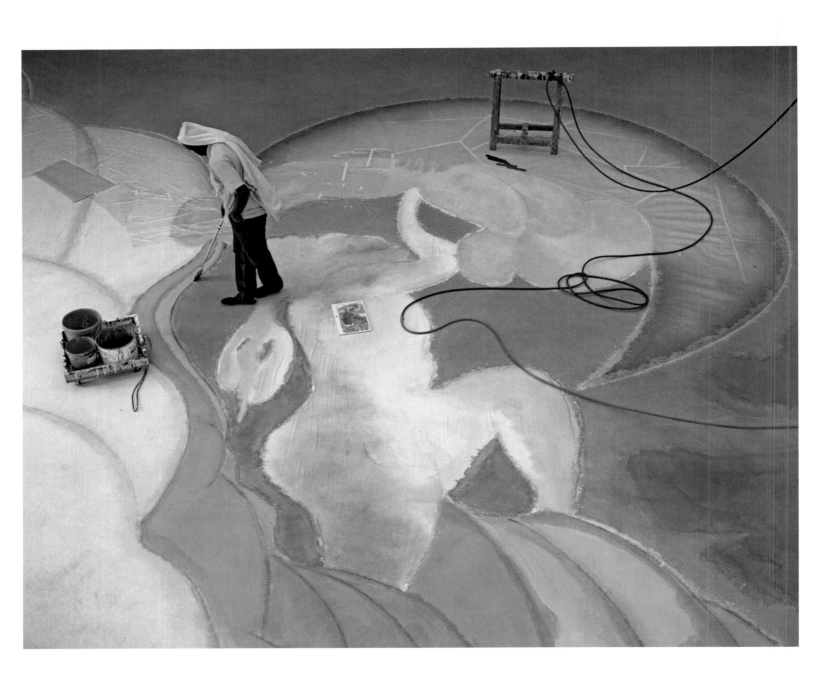

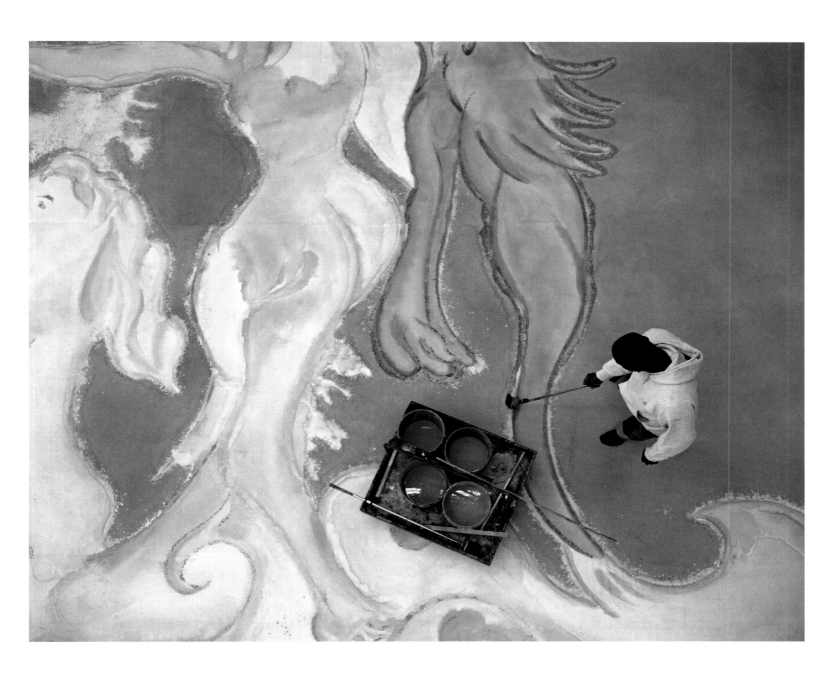

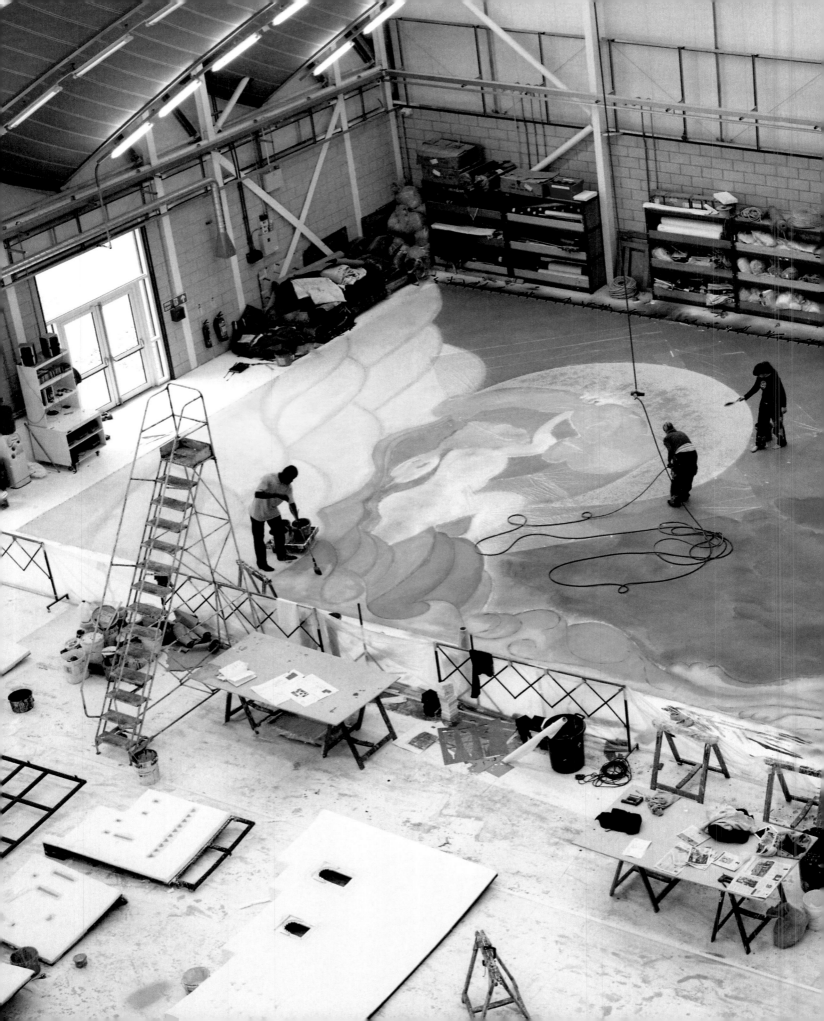

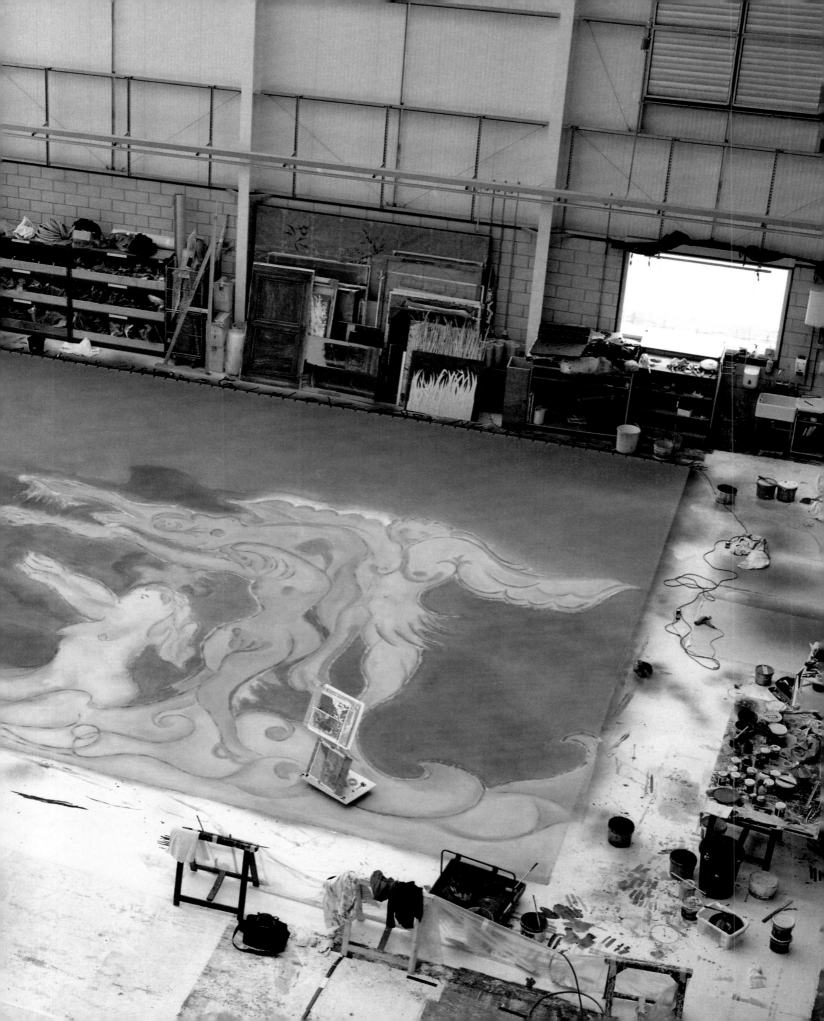

The layers of trees and vines also created a sense of depth, as well as this progression of concealment and revealing. It meant the audience had a relationship with the backdrop throughout. You know it's there and you're looking at it the whole time. But even if you see it fully only for a few moments at the end, the full reveal, you have this memory of all the sections that you've seen beforehand.

MME *How did you approach the designing of costumes?*

CO I used the same palette for the stage set and the costumes. In some parts, the costumes are more vivid in colour than the set, more concentrated, less watery. The orange of Diana's costume is much stronger than the moon, for example. Well, you don't want to lose the dancers! My first instinct was to take inspiration from Picasso and his 'crazy' sculptural creations for the cubist ballet *Parade* for the Ballets Russes [1917]. But the more time I spent around the dancers, the more I wanted them to feel comfortable, so they could push themselves. I thought about putting masks on the backs of the dancers' heads, which was an idea inspired by traditional New Guinean hunters. In the end, I went for all-in-one leotard and tights, customized for each character with head-dresses, jackets, body hair, and hand-held puppet heads for the hounds. Marianela Nuñez, who plays Diana, begins the ballet with a long flowing, watery cloak, which she discards to reveal her bright orange costume beneath. And I wanted Federico Bonelli, who played Actaeon, to have a costume that could be ripped away during the hound attack to reveal his wounded body. The costume department of the Royal Opera House was able to bring my drawings to life so well with their expertise. Working with such skilled individuals made the process so much easier: the dancers, choreographers, the costume department, set department, props, hair, make-up, everybody. One of the things I loved was to draw and paint directly on to the dancers' costumes. I really wanted to repeat the watercolour effect of the backdrop on the nymphs, and painting directly onto them was really the only way to achieve that.

MME *And for your group of paintings for the National Gallery, did you find that Titian breathed new energy into your work?*

CO It was like we were occupying the same territory, but he annoyed me at times. Ovid is specific about describing Gargaphie as devoid of all artifice, and yet Titian has a man-made arch or column in *Diana and Actaeon*. I thought that if he could do that, I can do what I want. Both of us approached the text in the same way. I just chose to come in through a different door.

MME *What I loved about* Ovid-Windfall (see page 15), *was how you fused Ovid's idea of a magical world of shape-shifting with the landscape of Trinidad. This figure with the dreadlocks who sits with his cauldron, out of which bodies and flames emerge, would seem to me very evocative*

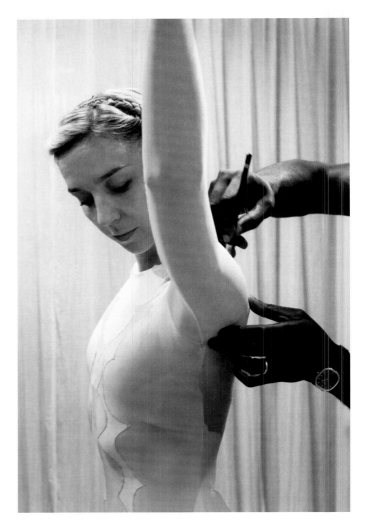

Chris Ofili drawing designs on a nymph's costume

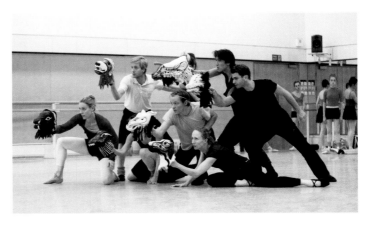

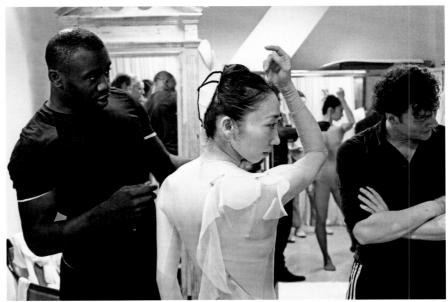

CLOCKWISE FROM TOP *Hound* (*Study for Diana & Actaeon*), 2012, charcoal on paper; the hounds in rehearsal; Chris Ofili and Liam Scarlett working on a nymph's costume; *Nymph* (*Study for Diana & Actaeon*), 2011, charcoal on paper; *Hound* (*Study for Diana & Actaeon*), 2012, ink and photo collage on paper

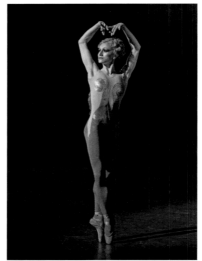

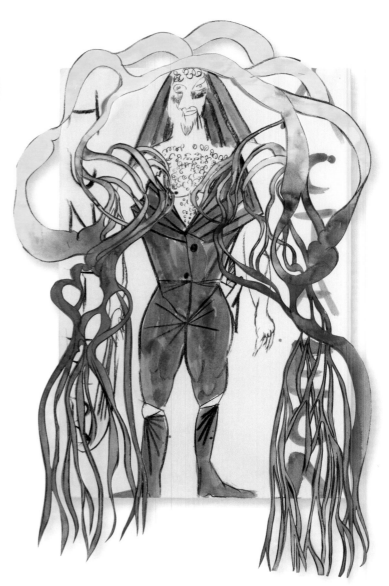

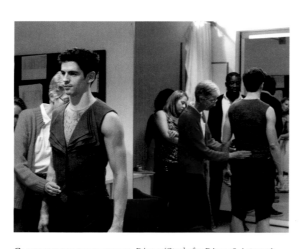

CLOCKWISE FROM TOP LEFT *Diana (Study for Diana & Actaeon)*, 2012, watercolour and charcoal on cut paper; Marianela Nuñez wearing the Diana costume; *Actaeon (Study for Diana & Actaeon)*, 2012, watercolour and charcoal on cut paper; Federico Bonelli being fitted for the Actaeon costume

of the landscape of Trinidad, an island which – am I right? – still retains an interest in these mysterious, magic men. And the deep blue / purple colour of the painting conjures up, to me, the blackness of night-time, when anything can happen and the spirits are at work …

CO I think I started with this character. I had worked with him before in another work called *The Healer*. I did some preparatory sketches and there's one in particular that had figures above the cauldron, which relates more to the story of Callisto being chosen from the group by Jupiter for being particularly beautiful. *Ovid-Windfall* was a lot more colourful at first, but the palette changed and it became more mysterious. Strange things happened with the paint itself as well as it aged in the pots I use. Its consistency changed and it got a kind of silvery-violet colour.

MME Ovid-Destiny *and* Ovid-Desire *(see pages 150–1) were two of my favourite paintings. I loved the window device, through which you can see a glimpse of the stage set.*

CO It was a very conscious decision to do that. I see the story as being this kind of tussle of love between a man and a woman, in a very general sense, so I thought of having a dancing couple. In those two paintings, they're both dancing, embracing, and a window or a painting on the wall hints that something is happening outside the room. In *Ovid-Desire*, it shows Gargaphie with the nymphs reaching up to the flowers or reaching at the crescent moon. They were tricky poses to draw from my imagination, so I got some life models to play with a very light beach ball. They almost had to hover to try and catch it, so I got some very beautiful freeze-frame photos, and I made drawings at the same time of them jumping and reaching up.

Marianela Nuñez being made up as Diana

MME *And was that because by this point you had been working at The Royal Ballet, had been watching the dancers in rehearsal and were affected by the movement and you wanted to capture some sense of it?*

CO That's right. They have really extraordinary bodies. I thought that I was quite in touch with the lines and shapes of the female form, but I was quite surprised to see that dancers' bodies are sculpted in a very, very particular way. They generally have quite slight upper bodies and much stronger legs and lower bodies.

MME *How about* Ovid-Bather *(see page 147)? It is was one of the first paintings you made, wasn't it? It has a different feel from the rest of the group in my opinion and I think that that is because you started it before you found your vocabulary, your 'Ovid-Titian' vocabulary.*

CO Yes, *Ovid-Bather* was pretty much the first painting I started. You're quite right that it's painted very differently, a lot slower – you're probably

the only one who's said that. And you're right about vocabulary too. That painting is a lot more about searching. The mindset was completely different. I wasn't working on the ballet at that point. It just didn't even exist in my mind yet. Instead, I was thinking about Courbet's painting of a bather in the Musée d'Orsay, *The Source*.

MME *Reflecting on the project now, three months later, do you think you would tackle this kind of project again?*

CO Definitely. But there's a benefit in not knowing what you're doing or not knowing where it's going. There are very few projects that one gets offered in one's life that are all engrossing, that involve a lot of people, so many elements, two years of time and you still don't know what you're going to end up with. All you know is that the journey will involve lots of twists and turns and uphills and downhills and sprints and complete standstills. And that's an accepted way of working: the unknown is truly unknown. The only certainty is that it's going to be presented to an audience. So I wouldn't substitute or change the process in favour of knowing more. Even if the result were better, I think the journey itself was so challenging and rewarding, mysterious and interesting. I've learnt things that I don't yet know or I'll become aware of only with time.

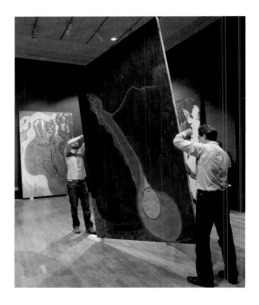

Top and above Installing the *Metamorphoses* paintings at the National Gallery
Opposite Chris Ofili, *Ovid-Bather*, 2010–12, oil and charcoal on linen

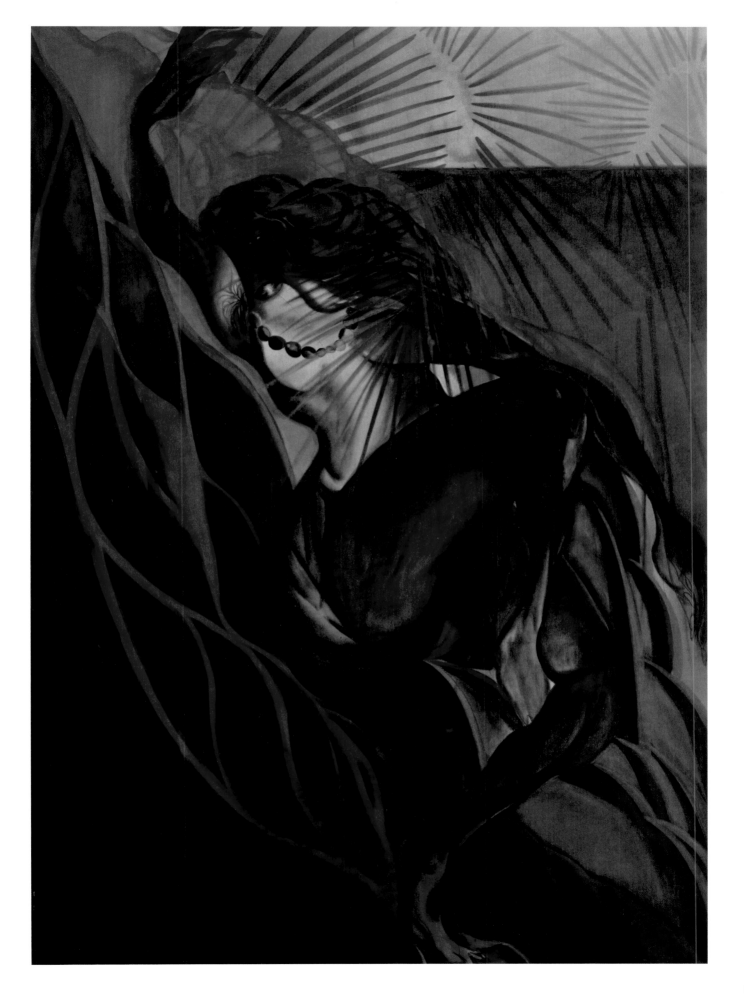

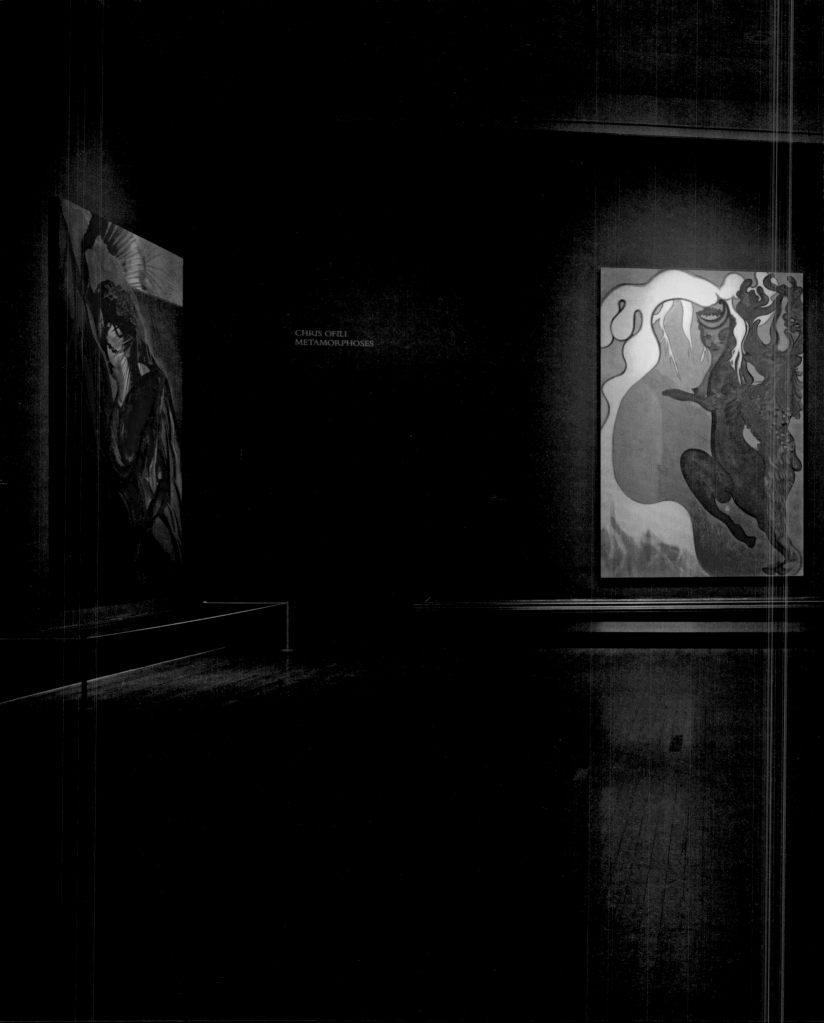

CHRIS OFILI
METAMORPHOSES

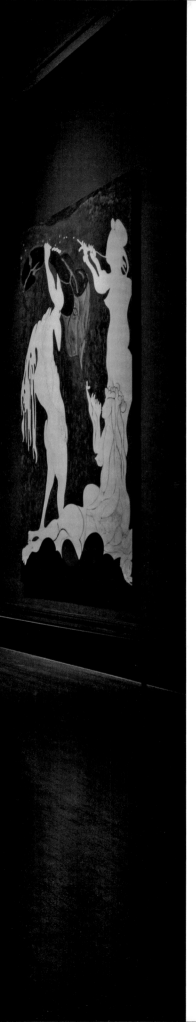

LEFT Installation view of *Metamorphoses*, showing from left
to right: *Ovid-Bather*; *Ovid-Stag*, 2012; and *Ovid-Actaeon*, 2011–12
OVERLEAF Installation view of *Metamorphoses*, showing from left
to right: *Ovid-Destiny*, 2011–12; and *Ovid-Desire*, 2011–12

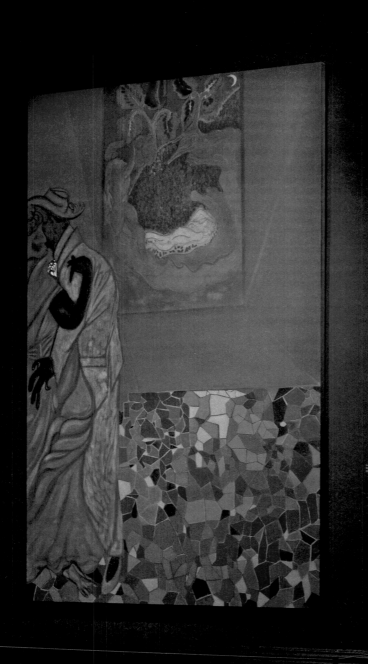

Working with the vibrancy and energy of Chris Ofili inspired me on so many levels. It took me in alternative directions, and the parameters of the project led to a refreshing approach to collaboration. Such details as the way Diana's cloak informed the language of her movement, or the Trinidadian inspiration for members of Actaeon's Hunt, all brought an exciting dynamic to the development of the piece. Joining with Chris reaffirmed to me that a positive process does not detract from making a serious work with genuine depth.
Jonathan Watkins

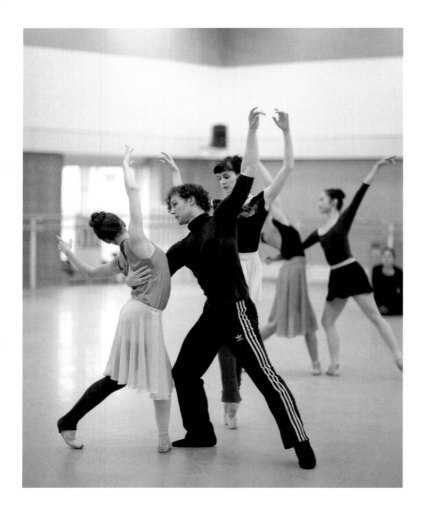

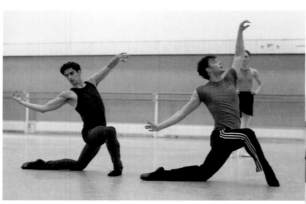

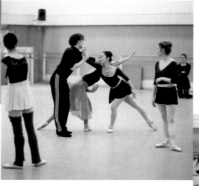

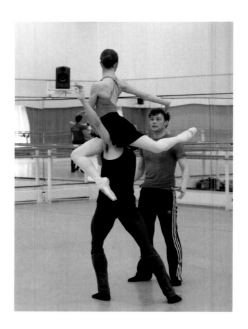

When I saw Titian's *Diana and Actaeon*, I was impressed with the curvaceousness of the women. The painting has a very structured form, but the content is very alluring. Choreographically, I like moving big groups of people around and I jumped at the opportunity to work with a corps de ballet of girls, which I wouldn't normally get the chance to do. I wanted to show them off a bit more than they're used to, not just have them stand at the side but to actually get them moving and portray this sensuality that's derived from the painting.

Liam Scarlett

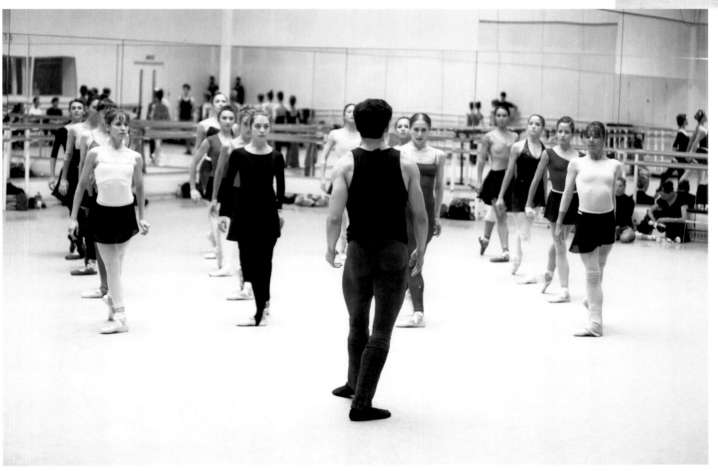

It's been a real gift to work on something that allows you to look at paintings in a way you would never have otherwise done. One of the things that fascinated me in the painting *Diana and Actaeon* is when they first see each other. I'm really interested in the gaze and the way that different perceptions of it have occurred through history. This led to the prismatic middle of the piece where there are three different duets, all of which are different takes on how they feel when they first meet. And looking at *The Death of Actaeon*, I loved the idea of the hounds. In the Ovid tale, they all have names and individual characters. In contrast to the technical duets that form the centre of our piece, I've used a quite different language for the hounds.
Will Tuckett

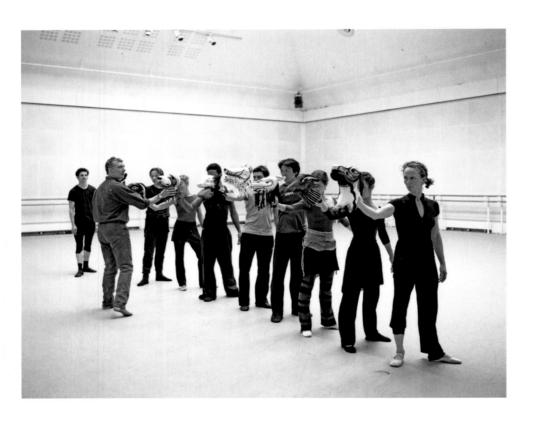

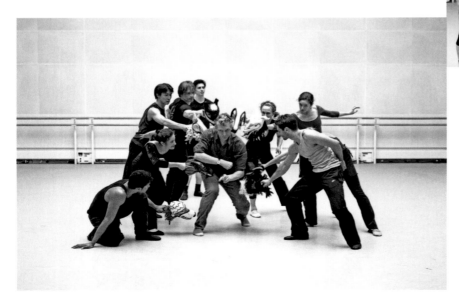

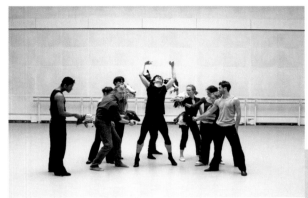

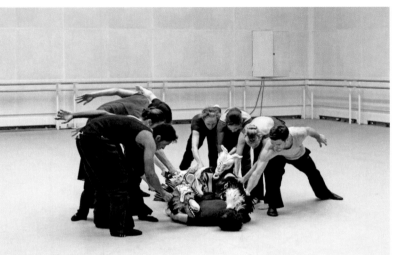

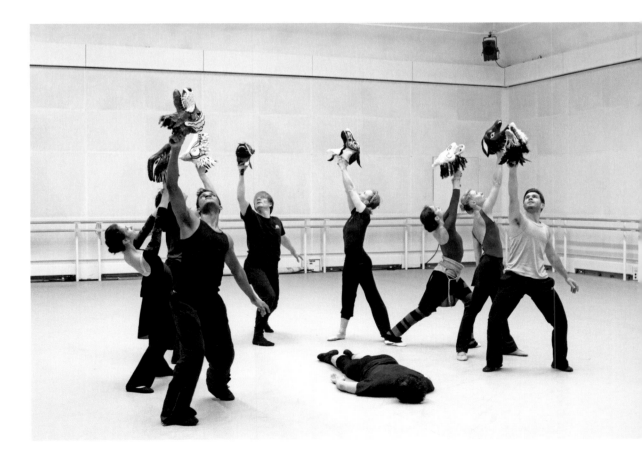

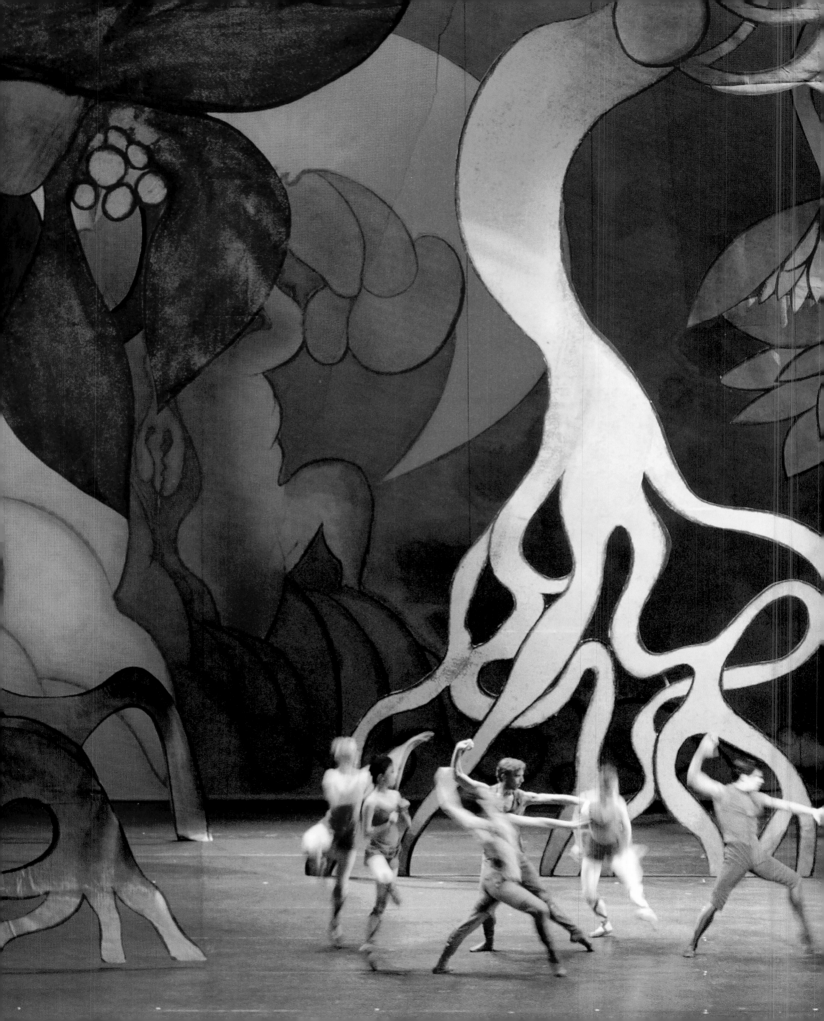

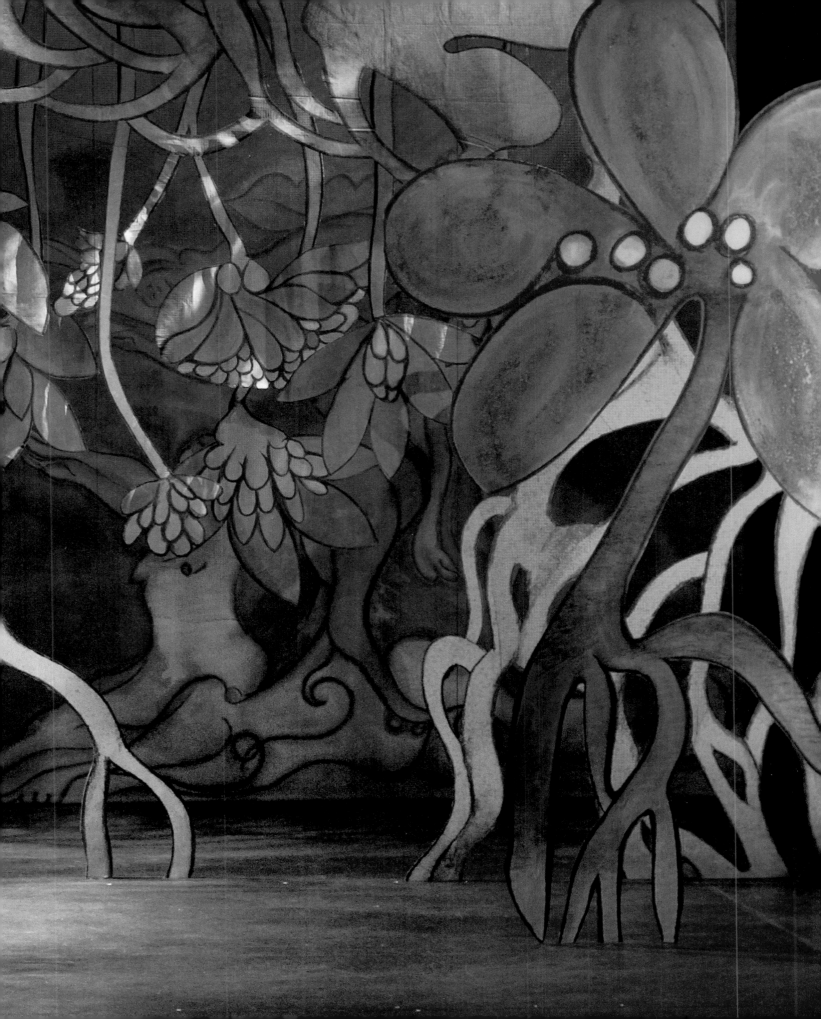

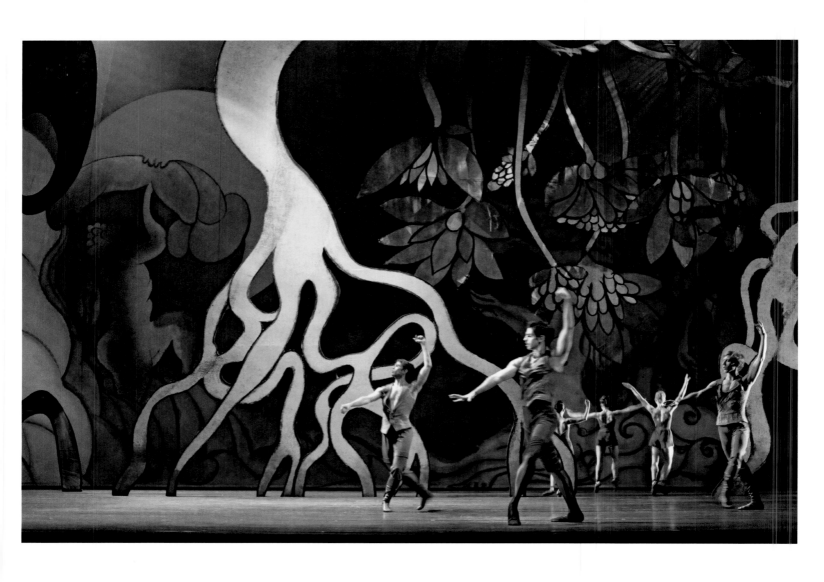

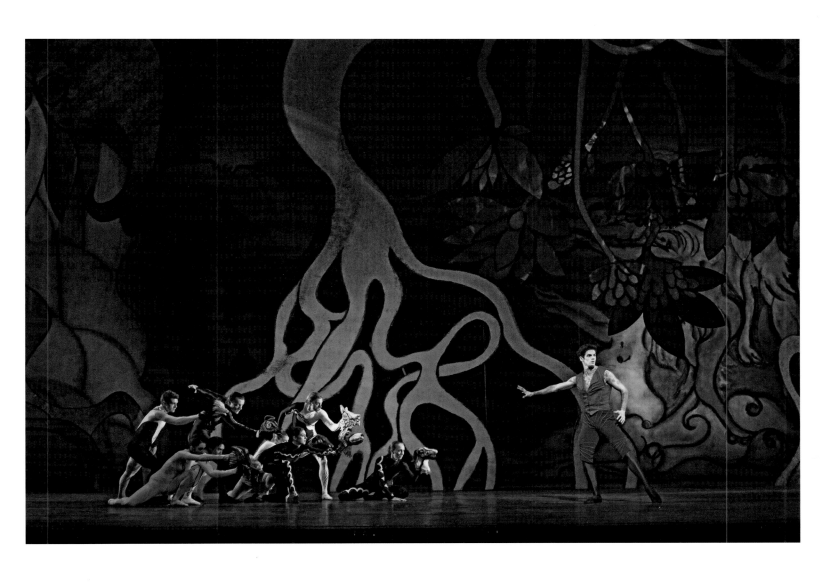

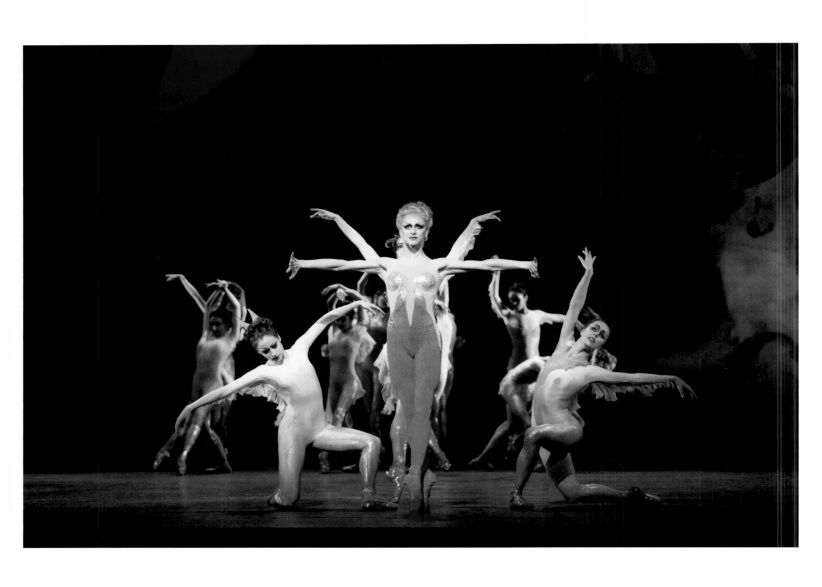

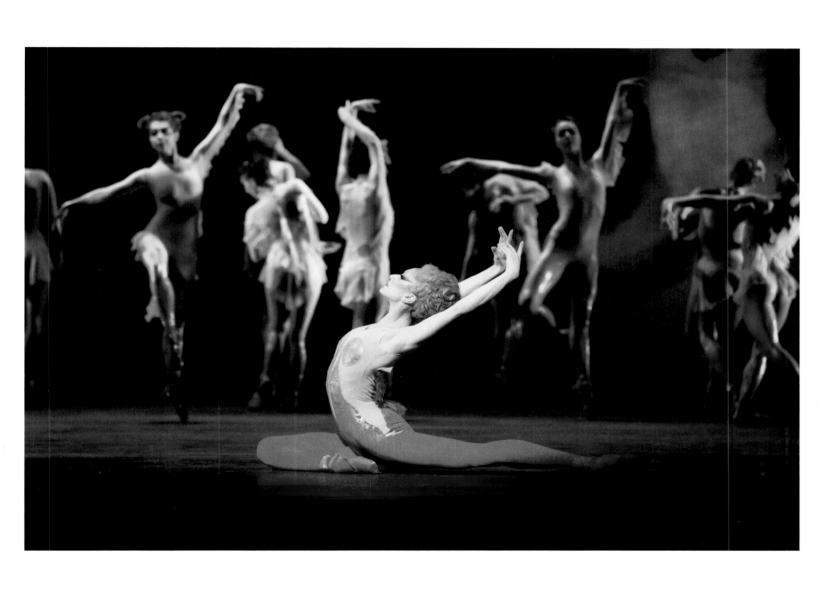

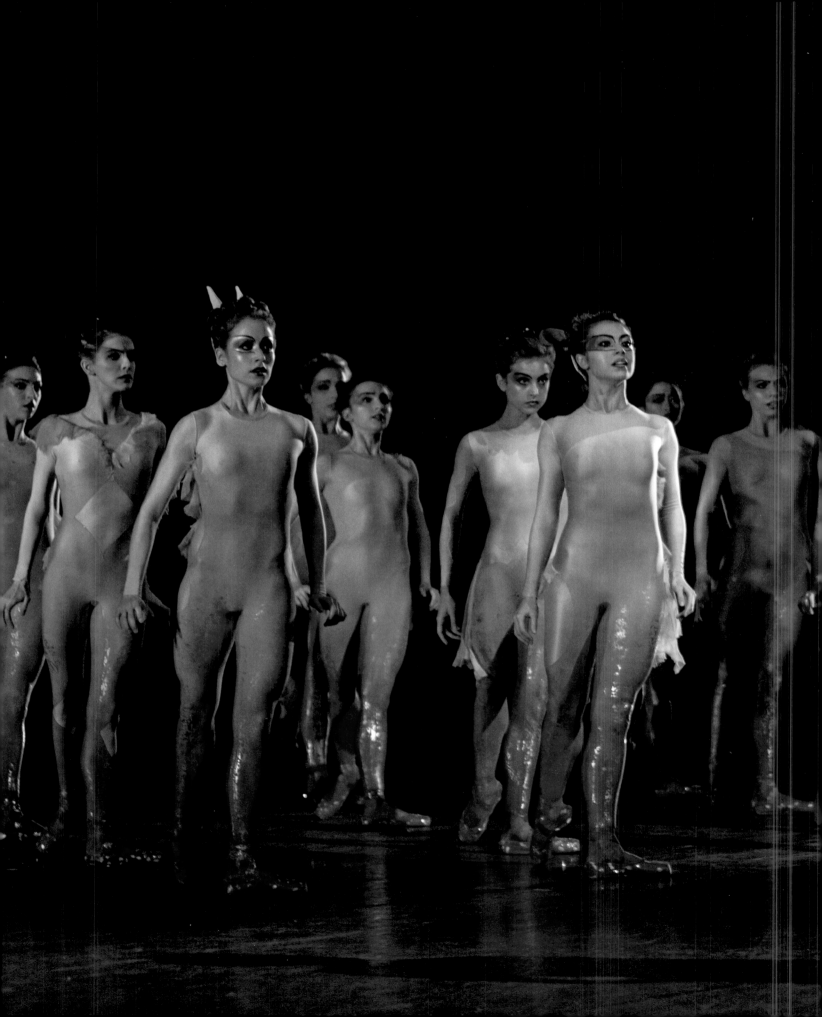

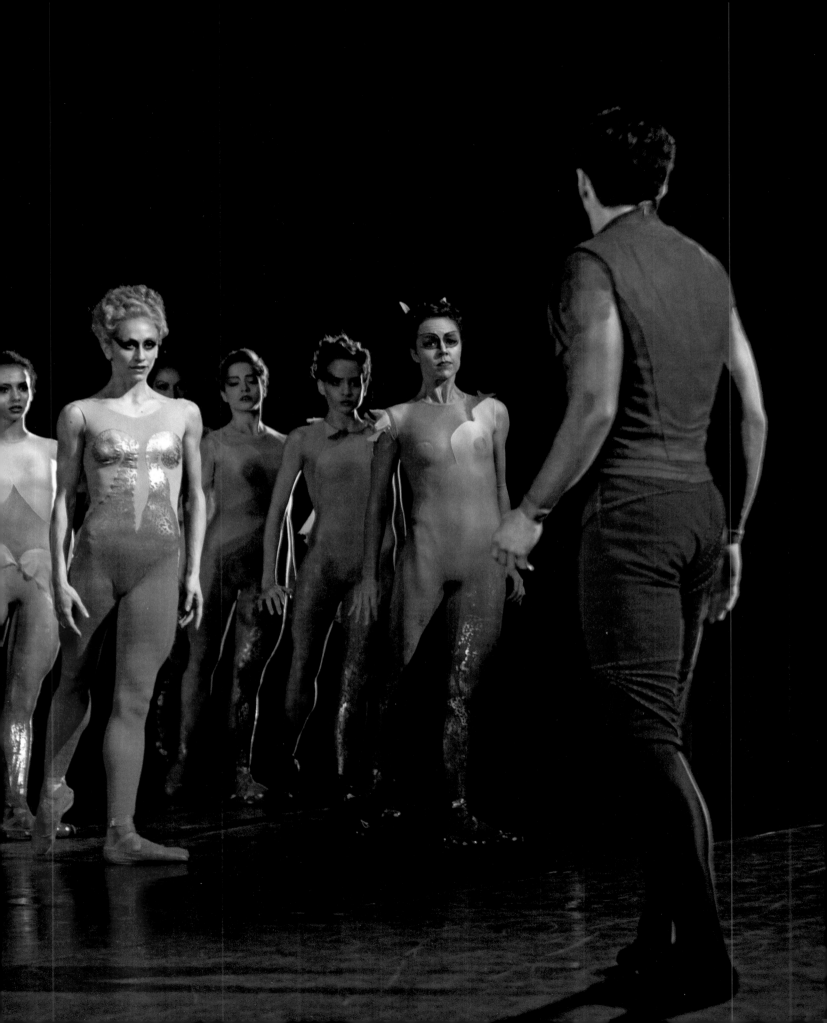

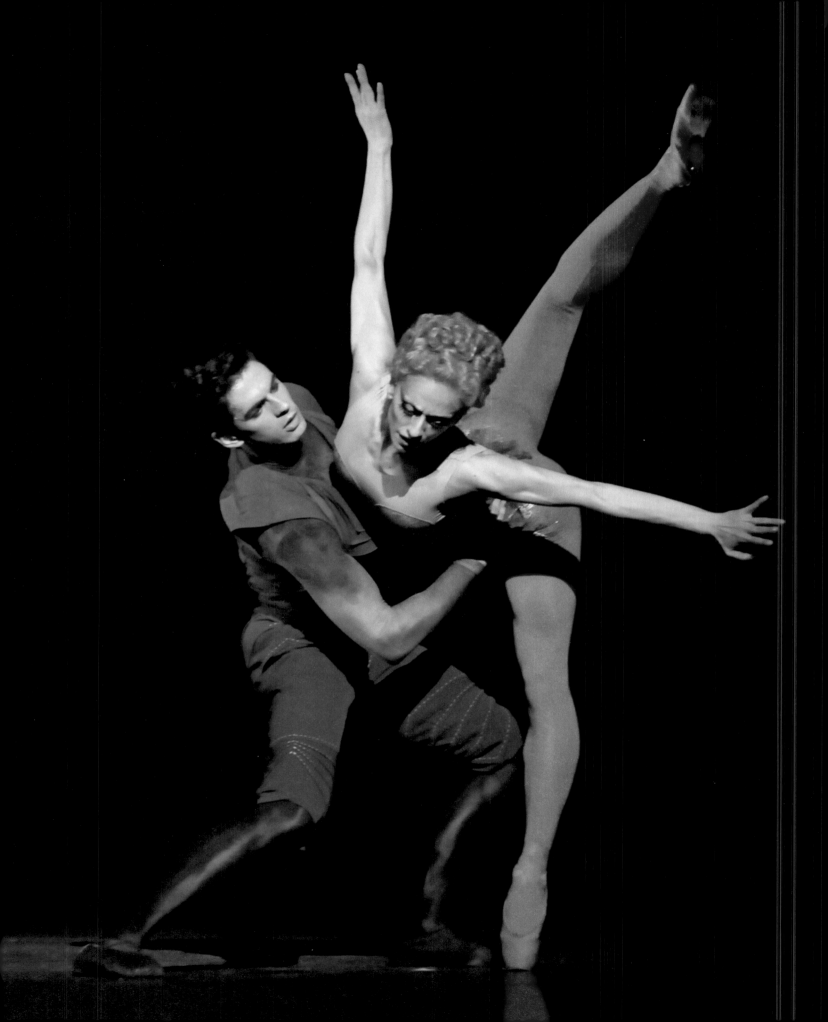

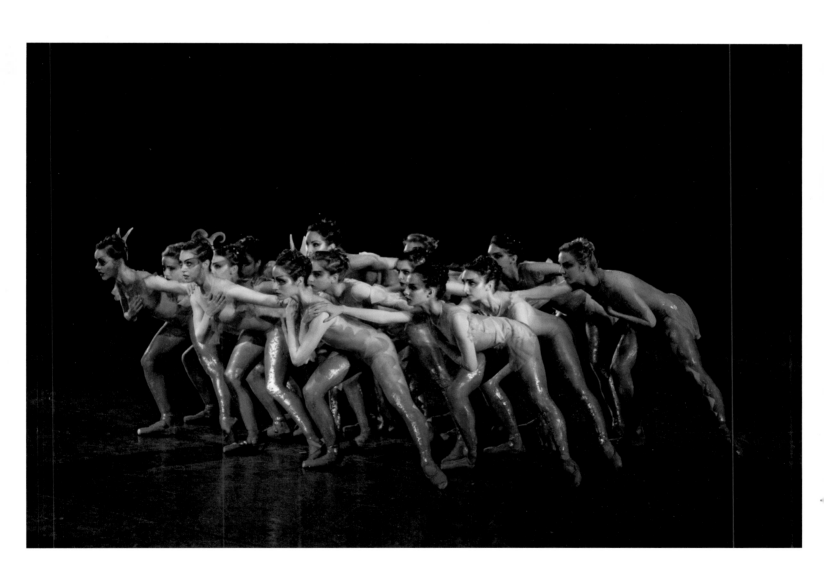

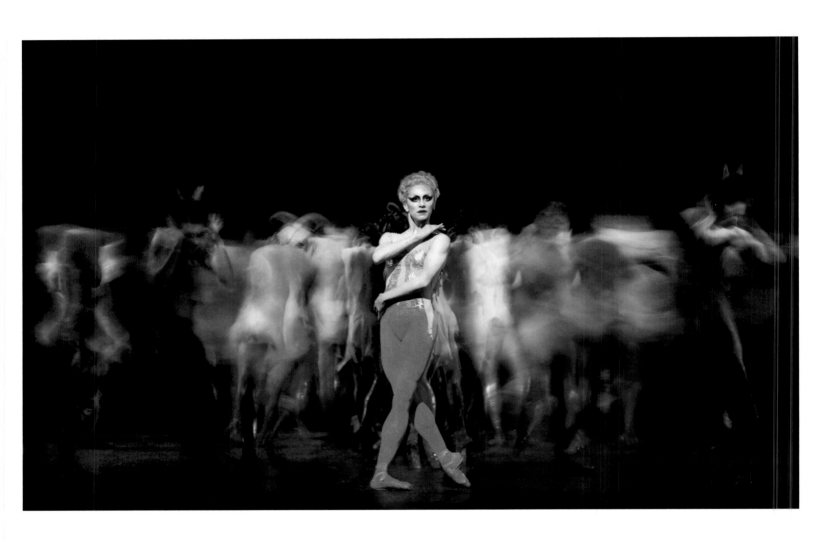

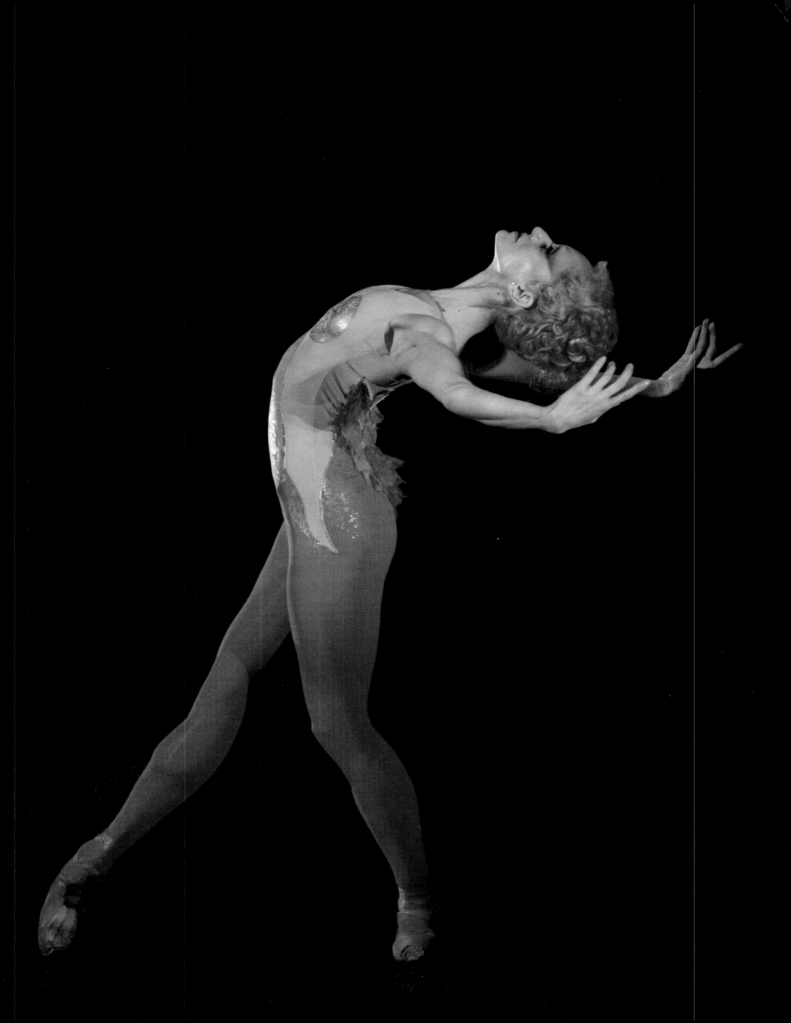

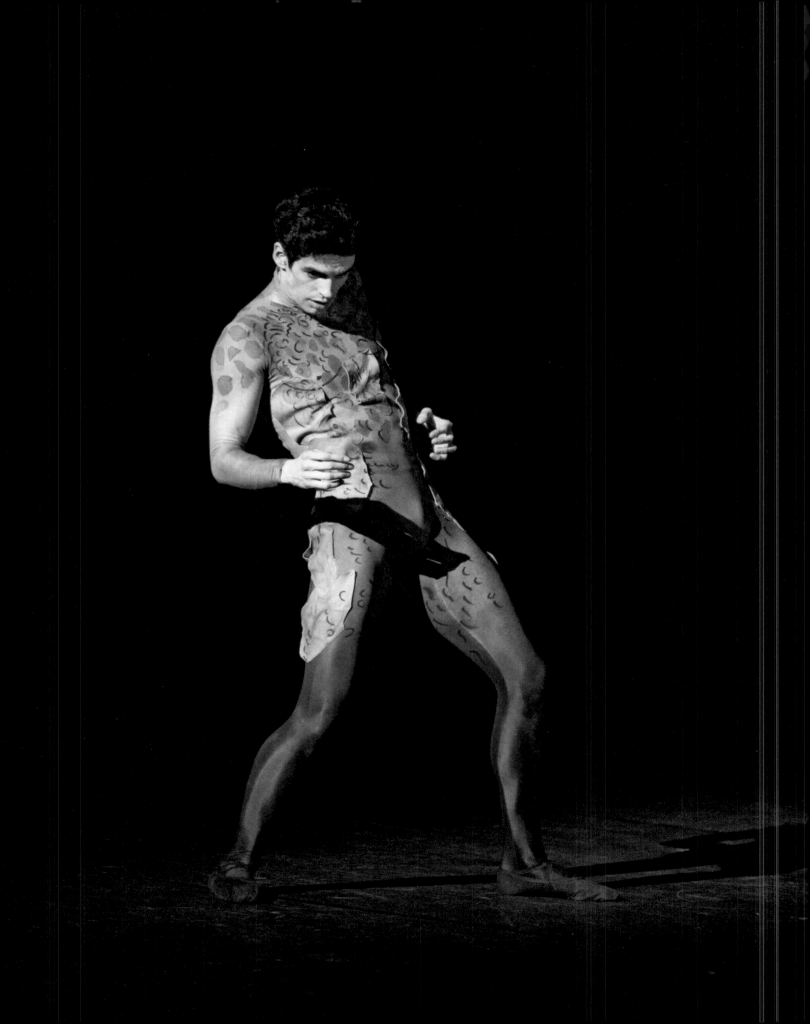

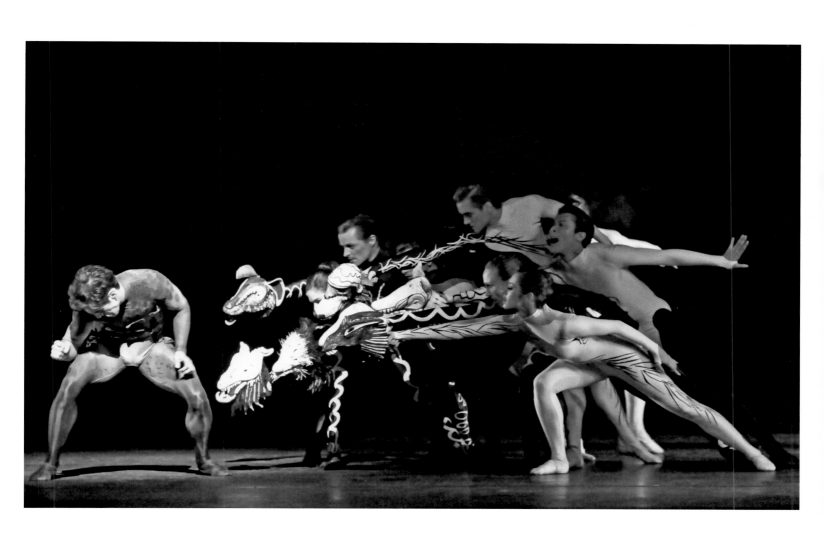

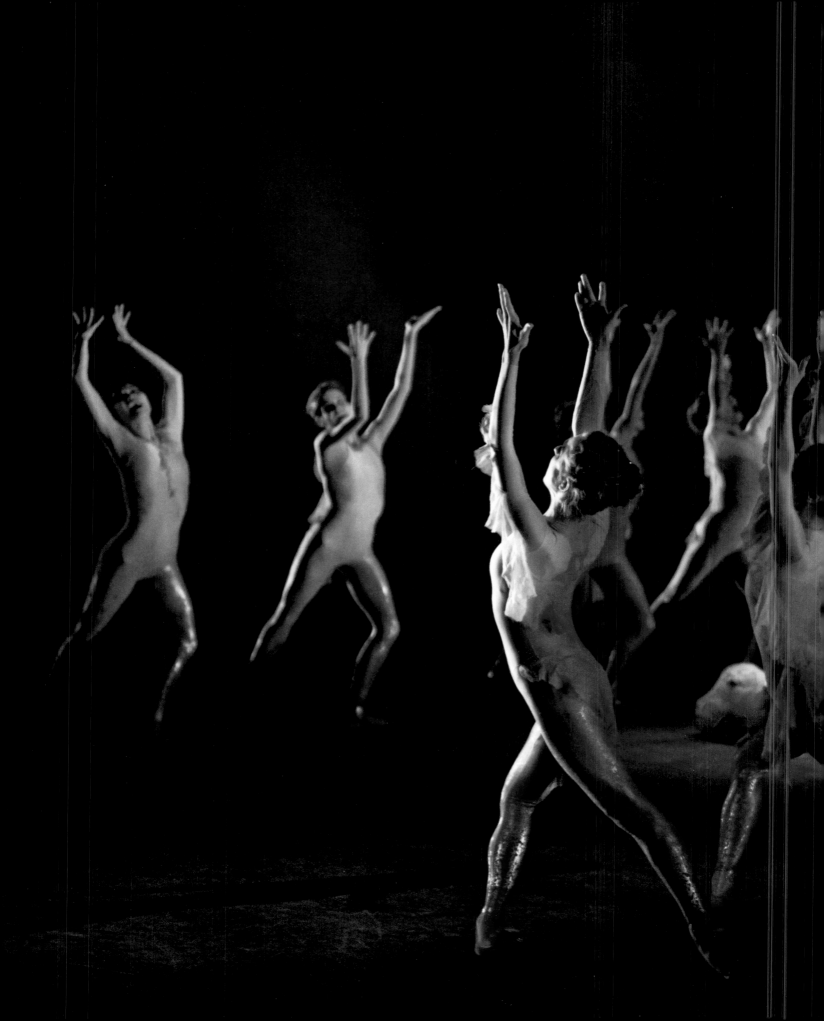

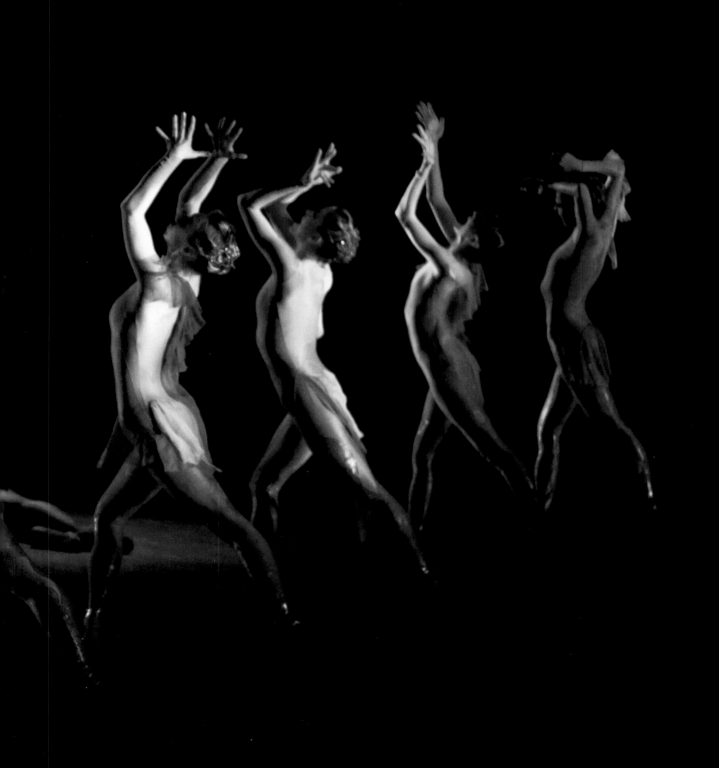

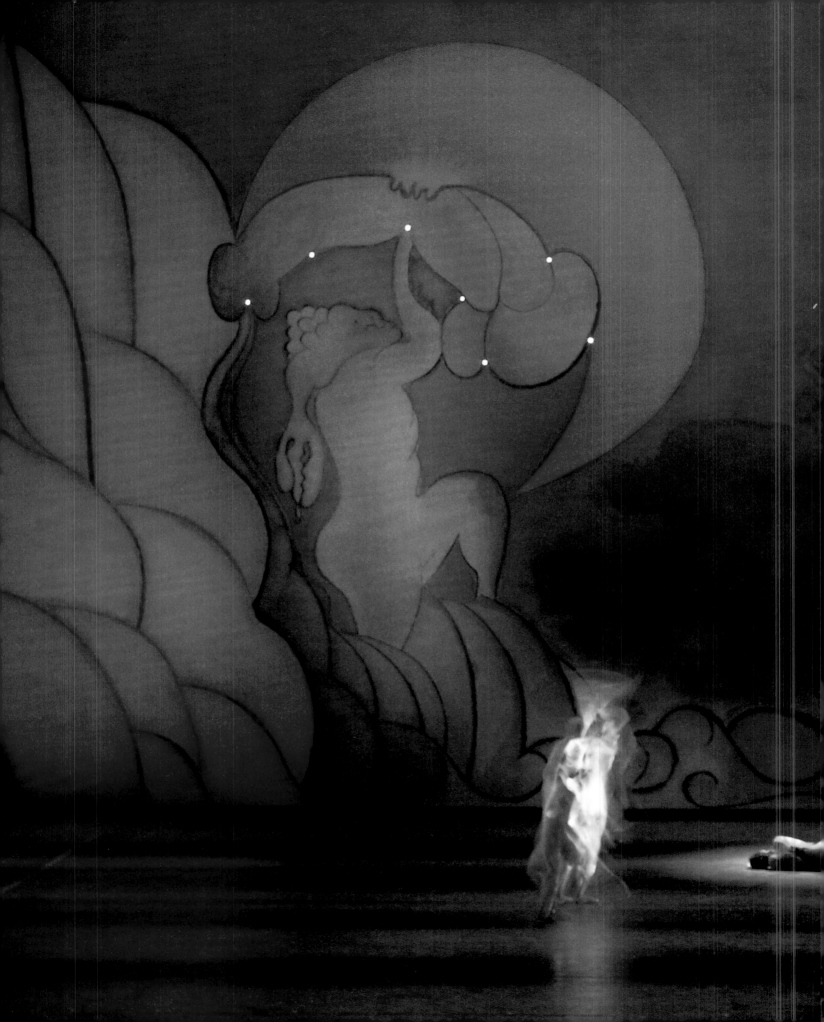

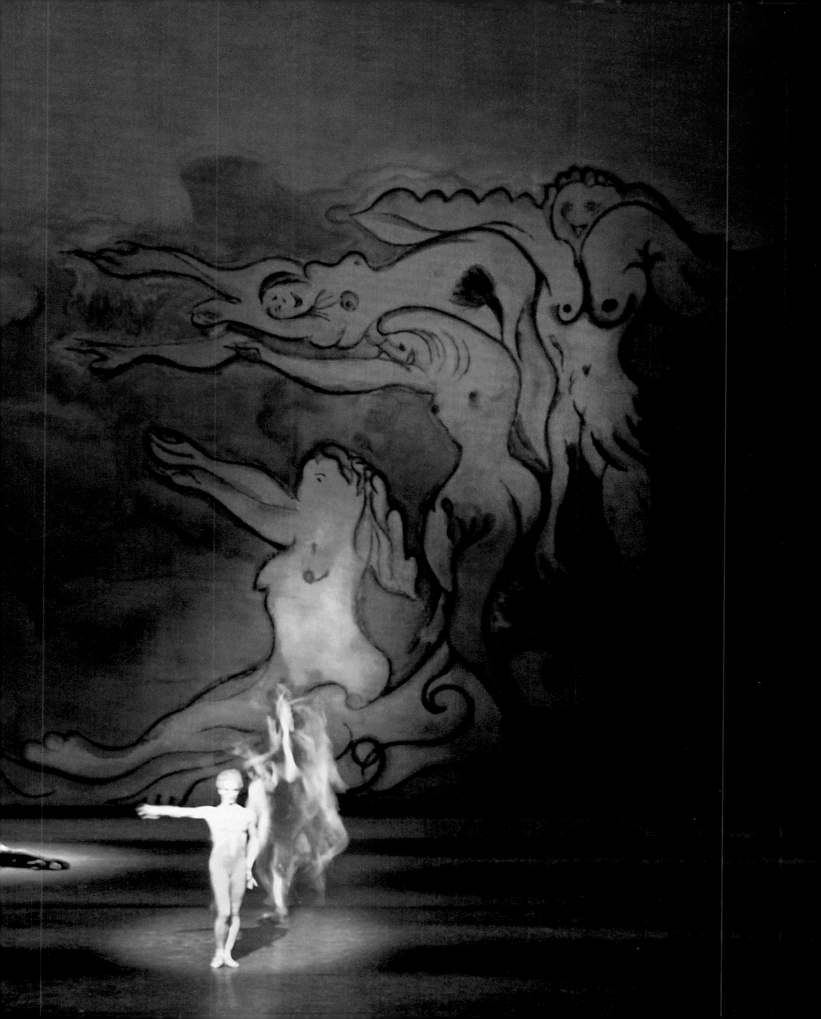

Libretto for *Diana and Actaeon*
Alasdair Middleton

Translations in italics are not set to music

1 *Diana alone*
DIANA

Pheraea	*Lady of the Beasts*
Agrotera	*Lady of the Hunt*
Dictynna	*Mistress of the Nets*
Lycaea	*Of the Wolves*
Elephaea	*Of the Deer*
Leucophryne	*Of the White Birds*
Daphnaea	*Mistress of the Laurels*
Cedreatis	*Of the Cedars*
Caryatis	*Of the Walnut Grove*
Limnaea	*Lady of the Shore*
Eurynome	*Of the Meadows*
Hecate	*The Far-Shooting*
Iocheaira	*She showers with arrows*
Chryselactus	*With shafts of Gold*
Celadinus	*The Strong-voiced*
Heurippe	*The Finder of Horses*
Phoebe	*Shining*
Hagne	*Pure*
Parthene	*Virgin*
Areste	*Best*
Calliste	*Most Beautiful*

2 *Hunt*
ACTAEON

Ades en comiti, Diva Virago,
Cuius regno pars terrarum
Secreta vacat, cuius certis
Petitur telis fera quae gelidum
Potat Araxen et quae stanti
Ludit in Histro.Tua Gaetulos
Dextra leones, tua Cretaeas
Sequitur cervas; nunc veloces
Figis dammas leviore manu.
Quidquid solis pascitur arvis
Arcus metuit, Diana, tuos.
Tua si gratus numina cultor
Tulit in saltus, retia vinctas
Tenuere feras, nulli laqueum
Rupere pedes; fertur plaustro
Praeda gementi; tum rostra canes
Sanguine multo rubicund gerunt
Repetitque casas rustica longo
Turba triumpho.

Be with your followers, manly Goddess,
For whose realm the secret parts of the earth are kept,
Whose arrows with certain aim find the prey which
drinks at the cold Araxes
Or plays in the frozen streams of Ister.
Your right hand follows Gaetulian lions, your left
Cretan deer;
Now with lighter hand you pierce the fleeing doe.
All things which feed in the lonely fields fear your
bow, Diana.
If, when he has made his sacrifice, your worshipper
takes your favour with him to the woods –
His nets hold the tangled prey,
No feet break his snares,
His catch is brought back on groaning wagons,
His hounds have their muzzles red with blood,
And all the hunters come home in a long
triumphant line.

3 *Dogs*
ACTAEON

Melampus, Pamphagus, Hylaeus
Blackfoot, Eat-all, Of Woods
Ichnobates, Oribasus, Nebrophonos
Tracker, Mountain-climber, Deer-slayer
Canace, Lycisce, Hylactor
Chewer, Wolfy, Snarler
Melaneus, Agriodus,
Blackie, White-tooth
Theron, Laelaps, Pterelas
Whirlwind, Hunter, Winged
Agre, Nape, Harpyia
Chaser, Valley, Snatcher
Ladon, Dromas, Poemenis
Catcher, Runner, Shepherd
Cyprius, Asbolus, Harpalus, Dorceus
Beauty, Sooty, Gabber, Gazelle
Sticte, Tigris, Alce, Leucon, Lacon
Spot, Tiger, Strong, White
Aello, Thous, Lachne, Lebros
Storm, Swift, Shaggy, Fury

6 *Actaeon sees Diana* (1)
DIANA

Scelus	*bad man*
Nefastus	*unlucky, ill-omened*
Impius	*infidel*
Nec castas pollue aquas!	*You defile these*
	chaste waters!

7 *Nymphs* (2)
DIANA

Crocale – Seashore
Nephele – Cloud
Hyale – Crystal
Phiale – Bowl
Rhanis – Misty
Psecas – Droplet

8 Actaeon sees Diana (2)

Diana	Lucina –
Actaeon	She leads into Light,
Diana	Phosphora –
Actaeon	The Bringer of Light,
Diana	Orsilochia –
Actaeon	The Helper at Childbirth
Diana	Hemerasia –
Actaeon	She who soothes.
Diana	Hecate –
Actaeon	The Far-Shooting.
Diana	Iocheaira –
Actaeon	She showers with arrows.
Diana	Chryselactus –
Actaeon	With shafts of Gold.
Diana	Phoebe –
Actaeon	Shining.
Diana	Hagne –
Actaeon	Pure.
Diana	Parthene –
Actaeon	Virgin.
Diana	Areste –
Actaeon	Best.
Diana	Calliste –
Actaeon	Most Beautiful.
	Pheraea –
Diana	Lady of the Beasts.
Actaeon	Agrotera –
Diana	Lady of the Hunt.
Actaeon	Dictynna –
Diana	Mistress of the Nets,
Actaeon	Lycaea –
Diana	Of the Wolves,
Actaeon	Elephaea –
Diana	Of the Deer,
Actaeon	Leucophryne –
Diana	Of the White Birds.
Diana	Taurica,
Actaeon	Britomart,
Diana	Melissa,
Actaeon	Selene,
Diana	Titania,
Actaeon	Aricina,
Diana	Astrateia,
Actaeon	Delia,
Diana	Soteira,
Actaeon	Diana.

11 Spell and Transformation
DIANA

Nunc tibi me posito visam velamine narres,
sit poteris narrare, licet!
Now tell, if you can, how you saw me naked!

12 Dogs kill Actaeon
ACTAEON

Blackfoot, Tracker, Eat-all, Gazelle!
Mountain-climber, Deerslayer, Whirlwind!
White, Strong, Swift, Shaggy!
Catcher, Runner, Chewer, Tiger!
Sparta, Spot, Wolfy, Storm!
Beauty, Blackie, Fury, Snarler!
Hunter, Chaser, Shepherd, Snatcher!
White-tooth, Sooty, Valley, Grabber!

Actaeon ego sum!
I am Actaeon!

13 Death of Actaeon
ACTAEON

Si nemus intravi vetitum, nostrive fugatae
Sunt oculis nymphae semicaperque deus;
Da veniam culpa[e]:
Nec noceat turbasse lacus: ignoscite nymphae,
Mota quod obscuras ungula fecit aquas.
Tu, dea, pro nobis fontes fontanaque placa,
Numina, tu sparsos per nemus omne deos,
Nec dryadas nec nos videamus labra Dianae,
Nec Faunum, medio cum premit arva die.

If I entered a forbidden grove and the nymphs
And half-goat god fled from my sight;
Forgive my offence:
Nor harm me for disturbing pools: Pardon, nymphs,
The trampling hooves for muddying your streams.
Goddess, placate for us the spirits of pools and streams,
Placate the gods who lurk in every grove.
Keep from our sight the Dryads and Diana's bath
And Faunus lying in the fields at mid-day.

The creative teams

Trespass

ALASTAIR MARRIOTT, CHOREOGRAPHER Born
in 1968, he joined The Royal Ballet in 1988, was
promoted to Soloist in 1992 and became Principal
Character Artist in 2003. Ballets created for
the Company include *Night Falls Fast* (2001),
Grey Garden (2002), *Prelude and Fugue* (2003),
Being and Having Been (2004), *Tanglewood*
(2005), *Children of Adam* (2007), *Sensorium*
(2009), *Schrumpf* (2010) and *Simple Symphony*
(2012). He has twice been nominated for a Critics'
Circle Award for best classical choreography.
He collaborated with Christopher Wheeldon
for the closing ceremony of the London 2012
Olympic Games. He has created all of his work
with the assistance of Jonathan Howells.

MARK-ANTHONY TURNAGE, COMPOSER Born
in 1960, he was Composer in Association with
the City of Birmingham Symphony Orchestra
between 1989 and 1993. His opera *The Silver
Tassie* won South Bank Show and Olivier awards.
He was the first Associate Composer for the BBC
Symphony Orchestra between 2000 and 2003;
and from 2005 to 2010 he was Composer
in Residence with the London Philharmonic
Orchestra. From 2006 to 2010 he was Mead
Composer in Residence with the Chicago
Symphony Orchestra. His third full-length
opera *Anna Nicole*, for The Royal Opera, had its
premiere in 2011. He is Research Fellow
in Composition at the Royal College of Music.

MARK WALLINGER, ARTIST Born in 1959,
he has had many solo exhibitions around
the world, including at the Serpentine Gallery,
Tate Liverpool, Vienna Secession, Museum
for Gegenwartskunst in Basel, Palais des
Beaux-Arts in Brussels, Kunstnernes Hus
in Oslo and the Neue Nationalgalerie in Berlin;
his video work *Via Dolorosa* is permanently
installed in a crypt of the Milan Duomo. In 1999,
his sculpture *Ecce Homo* was the first project
chosen for the vacant fourth plinth in London's
Trafalgar Square. He represented Great Britain
in the 2001 Venice Biennale and has been
nominated twice for the Turner Prize, winning
in 2007. In 2011, he collaborated with Wayne
McGregor and Mark-Anthony Turnage on
UNDANCE at Sadler's Wells. He is an Honorary
Fellow of Goldsmiths College and of the London
Institute and holds an honorary doctorate
from the University of Central England.
He is a member of the South Bank Board.

CHRISTOPHER WHEELDON, CHOREOGRAPHER
Born in 1973, he joined The Royal Ballet in 1991
and won the Gold Medal at the Prix de Lausanne
competition. In 1993 he left for New York City
Ballet, where he was promoted to Soloist in 1998.
In 2000 he retired from dancing, becoming
NYCB's first-ever Resident Choreographer.
In 2007, he founded Morphoses/The
Wheeldon Company. With Alastair Marriott,
he choreographed the closing ceremony of the
London 2012 Olympic Games. He has received
the Martin E. Segal Award from the Lincoln
Center and the American Choreography Award,
the Critics' Circle Award for Best New Ballet
and a South Bank Show Award. He was
nominated for an Olivier Award in 2006.

Machina

KIM BRANDSTRUP, CHOREOGRAPHER Born
in 1956, he studied film at the University of
Copenhagen and choreography with Nina
Fonaroff at the LCDS. He has worked as a
choreographer since 1983 and founded his
own dance company, Arc, in 1985. Recent prizes
include the Olivier Award for Best New Dance
Production for his 2010 work with Tamara Rojo,
Goldberg – The Brandstrup-Rojo Project. He has
choreographed for numerous international
ballet and opera companies, including Théâtre
des Champs-Elysées, Paris, Netherlands Opera,
Royal Danish Ballet, Opera North, English
National Opera, Glyndebourne, Greek National
Opera, Royal Swedish Ballet, English National
Ballet, Royal New Zealand Ballet, Rambert
and Norwegian Ballet, Les Grands Ballets
Canadiennes, Montreal.

WAYNE MCGREGOR, CHOREOGRAPHER Born
in 1970, he studied dance at University College
Bretton Hall, Leeds, and at the José Limón
School, New York. In 1992 he founded Wayne
McGregor | Random Dance, the Resident
Company of Sadler's Wells, for which he
has made more than thirty works. In 2003–4
he was a research fellow in the Department
of Experimental Psychology at Cambridge
University, and since 2009 he has worked
with cognitive scientists at the University
of San Diego. He was appointed Resident
Choreographer of The Royal Ballet in 2006.
He has created work for Stuttgart Ballet,
San Francisco Ballet, Paris Opéra Ballet,
Netherlands Dance Theatre, New York City
Ballet, the Australian Ballet, La Scala, Lyric
Opera of Chicago, Scottish Opera, and,
in London, English National Opera, English
National Ballet, the Old Vic, National Theatre,
Rambert Dance Company, Royal Court, Royal
Opera and the Peter Hall Company, among
many others. Awards include the Critics'
Prize at the Golden Mask Awards, three
Critics' Circle Awards, a South Bank Show
Award and Movimentos Award, a Benois
de la danse, two Time Out Awards and
two Olivier Awards. In January 2011 he
was appointed a CBE for Services to Dance.

Nico Muhly, Composer Born in 1981, he studied music at the Juilliard School, New York. Orchestral works include commissions for the American Symphony Orchestra, the Aurora Orchestra, the Boston Pops, the New York Philharmonic Orchestra and the Chicago Symphony Orchestra. He has written two full-length operas: *Two Boys*, a co-commission from ENO, the Metropolitan Opera and the Lincoln Center, and *Dark Sisters*, a co-commission by the Gotham Chamber Opera, Music-Theatre Group and the Opera Company of Philadelphia. Music for film includes scores for *Joshua* (2007) and *The Reader* (2008). For dance, his work has included *From Here on Out* for the ABT, *One Thing Leads to Another* for the Netherlands Ballet and *Twin Hearts* for NYCB, all in collaboration with Benjamin Millepied.

Conrad Shawcross, Artist Born in 1977, he studied at the Chelsea School of Art, London, the Ruskin School of Drawing and Fine Art in Oxford and the Slade School of Art, London. He has featured in numerous national and international group exhibitions and has had significant solo presentations at galleries and museums worldwide. Major public commissions include *Chord* for the Kingsway Tram Tunnel (2009) and *Space Trumpet* in the atrium of the refurbished Unilever Building, London (2007), which won the Art & Work 2008 Award for a Work of Art Commissioned for a Specific Site in a Working Environment. In 2009 he was awarded the Illy Prize for Best Solo Presentation at Art Brussels.

Jonathan Dove, Composer Born in 1959, he is a prolific opera composer, his diverse works including *Tobias and the Angel* (1999), *The Palace in the Sky* (2000), the community cantata *On Spital Fields* (2005), which won an RPS Award and a British Composer Award, and two operas for Channel 4, *When She Died* and *Man on the Moon*, which won the Opera Special Prize at the Rose d'Or Festival at Montreux. With Alasdair Middleton, he has written several operas for a family audience. He has worked as Artistic Director of the Spitalfields Festival and Music Advisor to the Almeida Theatre and is currently an Associate of the National Theatre. He was winner of the 2008 Ivor Novello Award for Classical Music.

Alasdair Middleton, Librettist Born in Yorkshire, he trained at the Drama Centre, London. His work with Jonathan Dove includes *The Walk from the Garden*, *Life is a Dream*, *Mansfield Park*, *Swanhunter*, *The Adventures of Pinocchio*, *The Enchanted Pig* and *On Spital Fields*. He collaborated with Will Tuckett on *Pleasure's Progress*, *Who Is This That Comes?* and *The Crane Maiden*. Other librettos include *The World Was All Before Them*, *On London Fields* (winner of an RPS Award), and *A Bird in Your Ear* (New York City Opera). His works as a playwright include *Aeschylean Nasty*, *Shame on You*, *Charlotte*, *Casta Diva* and *Einmal*.

Chris Ofili, Artist Born in 1968, he came to prominence in the early 1990s and was included in 'Sensation' at the Royal Academy in 1997. His tribute to the late South London teenager Stephen Lawrence formed part of his entry to the Turner Prize in 1998, a prize that he went on to win. His work has been the subject of solo exhibitions worldwide, including a major retrospective at Tate Britain in 2010. He was selected to represent Britain in the 50th Venice Biennale in 2003. His work is represented in many major international collections, including the Museum of Modern Art, New York, Tate, Britain, the Museum of Contemporary Art, Los Angeles, the British Museum, London, the Walker Art Center, Minneapolis, the Carnegie Museum of Art, Pittsburgh, and the Victoria and Albert Museum, London.

Liam Scarlett, Choreographer Born in 1987, he joined The Royal Ballet in 2005, and in 2008 was promoted to First Artist. Liam's interest in choreography began while at The Royal Ballet School, where he won both the Kenneth MacMillan and Ursula Moreton Choreographic Awards and was the first recipient of the De Valois Trust Fund Award. For The Royal Ballet, he created *Despite* and *Vayamos al Diablo* (2006), and has frequently choreographed for The Royal Ballet's *Draftworks*. His first main-stage work for The Royal Ballet was *Asphodel Meadows* (2010), nominated for a South Bank Award and an Olivier Award and winner of a Critics' Circle Award. He has twice been nominated for a Critics' Circle Dance Award for Best Choreography. In 2012 he was appointed the first Royal Ballet Artist in Residence.

Will Tuckett, Choreographer Born in Birmingham, he trained at The Royal Ballet School and joined the Sadler's Wells Royal Ballet before returning to The Royal Ballet. As a choreographer, he has created many works for the Company, and has worked as a choreographer and director for companies including The Royal Opera, English National Ballet, Rambert Dance Company, Dance Umbrella, National Ballet of China, the London Steve Reich Ensemble, K Ballet, DanceXchange, Ballet Black, Sarasota Ballet, Opera North, Grange Park and the Bregenz Festival. He devised the documentary TV series *Ballet Changed My Life: Ballet Hoo!* for Channel 4 in 2006. He is a Principal Character Guest Artist with The Royal Ballet, was Creative Associate for ROH2 and was the Clore Dance Fellow 2008/9.

Jonathan Watkins, Choreographer Born in 1984, he trained in his native Yorkshire and then joined The Royal Ballet School at the age of twelve. He won the Kenneth MacMillan Choreography Award aged fifteen. He graduated in 2003, joining the Company the same year. His main-stage debut came in 2010 with *As One*. He has created a variety of other works, including *Beyond Prejudice* and *Free Falling* for The Curve Foundation at the Edinburgh Fringe Festival, *NOW* for the NYCB's Choreography Institute, *Anger Fix* at Sadler's Wells and *From Within* for The Royal Ballet School. *Route 67* for The Slice Project was his first commission for dance on film. Most recently, he choreographed *Together Alone* for Ballet Black and collaborated on *INALA*, a unique joint project between the South African group Ladysmith Black Mambazo and dancers from The Royal Ballet. His two dance films for the *Random Acts* series were shown on Channel 4 in 2012.

Photography credits

Photographers
GD Gautier Deblonde
JP Johan Persson
AU Andrej Uspenski

l: left, c: centre, r: right, t: top, b: bottom

6 Photographer Chris Nash. Image concept: Dewynters in collaboration with the National Gallery. Design: The National Gallery. Photograph copyright © 2013 The National Gallery. **10** Photographer AU. **11** Photographer GD. **12t–b** Marianela Nuñez as Diana in *Diana and Actaeon*. Photographer AU; Tamara Rojo and Edward Watson in *Machina*. Photographer AU; *Trespass* performance shot. Photographer Ivor Kerslake. **13** Photograph copyright © 2013 The National Gallery. **14–16** Copyright © 2012 Chris Ofili. Photograph copyright © 2013 Stephen White. Courtesy the Artist and Victoria Miro Gallery, London. **17t–b** Copyright © 2012 Mark Wallinger. Courtesy the Artist; Photographer GD. **18–20** Photographs copyright © 2013 The National Gallery. **22t–b** Photograph copyright © 2013 The National Gallery; Photograph copyright © 2013 The National Gallery; Photographer GD. **23** Photographer GD. **24t** Copyright © 2012 Conrad Shawcross. Photograph copyright © 2013 Stephen White. Courtesy the Artist and Victoria Miro Gallery, London. **24b** Photographer AU. **25** Photographer JP. **26** Mark Wallinger in the National Gallery. Photographer GD. **28** Photographer GD. **29** Photographer AU. **30–5** Copyright © 2012 Mark Wallinger. Courtesy the Artist. **36** Photographer AU. **37t–b** Richard I'Anson/ Lonely Planet Images; Photographer GD; Courtesy Mark Wallinger; Photograph copyright © 2013 Dave Morgan. Courtesy DanceTabs. **38t** Photograph copyright © 2013 The National Gallery. **38b** Photographer GD. **39t** Copyright © 2012 Mark Wallinger. Courtesy the Artist. **39c** and **39b** © Succession Marcel Duchamp/ADAGP, Paris and DACS, London 2012. **40–1** Photographs copyright © 2013 The National Gallery. **42** Copyright © 2012 Mark Wallinger. Courtesy the Artist. **43** Photograph copyright © 2013 The National Gallery. **44** All copyright © 2013 Mark Wallinger. Courtesy the Artist. **45t** and **45c** Copyright © 2012 Mark Wallinger. Courtesy the Artist. **45b** Photographer GD. **46** Copyright © 2012 Mark Wallinger. Courtesy the Artist. **47** Photographer GD. **48** Beatriz Stix-Brunell and Nehemiah Kish in rehearsals for *Trespass*. Photographer AU. **49** Alastair Marriott and Christopher Wheeldon in the rehearsal studio with the dancers from *Trespass*. Photographer AU. **50** Melissa Hamilton rehearsing with the male corps de ballet from *Trespass*. Photographer AU. **51** Steven McRae and Sarah Lamb rehearsing for *Trespass*. Photographer AU. **52–3** Stage rehearsals for *Trespass* with Christopher Wheeldon. Photographer GD. **54–5** *Trespass* performance shots. Photographer GD. **56–7** *Trespass* performance shots. Photographer Ivor Kerslake. **58–61** Beatriz Stix-Brunell and Nehemiah Kish in *Trespass*. Photographer AU. **62–3** *Trespass* performance shots. Photographer Ivor Kerslake. **64–5** Steven McRae and Sarah Lamb in *Trespass*. Photographer AU. **66–7** Melissa Hamilton and the female corps de ballet in *Trespass*. Photographer JP. **68** Beatriz Stix-Brunell, Nehemiah Kish, Melissa Hamilton, Steven McRae and Sarah Lamb in *Trespass*. Photograph copyright © 2012 Dave Morgan. Courtesy DanceTabs. **69** Melissa Hamilton in *Trespass*. Photographer JP. **70** Melissa Hamilton and male corps de ballet in *Trespass*. Photographer JP. **71** Male corps de ballet in *Trespass*. Photographer AU. **72** Nehemiah Kish in *Trespass*. Photographer GD. **73** Melissa Hamilton and the female corps de ballet in *Trespass*. Photograph copyright © 2013 Dave Morgan. Courtesy DanceTabs. **74–5** *Trespass* performance shot. Photographer Ivor Kerslake. **76** Conrad Shawcross standing on the *Machina* robot, installed on the Royal Opera House stage. Photographer GD. **78** Copyright © 2013 Conrad Shawcross. Photograph copyright © 2013 Stephen White. Courtesy the Artist and Victoria Miro Gallery, London. **79–81** Copyright © 2012 Conrad Shawcross. Courtesy the Artist. **82** Photographer GD. **83** Copyright © 2012 Conrad Shawcross. Courtesy the Artist. **84–5** Copyright © 2012 Conrad Shawcross. Courtesy the Artist. **85t** and **85c** Photographer GD. **86t** and **86c** Photographs copyright © 2013 The National Gallery. **86b** Copyright © 2012 Conrad Shawcross. Photograph copyright © 2013 Stephen White. Courtesy the Artist and Victoria Miro Gallery, London. **87** Copyright © 2012 Conrad Shawcross. Photograph copyright © 2013 Stephen White. Courtesy the Artist and Victoria Miro Gallery, London. **88–9** Copyright © 2012 Conrad Shawcross. Photograph copyright © 2013 Stephen White. Courtesy the Artist and Victoria Miro Gallery, London. **90–1** Copyright © 2012 Conrad Shawcross. Courtesy the Artist. **92** Photographer AU. **93–4** Copyright © 2012 Conrad Shawcross. Courtesy the Artist. **96–7** Photographer GD. Computer simulations copyright © 2013 Conrad Shawcross. Courtesy the Artist. **98–9** Photographer GD. **100** Copyright © 2012 Conrad Shawcross. Courtesy the Artist. **101t–b** Tamara Rojo in *Machina*. Photographer AU; Tamara Rojo and Edward Watson in *Machina*. Photographer AU; computer simulation copyright © 2013 Conrad Shawcross. Courtesy the Artist. Carlos Acosta and Leanne Benjamin in *Machina*. Photographer AU; Detail of Tamara Rojo's costume in *Machina*. Photographer JP. **102–3** Carlos Acosta and Leanne Benjamin in *Machina*. Photographer GD. **104–5** Copyright © 2012 Conrad Shawcross. Courtesy the Artist. **106** Kim Brandstrup directing Tamara Rojo and Edward Watson in rehearsals for *Machina*. Photographer AU. **107** Tamara Rojo and Edward Watson rehearsing for *Machina*. Photographer AU. **108t–b** Wayne McGregor and Tamara Rojo at stage rehearsals for *Machina*. Photographer GD; Kim Brandstrup, Wayne McGregor and Dame Monica Mason at stage rehearsals for *Machina*. Photographer GD; Conrad Shawcross, Wayne McGregor and Tamara Rojo at stage rehearsals for *Machina*. Photographer GD. **109t–b** Wayne McGregor at stage rehearsals for *Machina*. Photographer GD; Kim Brandstrup at stage rehearsals for *Machina*. Photographer GD; Carlos Acosta at stage rehearsals for *Machina*. Photographer GD; Conrad Shawcross at stage rehearsals for *Machina*. Photographer AU; Wayne McGregor and Carlos Acosta at stage rehearsals for *Machina*. Photographer GD. **110–11** Edward Watson and Tamara Rojo in *Machina*. Photographer Ivor Kerslake. **112** Carlos Acosta and Leanne Benjamin in *Machina*. Photographer AU. **113t–b** *Machina* performance shot. Photographer AU; Tamara Rojo in *Machina*. Photographer AU; Edward Watson in *Machina*. Photographer AU. **114–5** Edward Watson and Tamara Rojo in *Machina*. Photographer JP. **116** Tamara Rojo and Edward Watson in *Machina*. Photographer GD. **117t** Carlos Acosta and Leanne Benjamin in *Machina*. Photographer JP. **117c** Carlos Acosta and Leanne Benjamin in *Machina*. Photographer GD. **117b** Carlos Acosta and Leanne Benjamin in *Machina*. Photographer GD. **118–19** *Machina* performance shot. Photographer Ivor Kerslake. **120–1** Tamara Rojo and Edward Watson in *Machina*. Photographer GD. **122–3** Tamara Rojo and Edward Watson in *Machina*. Photographer AU. **124–5** Tamara Rojo and Edward Watson in *Machina*. Photographer AU. **126–7** Edward Watson and Leanne Benjamin in *Machina*. Photographer Ivor Kerslake. **128** Chris Ofili in the National Gallery. Photograph copyright © 2013 The National Gallery. **130–1** Photographer GD. **136–42** Photographer GD. **143t** The Hounds rehearsing for *Diana and Actaeon*. Photographer AU. **143b** Photographer GD. **144t** Photographer AU. **144b** Photographer GD. **145** Photographer AU. **146** Photographs copyright © 2013 The National Gallery. **148–51** Copyright © 2012 Chris Ofili. Photograph copyright © 2013 Stephen White. Courtesy the Artist and Victoria Miro Gallery, London. **152** Jonathan Watkins directing rehearsals for *Diana and Actaeon*. Photographer AU. **153** Jonathan Watkins directing Marianela Nuñez and Federico Bonelli in rehearsals for *Diana and Actaeon*. Photographer GD. **154** Liam Scarlett directing rehearsals for *Diana and Actaeon*. Photographer AU. **155t** Marianela Nuñez in rehearsals for *Diana and Actaeon*. Photographer AU. **155b** Federico Bonelli in rehearsals for *Diana and Actaeon*. Photographer AU. **156–7** Will Tuckett directing the Hounds in rehearsals for *Diana and Actaeon*. Photographer GD. **158–9** Marianela Nuñez in *Diana and Actaeon*. Photograph copyright © 2013 Dave Morgan. Courtesy DanceTabs. **160–1** Federico Bonelli as Actaeon with the Hunt in *Diana and Actaeon*. Photographer Ivor Kerslake. **162** Federico Bonelli as Actaeon with the Hunt in *Diana and Actaeon*. Photographer GD. **163** Federico Bonelli as Actaeon with the Hounds in *Diana and Actaeon*. Photographer GD. **164 and 165** Marianela Nuñez as Diana with her Nymphs in *Diana and Actaeon*. Photographer JP. **166–7** Federico Bonelli as Actaeon and Marianela Nuñez as Diana with her Nymphs in *Diana and Actaeon*. Photographer AU. **168** Federico Bonelli as Actaeon and Marianela Nuñez as Diana in *Diana and Actaeon*. Photograph copyright © 2013 Dave Morgan. Courtesy DanceTabs. **169** The Nymphs in *Diana and Actaeon*. Photographer AU. **170** Marianela Nuñez as Diana with her Nymphs in *Diana and Actaeon*. Photographer JP. **171** Marianela Nuñez as Diana in *Diana and Actaeon*. Photographer AU. **172** Federico Bonelli as Actaeon in *Diana and Actaeon*. Photographer AU. **173** Federico Bonelli as Actaeon and the Hounds in *Diana and Actaeon*. Photograph copyright © 2013 Dave Morgan. Courtesy DanceTabs. **174–5** The Nymphs surround the slain Actaeon in *Diana and Actaeon*. Photographer AU. **176–7** *Diana and Actaeon* performance shot. Photographer Ivor Kerslake.